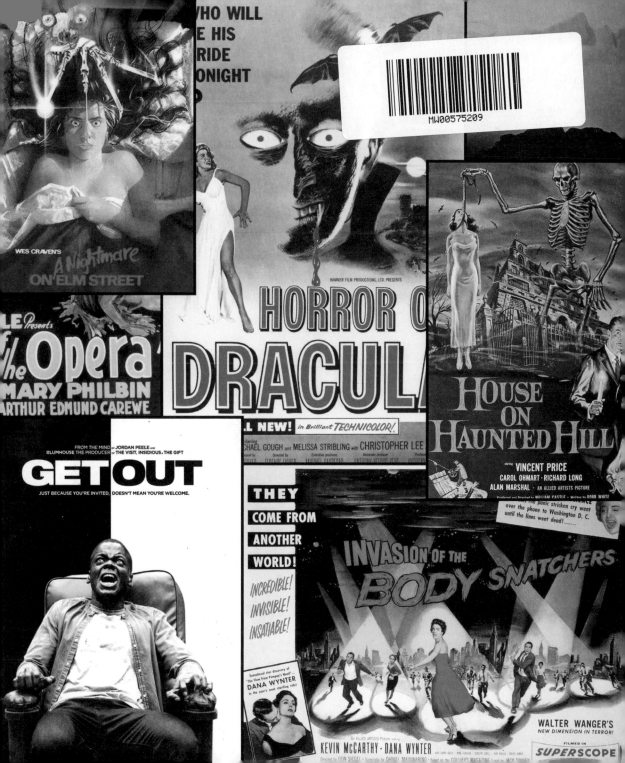

TURNER CLASSIC MOVIES

FRIGHT
FAVORITES

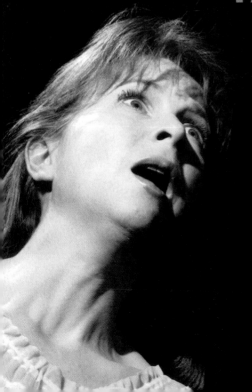

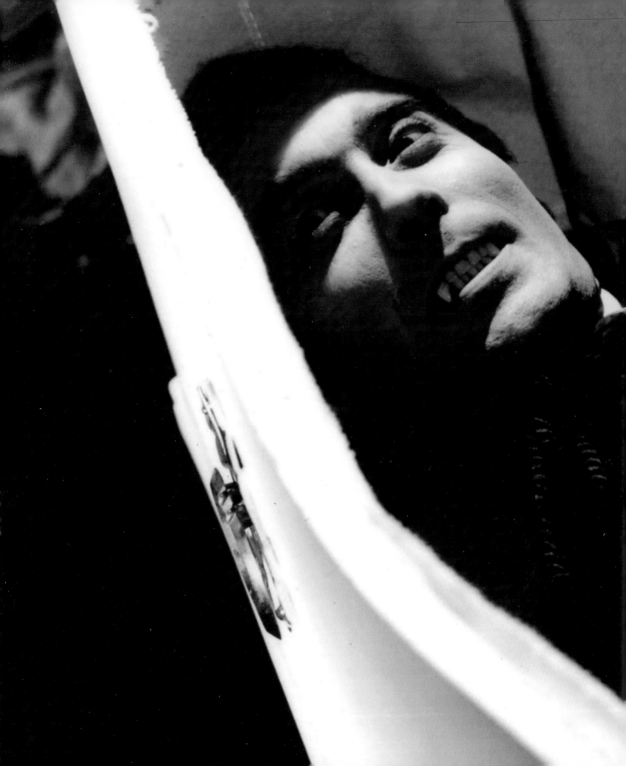

TURNER **CLASSIC** MOVIES.

FRIGHT
FAVORITES

31 MOVIES
TO HAUNT YOUR HALLOWEEN
AND BEYOND

DAVID J. SKAL

Running Press
PHILADELPHIA

Running Press
Hachette Book Group
1290 Avenue of the Americas, New York, NY 10104
www.runningpress.com
@Running_Press

Printed in China

First Edition: September 2020

Published by Running Press, an imprint of Perseus Books, LLC, a subsidiary of Hachette Book Group, Inc. The Running Press name and logo is a trademark of the Hachette Book Group.

The Hachette Speakers Bureau provides a wide range of authors for speaking events. To find out more, go to www.hachettespeakersbureau.com or call (866) 376-6591.

The publisher is not responsible for websites (or their content) that are not owned by the publisher.

Photo credits: Author's collection: front matter, table of contents, pages 1, 3–7, 8–10 (top), 11–19, 21–24 (top right), 26, 28–30, 32, 33, 35, 36 (right), 37 (top), 38–40, 42, 44, 45, 48, 50, 51, 52, 54, 57, 59, 60 (top), 61–68, 70, 71–73, 75, 76 (bottom), 81, 83, 84, 86 (top), 88, 89, 90–94, 96, 98, 100 (top, center), 102, 104–107 (top left, bottom right), 108, 110, 111, 113–124, 126, 134, 137, 138 (top), 140 (top), 143 (bottom right), 144, 145 (bottom right), 148–150 (center, bottom), 149–154 (bottom), 156–197, 204, 205, 207, 209, 211, 213, and 214. Courtesy Ronald V. Borst/Hollywood Movie Posters: dedication page, pages 10 (bottom), 27, 34, 37 (bottom), 41, 46, 47, 49, 69, 71, 72, 74, 78, 79, 80, 85, 87, 95, 101, 103, 105, 107 (bottom left), 108, 110, 112, 127, 139, 141, 142 (bottom), 143, 145, 147, 150 (top), 166, and 202. All other images courtesy Turner Classic Movies.

Print book cover and interior design by Joshua McDonnell.

Library of Congress Control Number: 2020932963

ISBNs: 978-0-7624-9762-1 (hardcover), 978-0-7624-9760-7 (ebook)

RRD-S

10 9 8 7 6 5 4 3 2 1

TO MONSTER KIDS OF ALL AGES EVERYWHERE.

(YOU KNOW WHO YOU ARE.)

—DJS

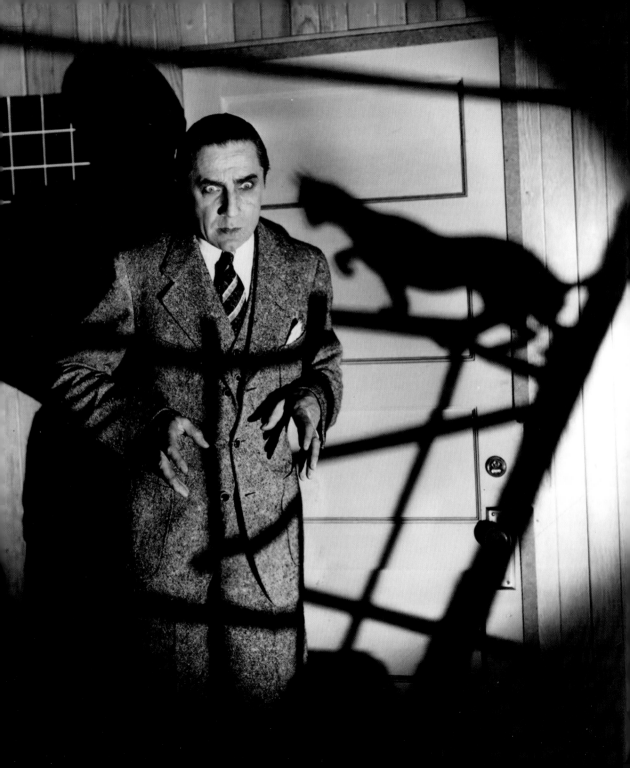

CONTENTS

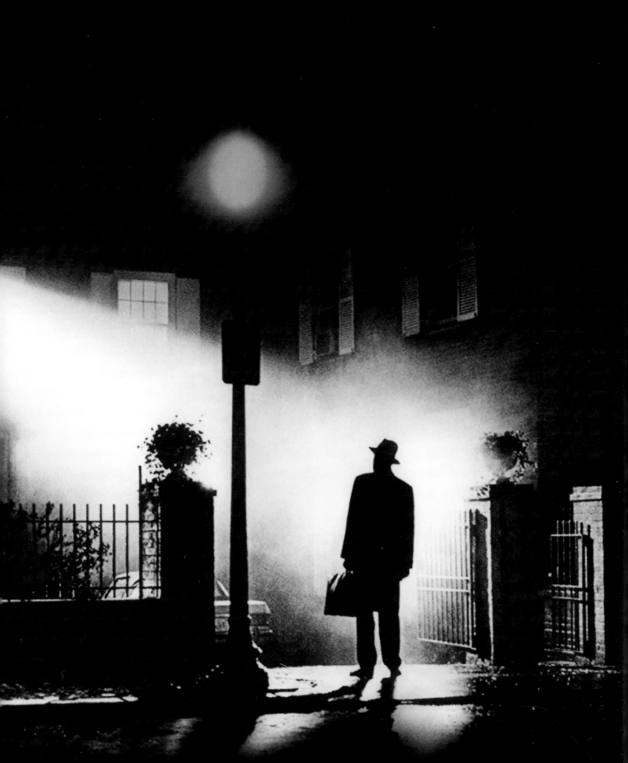

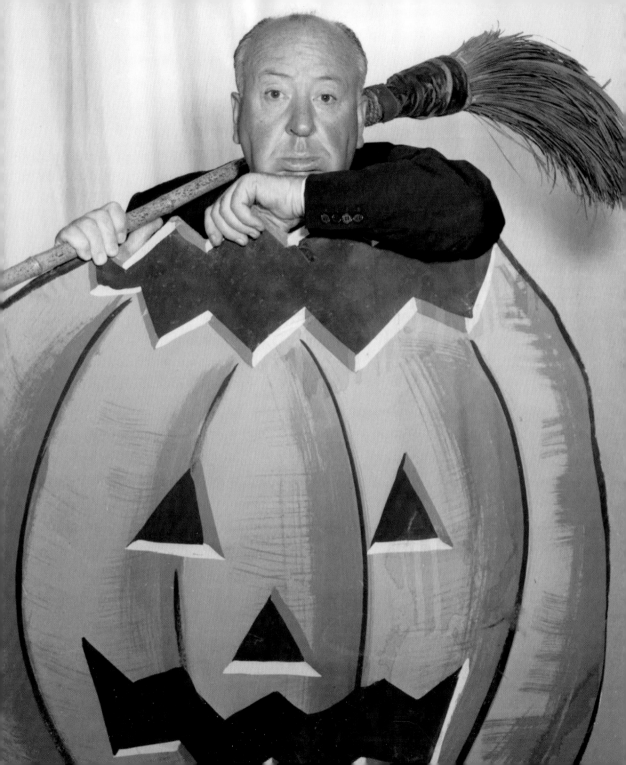

Ann Miller in an undated seasonal pinup

HALLOWEEN:
A HOLLYWOOD STATE OF MIND

Both Hollywood and Halloween emerged as significant cultural fixtures during the same decades of the early twentieth century. Americans have always believed that a malleable identity is our birthright, that we all have the prerogative and power to become anyone or anything of our individual choice. Like Halloween, Hollywood is about dressing up and acting out all the possibilities of our mercurial national personality.

Halloween made its American screen debut, however briefly, in *The Three of Us* (1914), starring Mabel Taliaferro, well known at the time as partner to the future horror director Tod Browning in Komic-Mutual two-reelers. *The Three of Us*, from the 1906 stage play by Rachel

Crothers, depicted a festive Halloween dinner in a Colorado mining town. A more upscale celebration was featured in *The Way of a Man with a Maid* (1918), directed by Donald Crisp, in which a struggling bookkeeper scrimps and saves to afford the fashionable attire that will impress a girl he escorts to a party on the magic night of October 31.

A far more sensational Halloween was featured in *Do the Dead Talk?* (1920), a story of seances and spiritualism that included actress Herminia France setting fire to her clothes while lighting a jack-o'-lantern. It was the first time a movie had sounded any kind of cautionary note about the holiday, presaging in a tiny way the tsunami of fake blood and rubber body parts that would eventually overwhelm the seasonal festivities. No one connected with *Do the Dead Talk?* could imagine that, a century later, Halloween celebrations would routinely include the movie-derived thrill of being chased through a theme park with a chainsaw.

Early Hollywood overwhelmingly approached Halloween affectionately. The wholesale commercialization of the holiday was a distinctly post–World War II phenomenon; studios like Universal, for instance, didn't begin licensing Halloween costumes of their famous monsters until the 1960s. Halloween made regular cameo appearances in films, and audiences smiled at the homespun costumes and activities that reflected their own holiday customs. In the real world, Halloween vandalism was a big problem during the Depression years, but Hollywood, ruled by the all-powerful Production Code,

would never depict anything but the mildest holiday prank on-screen for fear of demonstrating the forbidden "technique of crime" to the young and impressionable.

Fans of the classic movie magazines never saw October advertisements for Halloween film tie-ins and merchandise, but they were regularly treated to glamorous photo pinups of their favorite actresses inspired by traditional Halloween postcards and decorations. Starlets and established stars alike posed in pointy hats and racy witch costumes surrounded by the holiday's obligatory paraphernalia and imagery: jack-o'-lanterns, black cats, bats, and broomsticks. The pioneers of this durable tradition were silent stars like Clara Bow and Colleen Moore, followed by the likes of Myrna Loy, Joan Crawford, Shirley Temple, Ava Gardner, Betty Grable, Veronica Lake, Ann Miller, and Debbie Reynolds.

Spooky publicity photos of actors were usually reserved for top horror stars like Boris Karloff, Bela Lugosi, and Vincent Price. Their classic fright films were released year-round, but photographers never resisted vintage Halloween iconography for these assignments whenever they occurred. Shadow silhouettes of black cats, bats, and cobwebs worked just as well for movie marketing as they did for party favors and decorations.

Disney, as usual, always had its finger on the pulse of commercial possibilities for Halloween before its competitors. Its animated *Silly Symphony* series short, *The Skeleton Dance*, was a perfect embodiment of the holiday spirit, delighting audiences throughout the fall of 1929.

Clara Bow

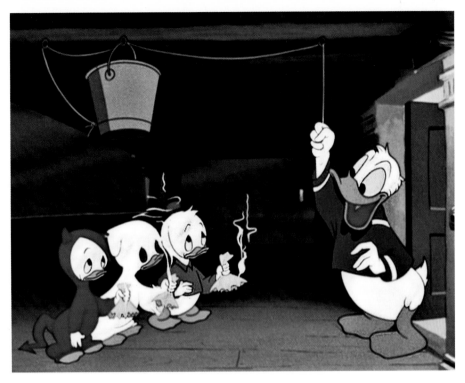

LEFT Yvonne de Carlo **ABOVE** Huey, Dewey, and Louie explain Halloween to postwar America in *Trick or Treat* (1952).

Mickey and Minnie Mouse were among the earliest examples of character licensing when they first appeared as Halloween costumes in the 1930s, and Disney's 1952 Donald Duck cartoon *Trick or Treat*, with its catchy title song, modeled and standardized the begging ritual for millions of suburban children, just as candy companies got on the bandwagon in a big way.

Halloween has been an expanding industry ever since, growing exponentially every decade, and is now a multibillion-dollar annual cash machine—the largest retail holiday after Christmas. In recent decades, Halloween has also become more cinematic than ever, with the latest scary movies competing for October release dates, and established entertainment franchises like *The Walking Dead* showcased in major theme park attractions, as in Universal Studios' long-running Hollywood Horror Nights. Beyond cold economic considerations, it's also an especially beloved celebration, with warmly treasured personal meaning and nostalgic memories for people of all ages, backgrounds, and interests. Therefore, this book is not intended as a comprehensive history of spooky films—indeed, scary movies now comprise such a multitude of genres and subgenres that such an undertaking would fill an encyclopedia set.

Instead, *Fright Favorites* is a diverse sampler of chilling, thrilling, and often laugh-provoking classic movies especially well suited to mark the thirty-one days of October (or, considering the year-round interest in all things Halloweenish, maybe we should make that the 365 days of October?). Some readers will be familiar with the films included here, but I hope you enjoy some fascinating new anecdotes and rarely seen images. Others of you will be discovering these gems for the first time. If that's the case, get ready for a holiday treat calculated to last the whole year through.

Halloween kicks up its heels: Disney's *The Skeleton Dance* (1929).

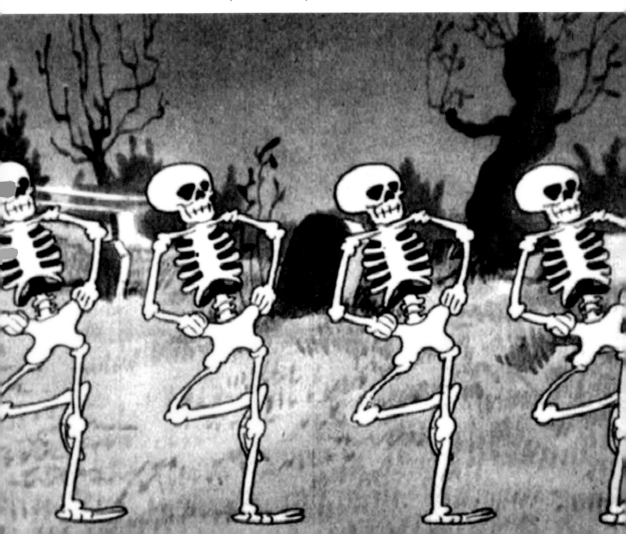

Vincent Price in a publicity photo for *The Bat* (1959)

NOSFERATU
A SYMPHONY OF HORROR

ONE OF THE MOST INFLUENTIAL HORROR MOVIES EVER MADE—
AND ALMOST LOST FOREVER.

Prana Film, 1922 (Germany)
Black and white (tinted),
94 minutes (restored version)

DIRECTOR
F. W. MURNAU

PRODUCERS
ALBIN GRAU AND ENRICO DIECKMANN

SCREENPLAY
HENRIK GALEEN, BASED ON THE NOVEL *DRACULA*,
BY BRAM STOKER

STARRING

COUNT ORLOK	MAX SCHRECK
HUTTER	GUSTAV VON WANGENHEIM
ELLEN	GRETA SCHROEDER
HARDING	GEORG HEINRICH SCHNELL
RUTH	RUTH LANDSHOFF
PROFESSOR SIEVERS	GUSTAV BOTZ
KNOCK	ALEXANDER GRANACH
PROFESSOR BULWER	JOHN GOTTOWT

he story behind *Nosferatu* is almost as frightening as the film itself, at least from the perspective of historic film preservation. Today an undisputed masterpiece of world cinema, F. W. Murnau's most celebrated achievement was the first, though completely unauthorized, film adaptation of Bram Stoker's *Dracula*, and the specter of copyright infringement haunted it from the beginning, endangering its very survival. Most silent films have been lost through neglect (75 percent, according to the Library of Congress). In the case of *Nosferatu*, the film was the target of a campaign aimed at its deliberate destruction. Had *Nosferatu* not survived, the entire trajectory of fantastic filmmaking could well have been materially altered—and greatly impoverished.

Nosferatu is a prime example of German expressionism, a broad category covering a range of artistic experimentation arising from the cataclysm of World War I, and often employing grotesquely distorted characters and situations, allegory, and social criticism. In cinema, expressionism employed stylized theatrical settings and a dramatic use of light and shadow. The most influential expressionist film was another horror story: Robert Wiene's *The Cabinet of Dr. Caligari* (1920), which featured skewed sets and sharp shadows reflecting a preoccupation with nightmares and insanity. The story of a mesmeric carnival charlatan (Werner Krauss) who controls a murderous somnambulist (Conrad Veidt) has been interpreted as a parable of the Great War itself, in which untold numbers of soldiers were

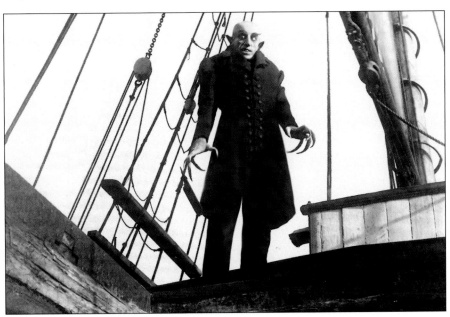

Blood vessel: the vampire commandeers a ship, killing its crew.

sent forth by madmen in positions of power to kill and be killed.

The guiding force behind *Nosferatu* was the artist and occultist Albin Grau, who in 1921 founded an independent production company, Prana Film, dedicated to supernatural themes. In the end, *Nosferatu* would be its only realized project. Grau hired Henrik Galeen, a screenwriter and actor known for his work on *The Golem* (1915), and the rising German director Friedrich Wilhelm Murnau. Grau took a hands-on approach to his vision, acting not only as producer but also as art director and costume designer; he additionally created all the publicity materials and posters.

Grau attributed the film's genesis to vampire legends he heard recounted in Serbia during his service in World War I. Like *Caligari*, *Nosferatu* told a story by way of allegory; Grau regarded the war itself as a "cosmic vampire" that had drained the lifeblood of Europe. He also interpreted Dracula (whom he renamed Count Orlok) as a rat-like vector of plague—a highly effective and grimly appropriate choice. Overcrowded hospitals attending maimed soldiers had proved a major breeding ground for the Spanish flu pandemic of 1918–1920. Like the fantasy world of *Nosferatu*, Europe itself was gripped by a plague, which by some accounts took more lives than the war.

No one knows exactly where the word "Nosferatu" originated. Bram Stoker assumed it was the Romanian/Transylvanian word for "vampire" (based on a claim made by a Scottish folklorist), but it cannot in fact be definitively

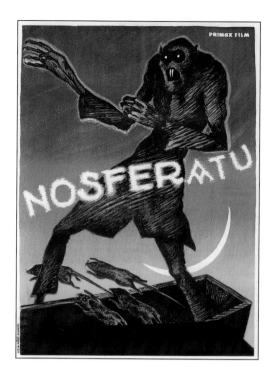

Original promotional art by Albin Grau
ABOVE Czech poster **BELOW** Russian herald

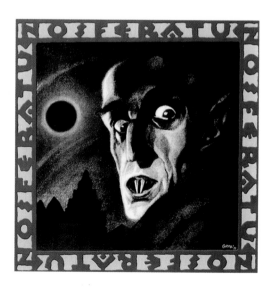

traced to any language. Nonetheless, it sounds authentically ancient and convincingly creepy, and it is now generally accepted as a synonym for "undead."

Whereas *Dracula* is set contemporaneously in Stoker's Victorian age, *Nosferatu* takes place much earlier in the nineteenth century, during the age of the Brothers Grimm, E. T. A. Hoffmann, and the full flowering of literary Romanticism. The characters are archetypal and simply delineated, like figures in a fairy tale. The actors all came from the German stage, which had already been advancing the acting and design conventions that greatly influenced expressionist film. The most memorable performance is that of Max Schreck as Orlok/Dracula, an indelibly disturbing amalgam of human and rat. Stoker's

Dracula was also repulsive—a fact usually overlooked by filmmakers—but Grau's conception exceeded even Stoker's vision.

While *Nosferatu* changed many aspects of Stoker's book, it retained others. *Dracula* is an epistolary novel—an assemblage of letters, diaries, newspaper clippings, and other documents—and *Nosferatu* parallels the technique through an extensive use of calligraphic title cards that provide an omniscient narrative framework. A direct borrowing from *Dracula* is the use of a ship captain's harrowing log, recounting the stowaway vampire's commandeering of the doomed vessel.

One of the most famous and chilling images in film history occurs after the heroine Ellen (Greta Schroeder) learns that the vampire can be

Hutter discovers his host's resting place and understands his true nature.

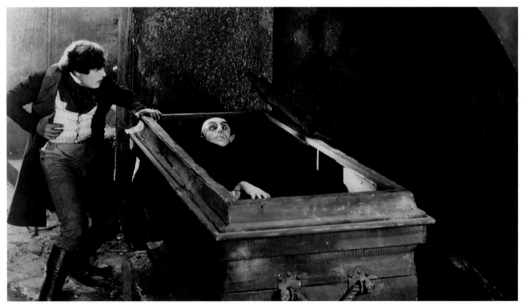

destroyed by a virtuous woman willingly inviting the monster to her bed and keeping him there until sunrise. Ellen makes the invitation by flinging open her window, and then, in what amounts to the most iconic pair of shots in German expressionist film, Count Orlok's shadow is seen stealing up the stairs to her bedroom, followed by the dark shape of his claw-like hand stretching out to her door.

A gala Berlin premiere, including a costume ball, was held in early 1922. Grau's publicity efforts were ambitious and extensive, reportedly costing more than the film's entire production budget, and word of the film's existence soon reached the widow of Bram Stoker, who had died ten years earlier. Florence Stoker struggled to maintain a stable income from *Dracula*'s royalties and was eager to exploit potential stage and film adaptations. Universal Pictures had considered a film version as early as 1915, but passed because of irregularities with the book's American copyright registration. Nevertheless, in 1920 Universal made a press announcement that it was considering *Dracula* as the next vehicle for its up-and-coming "mystery man" director Tod Browning—who, of course, would ultimately helm the famous 1931 version.

When *Nosferatu* appeared, the filmmakers naively made no attempt to hide the fact that it was "freely adapted" from *Dracula*. Florence Stoker was outraged at the brazen infringement of her copyright and immediately enlisted the assistance of the British Society of Authors to help press a legal case. A three-year legal war ensued, which bankrupted Prana Film.

Count Orlok (Max Schreck) welcomes Hutter (Gustav von Wangenheim) to Transylvania.

The widow never collected money, but in 1925 she did win a ruling by the German courts, which officially declared *Nosferatu* an infringement of her copyright and ordered all prints of the film and its negative to be destroyed. But even without copyright protection, pirated copies of *Nosferatu* were soon surreptitiously escaping Germany, seeking refuge in foreign lands in much the same way that Dracula had fled his native Transylvania.

Nosferatu, however, was not finished disturbing Florence Stoker's dreams.

Because *Nosferatu* never had a proper American distribution, when Murnau, by then

acclaimed for the Ufa production of *Faust*, relocated to Hollywood, interviewers and publicists didn't know of the earlier film's existence and never asked him about it. Murnau died tragically in a car crash in 1931, having never given an interview or other account of the film's production. *Nosferatu* essentially vanished until the 1960s, when prints began to resurface and the full importance of its achievement was recognized. It has since been regularly revived, often accompanied by highly creative new orchestral scores performed live. A definitive restoration utilizing the best available elements was finally completed in 2013.

In 1979 Werner Herzog's remake/homage, *Nosferatu the Vampyre*, starred Klaus Kinski closely resembling Schreck but playing Dracula as a tragic, lonely figure. In E. Elias Merhige's *Shadow of the Vampire* (2000), a fictionalized account of the making of Murnau's film, Willem Dafoe played Nosferatu/Schreck (the actor presented, cheekily enough, as an actual vampire), with John Malkovich as Murnau and Udo Kier as Albin Grau.

If you enjoyed *Nosferatu* (1922), you might also like:

THE HANDS OF ORLAC
PAN FILMS, 1924 (AUSTRIA/GERMANY)

Four years after *The Cabinet of Dr. Caligari*, director Robert Wiene rejoined forces with *Caligari* star Conrad Veidt for *The Hands of Orlac*, another expressionist masterpiece. Paul Orlac (Veidt) is a famous concert pianist whose hands are mangled in a train wreck. His wife begs doctors to do anything to save his livelihood, and they replace his hands with those of an executed murderer. Orlac becomes obsessed with the idea that the hands have a will of their own, and ensuing events seem to confirm his fears. *The Hands of Orlac* is a good example of films on both sides of the Atlantic after World War I that became fixated on physical mutilation and mental derangement while unprecedented numbers of disfigured veterans returned uneasily to civilian life. *Orlac* was remade in 1935 as *Mad Love*, starring Peter Lorre, and in 1960 under the original title, starring Mel Ferrer and Christopher Lee.

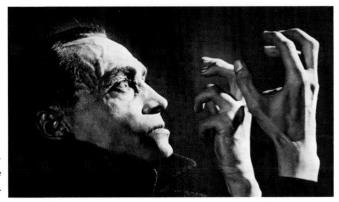

Conrad Veidt recoils from the transplanted hands that have taken on a life of their own in *The Hands of Orlac*.

THE PHANTOM
OF THE OPERA

A CLASSIC TALE OF IMPOSSIBLE LOVE HAD ITS OWN STAR-CROSSED JOURNEY TO THE SCREEN.

Universal Pictures, 1925
Black and white (tinted) with two-strip
Technicolor sequence,
101 minutes (restored version)

DIRECTORS
RUPERT JULIAN, EDWARD SEDGWICK, LON CHANEY
(UNCREDITED)

PRODUCER
CARL LAEMMLE

SCREENPLAY
ELLIOTT CLAWSON, RAYMOND L. SCHROCK (ADAPTATION);
BERNARD MCCONVILLE, JASPER SPEARING (TREATMENT);
FRANK M. MCCORMACK, WALTER ANTHONY, TOM REED
(TITLES); RICHARD WALLACE (ADDITIONAL COMEDY
MATERIAL); FROM THE NOVEL BY GASTON LEROUX

STARRING
THE PHANTOM LON CHANEY
CHRISTINE DAAÉ MARY PHILBIN
VICOMTE RAOUL DE CHAGNY NORMAN KERRY
LEDOUX ARTHUR EDMUND
CAREWE
GIBSON GOWLAND............... SIMON BUQUET
COMTE PHILIPPE DE CHAGNY JOHN ST. POLIS
CARLOTTA MARY FABIAN

roken bodies and ruined faces were common sights on the streets of America in the 1920s, as untold numbers of maimed and disabled World War I veterans tried, often unsuccessfully, to merge back into society. Broken bodies and ruined faces were also a curiously persistent feature of Hollywood movies in the Jazz Age, particularly those starring the protean Lon Chaney—"The Man of a Thousand Faces"—and directed by Tod Browning. Chaney never actually played a wounded soldier, but the public's need to confront the veterans' plight, however indirectly, may go far to explain the popularity of Chaney's trademark portrayals of disfigurement and disability.

In 1923, Universal Pictures released its sumptuous production of *The Hunchback of Notre Dame*, featuring Chaney as the deformed Parisian bell ringer, Quasimodo. The actor's established facility with greasepaint, putty, and prosthetics was given its biggest challenge to date, and he rose to the task by creating one of the most iconic characterizations of the silent era. During a trip to Paris, Universal's president, Carl Laemmle, had made the acquaintance of the French mystery writer Gaston Leroux, who gave him a copy of his 1910 novel *Le Fantôme de l'Opéra*. Immediately intrigued, Laemmle heeded his showman's instincts and purchased the screen rights for Chaney.

Leroux's story was, at its center, a modernized version of Jeanne-Marie Leprince de

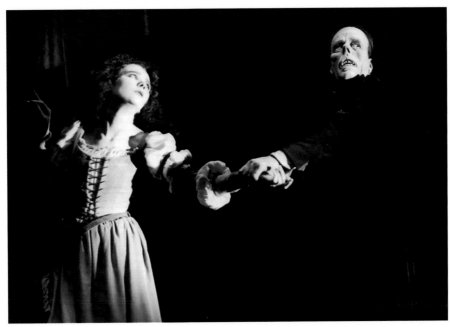

The Phantom leads Christine (Mary Philbin), his "angel of music," deep into the shadows of the opera house.

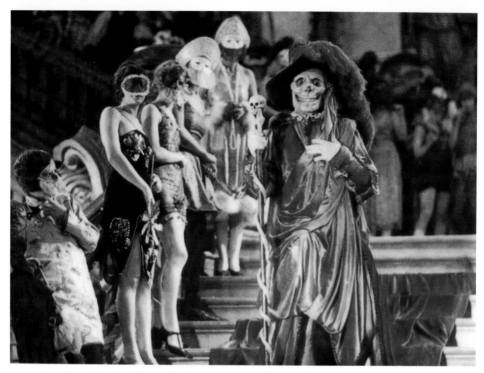

In the guise of the Red Death, the Phantom makes a daring public appearance at a masked ball.

Beaumont's *Beauty and the Beast*. The title character is Erik, whose face is hideously deformed since birth. A musical genius in his own right, the "Opera Ghost" haunts the cellars and boxes of the Paris Opera and becomes romantically obsessed with a rising young singer, Christine Daaé (Mary Philbin in the film). When the opera management fails to promote Christine as he demands, Erik drops the opera house's massive crystal chandelier on an unsuspecting audience. Amid the ensuing horror and confusion, Erik abducts Christine to his subterranean lair. Provoked by the face covering he wears, she rips away the mask, revealing the living death's head he has kept hidden from the world. The rest of the story involves the efforts of Christine's real-world lover, Raoul de Chagny (played by Norman Kerry), to rescue her, Christine's pity for her kidnapper, his threat to dynamite the opera house, and the Phantom's eventual death from the heartbreak of unrequited love.

Chaney's makeup, withheld from the public in all advance publicity, re-created the look of a skull by enlarging the actor's nostrils with dark paint and pulling up the tip of his nose with small hooks and fine wires hidden by makeup and putty. There are few cinema faces more indelible and iconic than Chaney's Phantom, a single photo of which still has the power to immediately conjure the world of silent film.

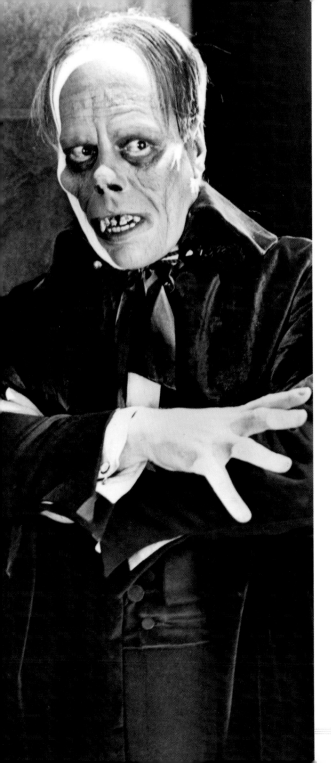

To re-create the interior of the Paris Opera, Universal erected a new, steel-reinforced, state-of-the-art building—Stage 28—that could support the weight of massive sets and hundreds of extras. These extras played the audience members who witness the crashing of a full-scale crystal chandelier onto the stalls, and the revelers at a lavish masked ball that takes place on an exact replica of the Paris Opera's grand staircase. Stage 28 achieved the distinction of being the world's oldest working soundstage before its demolition in 2014, and the venerable opera boxes appeared in many other Universal films over the decades, the last being *The Sting* in 1973. The preserved sets were afterward occasionally undraped for photo shoots and documentaries.

The film had a Hollywood preview in January 1925 and was poorly received. The production had been compromised by director Rupert Julian, who clashed repeatedly with the cast, especially Chaney, who ultimately directed himself in most scenes. To protect its investment, the studio took the drastic step of reshooting the majority of the footage, adding subplots and comic relief that radically changed the film. In the process, Julian quit and was replaced by Edward Sedgwick. One of Sedgwick's major contributions was replacing Erik's mawkish, lovesick demise with an exciting chase as a mob storms the Phantom's lair and then drowns him in the Seine. Nonetheless, an April preview in San Francisco proved a complete disaster; the

Lon Chaney as Erik, the unforgettable Opera Ghost

ABOVE In this original version of the film, the Phantom dies of a broken heart.
BELOW In the 1943 remake, Claude Rains wore a stylized mask patterned after his own face.

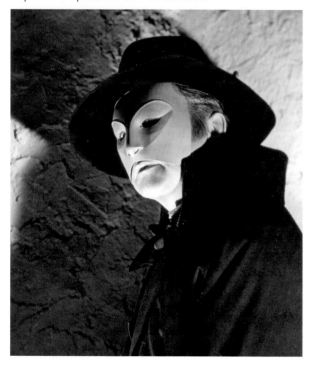

audience actually jeered and booed. Film editor Maurice Pivar and Universal's prolific (and at one point highest-paid) director Lois Weber were given the task of creating a third and final edit of the film. Weber had Carl Laemmle's complete trust, and her extensive and trailblazing work as an actress, screenwriter, producer, and director made her unusually qualified to impose a workable dramatic shape on the troubled production.

When the picture finally premiered in September 1925, with a general release in November, it clicked with audiences and reviewers alike. Its worldwide gross was $2 million, less than the $3.5 million earned by *The Hunchback of Notre Dame* but still enough to make it a major success. Chaney's performance was widely praised, but Philbin's doll-like demeanor failed

to endear the actress to critics. Universal released a reworked, part-talking version in 1929, with music and new dialogue sequences featuring Philbin and Kerry.

Notably, later screen versions of *The Phantom of the Opera* didn't even try to replicate Chaney's singular makeup achievement, although the 1957 Universal biopic *Man of a Thousand Faces* featured James Cagney in freely stylized interpretations of Chaney's most famous portrayals. That film's faces were created by Universal's makeup chief, Bud Westmore, in molded latex. The studio's elaborate 1943 remake starring Claude Rains had a long development period in which the Phantom's backstory of congenital deformity was jettisoned in favor of acid mutilation as a plot point. The conceit was carried over to the second remake by Hammer Films in 1962, with Herbert Lom in the title role. Interestingly enough, in preparation for the Rains version, Universal considered making Erik a shell-shocked war veteran whose unmasking reveals a normal face, since his true disfigurement is from psychological trauma.

Andrew Lloyd Webber's 1986 musical adaptation became the longest-running show in Broadway history, with total world receipts of $5.6 billion. A film version was released in 2004, with Gerard Butler in the title role. Universal never acquired stage rights of any kind to the Leroux book, and when it failed to renew the film's copyright, which expired in 1953, the novel entered the public domain, where it continues to keep the Phantom's legend alive.

If you enjoyed *The Phantom of the Opera* (1925), you might also like:

THE MAN WHO LAUGHS
UNIVERSAL PICTURES, 1928

Yet another costume melodrama about disfigurement and thwarted love, *The Man Who Laughs* was built around the proven Lon Chaney story formula and in fact was originally intended by Universal as a vehicle for Chaney in 1923. But by the time *The Man Who Laughs* was actually filmed, Chaney was under contract to MGM, and Conrad Veidt, the menacing somnambulist of *The Cabinet of Dr. Caligari*, was cast in his first American role. Under the direction of master German expressionist Paul Leni, the film tells the story of Gwynplaine, an aristocratic child whose father (also played by Veidt) is sentenced to death in an Iron Maiden by King James II, and whose own face is carved into a ghastly perpetual grin as additional family punishment. Gwynplaine, banished to a freak show, falls in love with a blind girl, Dea (Mary Philbin), who sees only his inner beauty and none of his ugliness. When it becomes apparent that he is the rightful heir to his father's fortune, he is romantically targeted by a scheming duchess (Olga Baclanova). A photo of Veidt's startling visage was reportedly the original inspiration for the DC Comics supervillain the Joker.

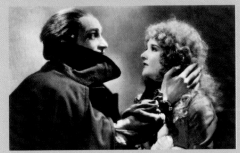

Conrad Veidt and Mary Philbin

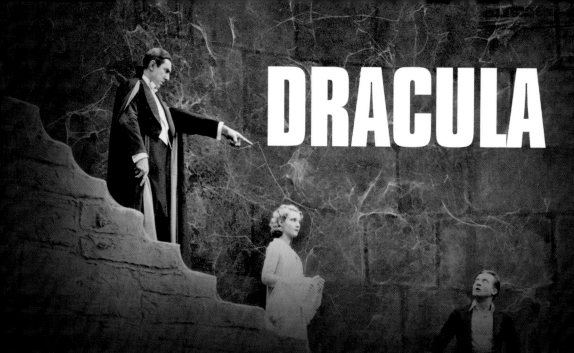

DRACULA

UNIVERSAL'S FIRST TALKING HORROR PICTURE, ABOUT A TRANSYLVANIAN SHAPE-SHIFTER, WAS ALSO A HOLLYWOOD GAME-CHANGER.

Universal Pictures, 1931
Black and white, 75 minutes

DIRECTOR
TOD BROWNING

PRODUCER
CARL LAEMMLE JR.

SCREENPLAY
GARRETT FORT, FROM THE NOVEL BY BRAM STOKER,
ADAPTED FOR THE STAGE BY HAMILTON DEANE AND JOHN L.
BALDERSTON

STARRING
COUNT DRACULA BELA LUGOSI
MINA SEWARD HELEN CHANDLER
JOHN HARKER DAVID MANNERS
LUCY WESTIN FRANCES DADE
RENFIELD DWIGHT FRYE
VAN HELSING EDWARD VAN SLOAN
DR. SEWARD HERBERT BUNSTON
BRIGGS JOAN STANDING
MAID MOON CARROLL
INNKEEPER MICHAEL VISAROFF
INNKEEPER'S WIFE BARBARA BOZOKY
COACH PASSENGER DAISY BELMORE
MAN IN COACH NICHOLAS BELA
GIRL IN COACH CARLA LAEMMLE

n February 12, 1931, a profound change occurred in American entertainment. All throughout the silent era, monstrous and frightening characters had been standard fixtures of the movies, but without exception they were presented as flesh-and-blood people, and any apparent manifestation of the supernatural always had a rational explanation, usually revolving around an elaborate criminal conspiracy. But as the lights came up at New York's Roxy Theatre, the packed house must have been a bit dumbfounded at what they had just seen. In a short epilogue to the strange film, one of the actors stepped forth in front of a motion picture screen and attempted to reassure the audience. "When you get home tonight and you are afraid to look behind the curtains and you dread to see a face at the window . . . why, just pull yourself together and remember, after all—*there are such things!*"

Never before had American audiences been asked to accept a purely supernatural premise, and there was no guarantee of a positive response. Universal Pictures took quite a risk when it released *Dracula* on an unsuspecting public during the worst year of the Great Depression. Surely Depression audiences were interested in escapism, but did *Dracula* go too far?

The movie shocked audiences, but it also shocked the studio by upending box-office records everywhere it played, doing much to stabilize Universal's shaky finances.

The studio had first considered *Dracula* for a silent film in 1915, the year of the studio's

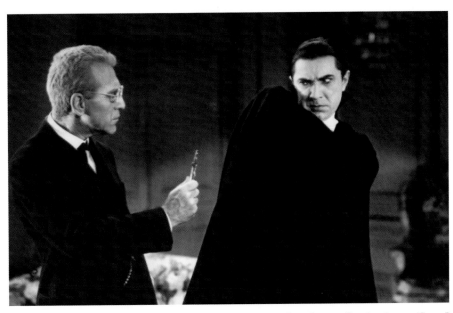

Van Helsing (Edward Van Sloan) banishes the count with a repellent "more effective than wolfbane."

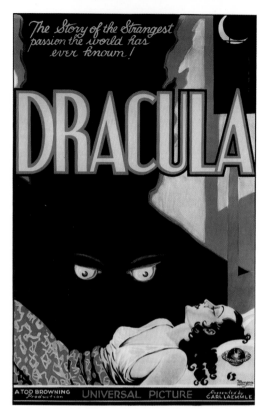

The Story of the Strangest passion the world has ever known!

DRACULA

A TOD BROWNING Production UNIVERSAL PICTURE Presented by CARL LAEMMLE

founding. In 1920 an announcement was made that *Dracula* would be the next project for its up-and-coming director Tod Browning, a mystery specialist who had just begun collaborating with Lon Chaney. Universal's silent *Dracula* was never realized, but both Browning and Chaney remained interested in the property throughout the 1920s.

In 1924, fresh from the copyright battle she had won over *Nosferatu*'s infringement of the novel, Stoker's widow assigned dramatic rights to Hamilton Deane, an actor/manager with a large following in the English provinces. He pared down the sprawling book to the manageable dimensions of a drawing-room

mystery-melodrama—and completely reworked the king of vampires from Stoker's repulsive human leech into a far more palatable character, one who could plausibly be at home in polite company. It was Deane who gave Dracula evening clothes and an opera cape (with its trademark stand-up collar) and all the trappings that are today immediately associated with the character.

John L. Balderston, an American journalist and playwright based in London, was asked by New York producer Horace Liveright to adapt the play for Broadway, where it was a hit. Universal's new production head, Carl Laemmle Jr., loved creepy movies, but he clashed with his father over the subject of horror films. Laemmle Sr. approved the purchase of *Dracula* with the proviso that the film would star the dependably bankable Lon Chaney and no one else. This proved impossible, but it was not until after the sale had been made that the Laemmles learned that Chaney was dying of lung cancer.

Tod Browning had been wooed away from Metro with the apparent understanding that Chaney would come with him. Bela Lugosi would seem to have been the next natural choice to star since the Hungarian actor had scored a considerable stage success in the part, but he was ultimately the last choice after a raft of actors, including John Wray, William Courtenay, Ian Keith, and Chester Morris, were considered. Today, of course, it is difficult to imagine anyone other than Lugosi in the film.

Browning, a self-taught master of silent direction, was not entirely comfortable with

Countess Zaleska (Gloria Holden) consigns her father's corpse to the flames in *Dracula's Daughter*.

talkies, and the film's long, soundless stretches suggest he is consciously or unconsciously shooting a silent feature. Despite his singularly distinctive voice, Lugosi's dialogue is sparse, and he essentially gives a pantomime performance. Actor David Manners told this author that all his dialogue scenes were in fact directed by cameraman Karl Freund, whose moody, fluid cinematography is responsible for *Dracula*'s most distinctive sequences, especially the second reel, memorably shot on the massive, cobweb-festooned sets of Castle Dracula and including the film's most memorable lines: "Listen to them—children of the night! What music they make!" and "I never drink . . . wine."

Overall, the film roughly adhered to the outline of Stoker's story: a five-hundred-year-old vampire leaves his desolate castle in Transylvania

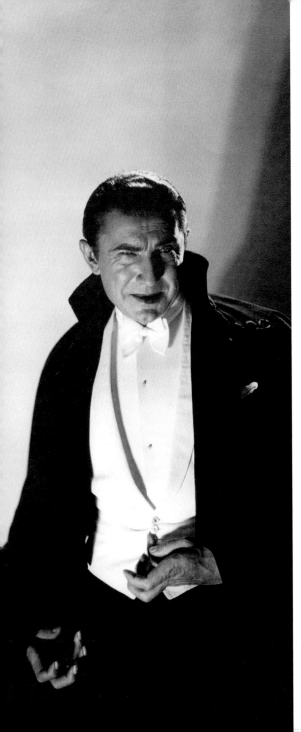

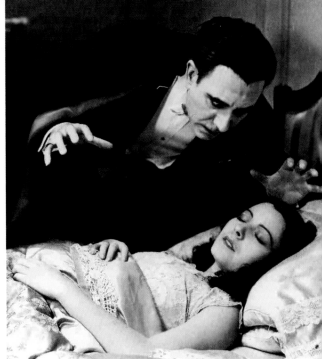

ABOVE Lupita Tovar and Carlos Villarías in the Spanish-language version of *Dracula* LEFT Bela Lugosi as Dracula, the role of his lifetime

for the greater feeding opportunities afforded by modern London. He commandeers a ship that transports the earth boxes in which he must sleep by day, killing the crew and landing the vessel as a ghost ship on the English coast. He is assisted by a fly-eating madman, Renfield (Dwight Frye), and victimizes two women in turn: first Lucy (Frances Dade), who dies and becomes a vampire herself, and then her best friend, Mina Seward (Helen Chandler), whose father, John Seward (Herbert Bunston), operates an asylum where Renfield is a patient. When Mina begins to waste away under Dracula's stealthy predation, a Dutch specialist in obscure diseases,

Professor Van Helsing (Edward Van Sloan), is consulted. Van Helsing correctly identifies the vampire and pursues him to destruction. The oddest departure from Stoker is the downsizing of Mina's fiancé and the book's hero, Jonathan Harker (David Manners), to an ineffectual bystander. His trip to Transylvania to sell Dracula a London house is assigned to Renfield, who returns quite mad.

Due to budgetary pressures, the latter portions of the movie dwindle to a filmed record of the stage play, though a simultaneously shot Spanish-language version, starring Lupita Tovar and Carlos Villarías, and directed by George Melford, was resourceful in finding ways to improve the staging and shooting of otherwise static scenes. Despite technical deficiencies, the bizarre novelty of the film led to strong box office everywhere. Universal, of course, was eager to produce a sequel, but the enforcement of the industry's highly moralistic Production Code, beginning in 1934, almost immediately raised censorship issues and delayed the project. Aside from a quickly glimpsed wax effigy of Lugosi in a coffin and on a funeral pyre, Dracula himself didn't appear in *Dracula's Daughter* (1936).

Lugosi returned to the role at Universal in 1948 for the affectionate spoof *Abbott and Costello Meet Frankenstein*. Although audiences forever would associate him with the role he played in 1931, he only essayed the part twice on screen. His public identification with the role was so complete that, upon the actor's death in 1956, his family requested that he be buried in full costume and makeup as Count Dracula.

If you enjoyed *Dracula* (1931), you might also like:

MARK OF THE VAMPIRE
MGM, 1935

One of the hallmarks of Tod Browning's work is the almost obsessive repetition of themes, situations, and imagery from film to film. In the case of *Mark of the Vampire*, Browning revisited two earlier films, *London After Midnight* (1927) and *Dracula*, recombining elements in a short but highly atmospheric chiller harkening back to the mystery plays and films of the 1920s in which the uncanny element was always given a rational explanation. Originally titled *The Vampires of Prague*, the story strains credulity throughout, especially when we are asked to believe that the elaborate "vampire" effects we have witnessed—including a visually unobstructed bat transformation, a flying lady with enormous webbed wings, and more—have been accomplished by a troupe of actors operating out of a single theatrical trunk. Nonetheless, it's great fun to watch. It also gives us a chance to ponder what kind of *Dracula* Browning might have produced with all the superior technical resources of MGM at his disposal.

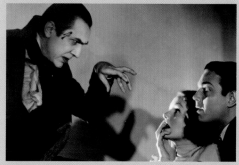

Bela Lugosi, Elizabeth Allan, and Henry Wadsworth in *Mark of the Vampire*

FRANKENSTEIN

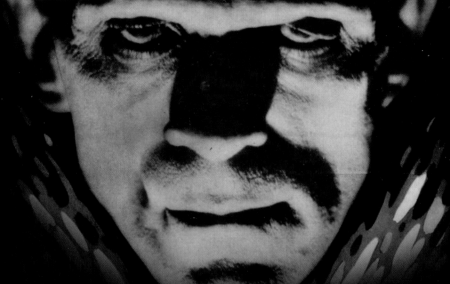

THE MOST IMITATED MONSTER MOVIE EVER MADE
HAD SURPRISING ORIGINS IN THE THEATER.

Universal Pictures, 1931
Black and white, 63 minutes

DIRECTOR
JAMES WHALE

PRODUCER
CARL LAEMMLE JR.

SCREENPLAY
GARRETT FORT, BASED ON THE COMPOSITION BY JOHN L.
BALDERSTON, ADAPTED FROM THE PLAY BY PEGGY WEBLING,
FROM THE NOVEL BY MARY WOLLSTONECRAFT SHELLEY

STARRING
HENRY FRANKENSTEIN COLIN CLIVE
ELIZABETH MAE CLARKE
VICTOR MORITZ JOHN BOLES
THE MONSTER BORIS KARLOFF
DOCTOR WALDMAN EDWARD VAN SLOAN
BARON FRANKENSTEIN FREDERICK KERR
FRITZ . DWIGHT FRYE
BURGOMASTER LIONEL BELMORE
LITTLE MARIA MARILYN HARRIS

The surprise success of *Dracula* had been like manna from heaven for Universal. The studio was in the process of acquiring a stage adaptation of Mary Shelley's *Frankenstein* from *Dracula*'s theatrical team that was being readied for a Broadway premiere before it made the transformative leap from stage to screen. The play, by Peggy Webling, was called *Frankenstein: An Adventure in the Macabre.* Hamilton Deane had already produced it successfully in England, playing the part of the monster. John L. Balderston had written a new adaptation, and Horace Liveright was set to produce. The veteran Welsh actor Lyn Harding was chosen as the monster. Sixty-four years old in 1931, he was hardly obvious casting, but Harding had an illustrious stage and screen career in Britain as well as the confidence of all involved. Ultimately, he never played the monster in any medium, but he did go on to appear in a variety of striking parts, such as Professor Moriarty in the 1935 British film *The Triumph of Sherlock Holmes.*

The Laemmles, unwilling to endure the one- or two-year delay a theatrical engagement might entail, finally struck a deal with the playwrights that preempted a stage run and allowed the movie to proceed immediately. The studio's first choice for director was the French

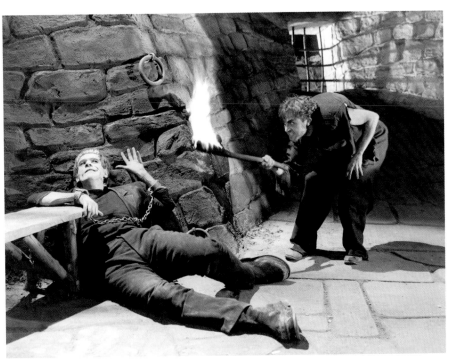

The monster is tormented by Frankenstein's sadistic laboratory assistant, Fritz (Dwight Frye).

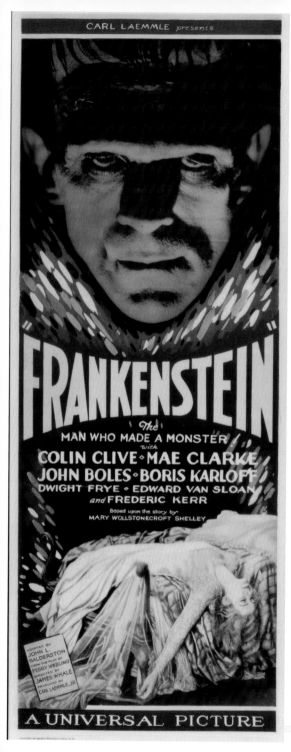

"FRANKENSTEIN"

The
MAN WHO MADE A MONSTER
with
COLIN CLIVE ∘ MAE CLARKE
JOHN BOLES ∘ BORIS KARLOFF
DWIGHT FRYE ∘ EDWARD VAN SLOAN
and FREDERIC KERR
Based upon the story by
MARY WOLLSTONECROFT SHELLEY

ADAPTED BY
JOHN L.
BALDERSTON
FROM THE PLAY BY
PEGGY WEBLING
DIRECTED BY
JAMES WHALE
PRODUCED BY
CARL LAEMMLE, JR.

A UNIVERSAL PICTURE

filmmaker Robert Florey, who wrote the original screenplay and planned his *Frankenstein* as a brooding homage to German expressionism. Next, it was announced that Bela Lugosi—"the new Lon Chaney," as he was called in advertisements for *Dracula*—would star. Lugosi assumed that he would play the title character, an anti-hero in the classic Romantic fashion, but he overlooked one thing. The Webling/Balderston playscript referred to both the maker *and* the monster as "Frankenstein," underscoring the idea that Henry Frankenstein (Victor in the novel) had created something in his own image.

And indeed, Universal wanted Lugosi to play the creature, his face buried under grotesque makeup, with no dialogue whatsoever. Webling's character was at least fitfully articulate, but Florey wanted a mute distillation of pure evil—a soulless killing machine fabricated from dead flesh. A screen test was made with Lugosi in full makeup that has been described variously as resembling the golem of silent German cinema, with clay-like skin and a broad wig (according to actor Edward Van Sloan, a participant in the test), or as having "striations" in multiple colors of greasepaint (so said an anonymous Los Angeles newspaper account). It was described by Robert Florey himself, improbably, as being almost identical to the makeup eventually worn by Boris Karloff. In any case, Lugosi wanted none of it.

LEFT Original insert card RIGHT The monster menaces Elizabeth (Mae Clarke), Henry Frankenstein's fiancée.

Karloff, a perpetually struggling actor who nonetheless had already appeared in nearly eighty films, did not become involved until the project had been transferred from Florey to the British stage director James Whale, who had come to Hollywood to direct the film version of his stage success *Journey's End*, a World War I drama by R. C. Sherriff starring Colin Clive. Universal had considered Leslie Howard for the title role and actually announced in the trades that Hollywood newcomer Bette Davis would play Frankenstein's fiancée, Elizabeth.

Whale had other ideas. Clive was cast as Henry Frankenstein, Mae Clarke as Elizabeth, and John Boles, a dependable Universal heartthrob, as their friend Victor Moritz, a conflation of disparate names from the novel. Legend has it that Whale met Karloff in the studio commissary

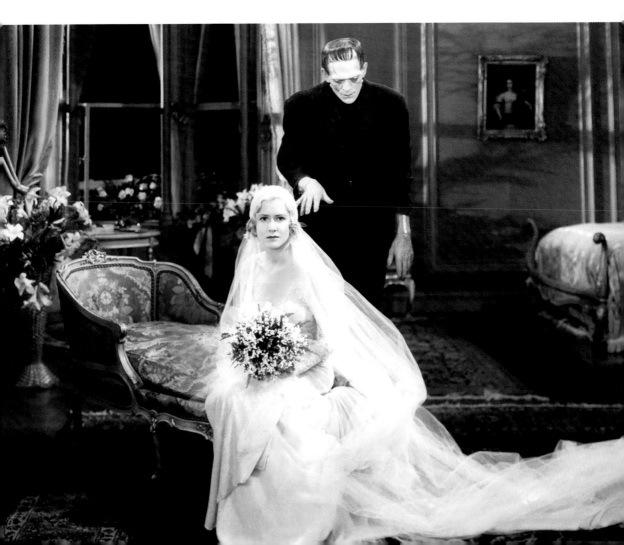

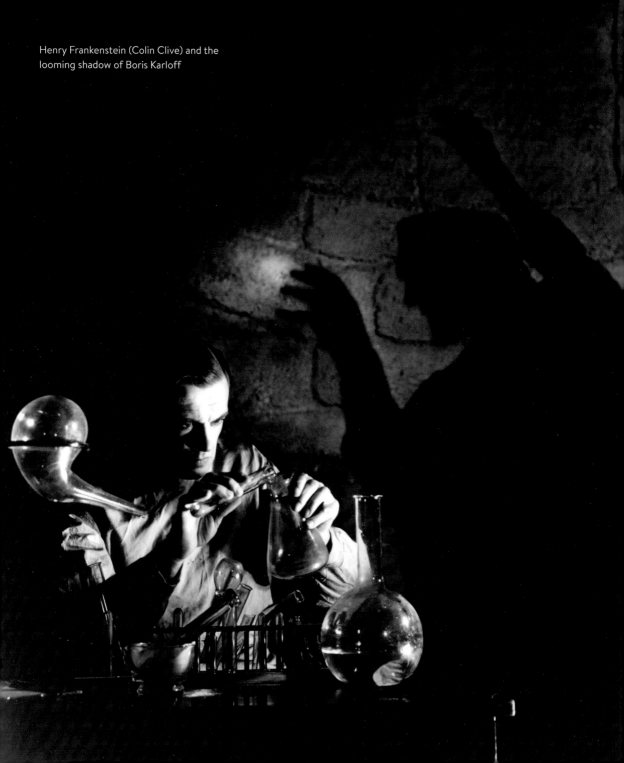

Henry Frankenstein (Colin Clive) and the looming shadow of Boris Karloff

and almost immediately knew that he had found his monster. What is more definitely known is that Karloff spent about two unpaid weeks in Jack Pierce's makeup chair, undergoing time-consuming and uncomfortable tests until a final version of the monster was approved. Boris did not sign a contract until principal photography was already under way in the summer of 1931.

The monster's creation scene is arguably the single most famous sequence in any horror film—imitated, referenced, paid homage to, praised, and parodied in popular culture, almost to infinity. Kenneth Strickfaden's crackling electrical gizmos, inspired by those of Nikola Tesla, defined for all time the visual essence of mad science. Bowing to complaints from religious groups, Clive's "blasphemous" exhortation—"In the name of God, now I know what it feels like to *be* God!"—was cut from the original sound-on-film prints, but the audio was ultimately recovered from a synchronized sound disc (also used in many theaters in 1931), and it was restored by Universal Studios Home Video for the film's first DVD release in 1999.

Another scene that caused a censorship uproar during the film's first theatrical engagements (inspired by a scene in Balderston's adaptation of Peggy Webling's play) showed the monster accidentally drowning a young girl during an otherwise happy game of floating daisies on the surface of a lake. But the resulting "solution"—an abrupt cut of Karloff as he reaches out to the girl—unintentionally left audiences to imagine a still darker action.

Whale and Karloff joined forces again in 1935 for *Bride of Frankenstein*, a horror movie that is also a dazzling dark comedy and the jewel in the crown of Universal's original monster cycle. The story is based on a sequence of events in the Shelley novel not used in the original film, wherein the monster demands a female companion. The monster, however, destroys the she-monster before she ever lives. In Whale's film, the experiment is finished—complete with wedding bells at the end of the creation scene.

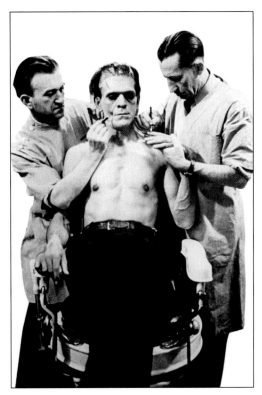

Jack Pierce begins the transformation of Boris Karloff into the monster.

But when Karloff presents himself to the bride—Elsa Lanchester in an unforgettably campy, electrified hairdo—she recoils, and the monster blows the laboratory sky-high.

Karloff rose from the rubble to play the monster for Universal one last time, in 1939's *Son of Frankenstein*, a visual ode to high German expressionism directed by Rowland V. Lee and costarring Basil Rathbone and Bela Lugosi. In *Bride*, the monster had been given a halting power of speech, to which Karloff had objected, strongly believing the pathos of the character resided in pantomime. Amid the stylized shadows of *Son*, Karloff ended his career as the monster in the expressionistic silence from which it had risen.

RIGHT Boris Karloff in the most celebrated monster makeup of all time **BELOW** Elsa Lanchester and Boris Karloff in *Bride of Frankenstein*

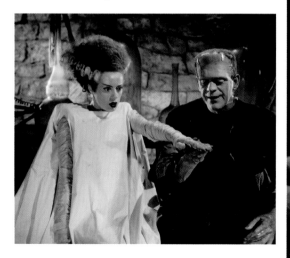

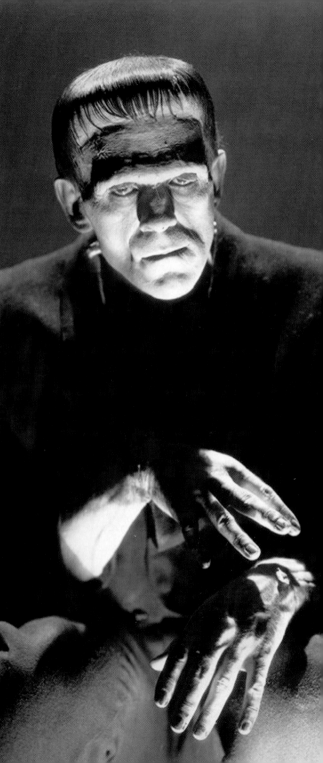

FRANKENSTEIN

EDISON COMPANY, 1910

The first screen adaptation of *Frankenstein* was considered one of the ten most important "lost" motion pictures until a complete print was discovered in the possession of a Wisconsin collector in the early 1980s. Charles Stanton Ogle, a prolific actor in silent films, is remembered almost exclusively for his landmark portrayal of the monster. Ogle is presumed to have created the makeup himself, which produced a Kabuki-like creature, its hair a wild, tangled mane. The creation was presented as chemical alchemy, fueled by fire instead of electricity. In the scene, shot with an upside-down camera and printed in reverse, a burning marionette dummy seemed to reconstitute itself from its own ashes. The film is especially significant in its treatment of the monster as its maker's metaphoric double, a psychological insight barely incorporated into literary criticism at the time, but now usually regarded as central to an understanding of Shelley's novel. Upon the movie's release in March 1910, *Moving Picture World* praised the camera wizardry and recognized the small film's large importance to the future of fantastic storytelling, predicting that "the entire film is one that will create a new impression that the possibilities of motion pictures in reproducing these stories are scarcely realized."

Charles Ogle as the Frankenstein monster in the 1910 film adaptation of the story

DR. JEKYLL AND MR. HYDE

A LEGENDARY TALE OF TERROR HAS ENJOYED THREE MAJOR HOLLYWOOD INCARNATIONS.

Paramount Pictures, 1931
Black and white, 98 minutes

DIRECTOR
ROUBEN MAMOULIAN

PRODUCER
ADOLPH ZUKOR

SCREENPLAY
SAMUEL HOFFENSTEIN AND PERCY HEATH, BASED ON THE
NOVELLA BY ROBERT LOUIS STEVENSON

STARRING
DR. HENRY JEKYLL/ MR. EDWARD HYDE	FREDRIC MARCH
IVY PEARSON	MIRIAM HOPKINS
MURIEL CAREW	ROSE HOBART
DR. JOHN LANYON	HOLMES HERBERT
BRIG. GEN. DANVERS CAREW	HALLIWELL HOBBES
POOLE	EDGAR NORTON

obert Louis Stevenson's hair-raising novella about dual identity, *Strange Case of Dr. Jekyll and Mr. Hyde*, was first published in 1886, and after the great Victorian actor-manager Henry Irving declined to acquire the rights—some say foolishly—the story was successfully adapted for the stage by Richard Mansfield, an acclaimed American actor. Mansfield's version, written in collaboration with Thomas Russell Sullivan, added two elements that would be crucial to film adaptations: female characters (Stevenson's story was somewhat like a stuffy men's club, told with male characters only) and special visual effects to aid Jekyll's potion-fueled transformation into Hyde. Mansfield morphed himself into a monster in full view of the audience, using physical contortions and colored lights that could reveal and conceal correspondingly tinted makeup. Mansfield continued producing and starring in the play until 1904.

Several silent film versions were released in America and Europe beginning in 1908, the most notable being the 1920 Paramount production starring the legendary actor John Barrymore and directed by John S. Robertson. Barrymore achieved the transformation in a tour de force of contortions, covering his face with his hands in order to surreptitiously apply makeup, and adding claw-like extensions

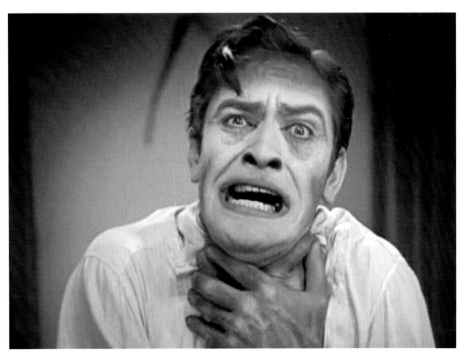

The beginning of Fredric March's transformation sequence.

to his fingers. (It is entirely possible this last detail was noticed by *Nosferatu*'s art director, Albin Grau, who two years later would affix talons to the hands of actor Max Schreck for a similarly predatory look.) The Paramount film was an international sensation, exhibited widely in Germany and other European countries.

With the advent of sound, Paramount was eager to take advantage of the lucrative horror market being staked out by Universal, and in 1931 the studio asked Barrymore if he would repeat his acclaimed performance in a talkie. Barrymore, now a mature character actor and no longer the matinee idol that had made his Jekyll/ Hyde transformation all the more startling, was

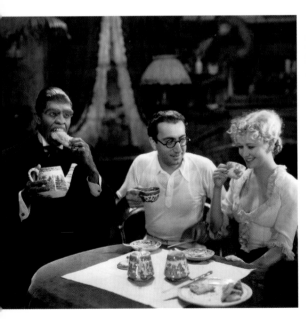

ABOVE Fredric March, Rouben Mamoulian, and Miriam Hopkins take a tea break on the set.
RIGHT 1931 poster for *Dr. Jekyll and Mr. Hyde*

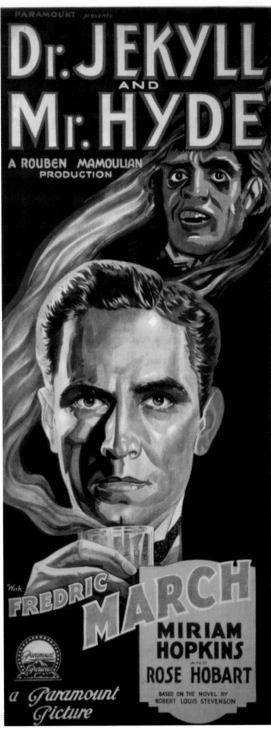

perhaps no longer ideal, but he was unavailable in any event, having contracted with MGM. Paramount hired the Armenian-American film and theater director Rouben Mamoulian, who personally selected Fredric March to star. The previous year, March had received an Academy Award nomination for a role based directly on John Barrymore in *The Royal Family of Broadway*.

Makeup artist Wally Westmore's first tests seemed to draw inspiration from both Werner Krauss in *The Cabinet of Dr. Caligari* (1920) and Lon Chaney's costume and makeup from *London After Midnight* (1927). Previous dramatic interpretations of Hyde had been ugly, cruel, wicked, and thuggish—but still human. Mamoulian wanted his Hyde to be an animal. Ultimately, Westmore's makeup devolved in stages, giving March a simian look that grew increasingly hideous with each transformation.

Mamoulian and cinematographer Karl Struss brilliantly adapted Richard Mansfield's colored-light stage trickery for black-and-white film. Since the color filtering would be invisible on monochromatic film, the lines and contours of the "hidden" makeup seemed to emerge inexplicably from the actor's skin. The ape-like facial appliances were even more unpleasant for March than Karloff's headpiece and scars had been in *Frankenstein*. Glued directly to his skin, each progressive version became more and more difficult to remove, until, as March's costar Rose

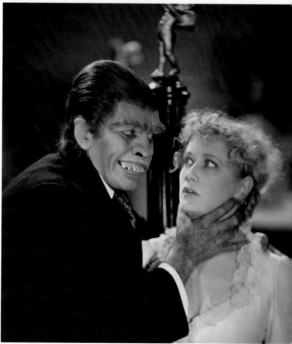

TOP Martha Mansfield and John Barrymore
BOTTOM Fredric March and Miriam Hopkins

Hobart remembered, his skin began to pull away along with the prosthetic, and the actor was hospitalized with facial abrasions.

In the 1920 film, Jekyll had a proper fiancée, and Hyde had a lower-class girl on the side, but he soon breaks off the dalliance. The 1931 screenplay, by Samuel Hoffenstein and Percy Heath, brilliantly mirrors the Jekyll/Hyde duality with its female equivalents: Jekyll's straitlaced fiancée (Hobart) and Hyde's transgressive bar singer, Ivy Pearson, played by Miriam Hopkins as the quintessence of a pre-Code bad girl. Ivy's increasingly violent and ultimately fatal entanglement with Jekyll's alter ego is as raw and disturbing as the most harrowing accounts of domestic abuse. Especially chilling is the scene where she brazenly flirts with the good Dr. Jekyll, unaware she is inviting Mr. Hyde to come out to play. Eight minutes of cuts were demanded by the censors, even in a time of lax Code enforcement.

In 1941, MGM acquired all the rights to the Paramount film in order to produce a remake starring Spencer Tracy, Ingrid Bergman as Ivy, and Lana Turner as the fiancée. The Mamoulian version was consigned to the MGM vaults for an exhibition embargo that would last for decades, much to the dismay of film historians. Tracy was eager to play Hyde as a man in the grip of alcohol or drugs, which made Jekyll's transformation more psychological than physical. Tracy may well have been drawing on his own well-documented struggles with alcohol, just as many commentators have attributed the genesis of Stevenson's story to the author's periodic, uncontrollable drinking binges. The studio met Tracy halfway

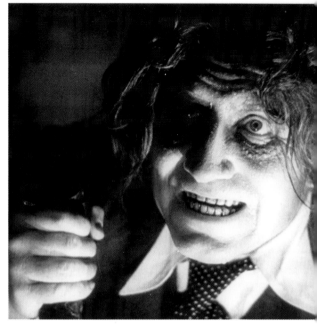

Spencer Tracy as Mr. Hyde

with the approach, retaining Stevenson's original nonalcoholic elixir. Makeup artist Jack Dawn, who had created all the memorable characters for *The Wizard of Oz*, sharpened the actor's natural features only slightly, allowing his acting to do the rest. Under Victor Fleming's capable direction, Tracy's performance is a truly horrifying portrait of unbridled malevolence and cruelty.

Because the story's theme of the divided human spirit sounds so many universal chords, *Dr. Jekyll and Mr. Hyde* is one of the most frequently dramatized works in the classic horror canon, the roles essayed on-screen by an endless succession of fine actors, including Louis Hayward, Christopher Lee, Jack Palance, and John Malkovich.

If you enjoyed *Dr. Jekyll and Mr. Hyde* (1931), you might also like:

DR. JEKYLL AND SISTER HYDE

HAMMER/AMERICAN INTERNATIONAL, 1971

Gender-bending monsters are fairly rare in horror films, and Hammer's *Dr. Jekyll and Sister Hyde* is a clever and entertaining variation on the perennially fascinating theme of split personality. The approach was probably inevitable, given that the sexually liberated 1970s teemed with pop-psychological encouragement to men about embracing their "inner woman." Jekyll (Ralph Bates) is a doctor trying to extend life by experimenting with female hormones since women are known to have longer life spans than men. At first he obtains female glands from the legendary grave robbers Burke and Hare. Later, when the serum physically transforms him into an evil woman, he passes her off as his widowed sister, Mrs. Hyde (Martine Beswick). When the resurrection men can no longer provide enough corpses to maintain the metamorphosis, Jekyll begins to commit the eviscerating murders attributed to Jack the Ripper. Lurid posters and advertisements seemed to promise a nude, graphic transformation scene, which the film, unsurprisingly, never delivered.

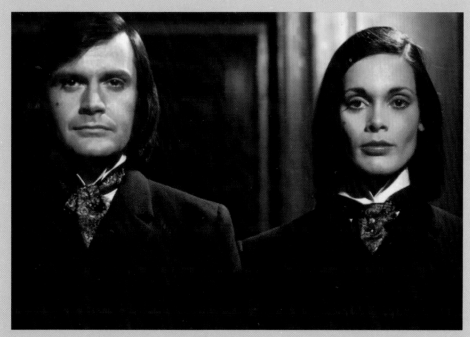

Ralph Bates and Martine Beswick in *Dr. Jekyll and Sister Hyde*

THE MUMMY

BURIED FOR THOUSANDS OF YEARS IN A FORGOTTEN EGYPTIAN TOMB, AN UNDYING PASSION WALKS THE EARTH AGAIN.

Universal Pictures, 1932
Black and white, 73 minutes

DIRECTOR
KARL FREUND

PRODUCER
CARL LAEMMLE JR.

SCREENPLAY
JOHN L. BALDERSTON, FROM STORIES BY NINA WILCOX
PUTNAM AND RICHARD SCHAYER

STARRING
IMHOTEP/ARDATH BEY BORIS KARLOFF
HELEN GROSVENOR ZITA JOHANN
FRANK WHEMPLE DAVID MANNERS
SIR JOSEPH WHEMPLE ARTHUR BYRON
DOCTOR MULLER EDWARD VAN SLOAN
BRAMWELL FLETCHER RALPH NORTON
THE NUBIAN NOBLE JOHNSON

ohn L. Balderston, the playwright responsible for the *Dracula* stage adaptation that was a major hit in New York, wasn't entirely happy with Universal's film. The last third "dropped badly," he wrote. When Universal hired him to script the film ultimately to be known as *The Mummy*, he had the chance to incorporate and improve elements from the earlier film, and he drew also on his extensive knowledge of the opening of King Tutankhamen's tomb, which he had covered firsthand a decade earlier for the *New York World*.

Balderston was given an existing screenplay called *Cagliostro*, by Nina Wilcox Putnam, which had already been announced, with some trade-magazine fanfare, as Boris Karloff's next assignment. Cagliostro was a historical character, a seventeenth-century Parisian mountebank who convinced the rich and powerful that he had, somehow, lived for centuries. Universal liked the theme but not the script. It was Balderston's idea to shift the focus to Egyptology, which had become a fashionable interest ever since Tut's treasures were unearthed. The morbid details of Egyptian burial rites, as well as the public's fascination with the curse of King Tut (completely contrived), were natural associations that upped the horror ante for an eagerly anticipated Karloff vehicle. Balderston's most significant contribution was the reincarnation-of-a-lost-love motif,

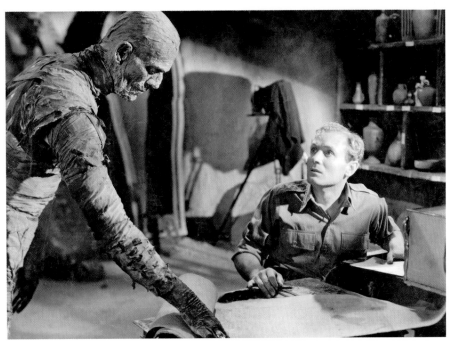

An archeologist (Bramwell Fletcher) inadvertently brings the mummy to life.

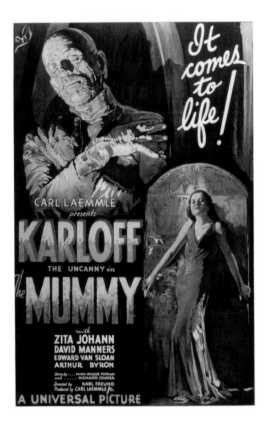

which has become a sturdy trope of supernatural horror movies, including most newer versions of *Dracula*.

During preproduction, the project was alternately called *Imhotep* (after the actual Egyptian architect who built the pyramids but had no relation to the story) and *King of the Dead*. The studio had enough faith in Karloff's rapidly ascending celebrity that it made the bold marketing decision to bill him solely by his last name—the sort of star treatment hitherto reserved for Garbo or Chaplin. The first actress considered for his leading lady was Katharine Hepburn, but when she proved unavailable the

part went to the highly regarded New York stage actress Zita Johann. Making his directorial debut was cinematographer Karl Freund, reunited with two actors he had worked with on *Dracula*, Edward Van Sloan and David Manners, who essentially reprised their roles as the Wise Doctor and Worried Lover, respectively.

As it does in the previous film, the plot concerns an ancient, undead menace who returns from the dead to claim a modern bride. In an opening vignette, we witness the inadvertent midnight resurrection of Imhotep at an archeological dig. Ten years later, in Cairo, he is without bandages and partially rejuvenated, using the name Ardath Bey. He ingratiates himself into the good favor of the unsuspecting archeologists who reanimated him, leading them to the tomb of an Egyptian princess, Anck-es-en-Amon. They excavate the tomb for its treasures, which Bey donates to the Cairo Museum. He doesn't tell them that the princess is his mummified lover, and that he has waited three thousand years to bring her back from the dead. His first attempt, in ancient Egypt, was a sacrilegious transgression that resulted in his being buried alive with the Scroll of Thoth, which has power over life and death. Bey meets a half-English, half-Egyptian woman, Helen Grosvenor, whom he immediately recognizes as the princess's modern reincarnation. He intends to sacrifice her, rejoining her soul with the princess's mummy, but his second attempted sacrilege is foiled by the goddess Isis, who incinerates the cursed scroll. Without it, Imhotep crumbles into bones and dust.

The scene that impresses most is the

awakening of Imhotep, a brilliantly minimalist sequence that succeeds by showing almost nothing, especially when compared to the histrionic razzle-dazzle of the creation scene in *Frankenstein*. A young archeologist opens an ancient scroll and begins to read, not suspecting the forces he is about to unleash. The mummy's eye cracks open, its arm moves slightly, and then, instead of a full reveal, we see only the

RIGHT Edward Van Sloan, David Manners, Zita Johann, and Karl Freund on set
BELOW The preparation for ritual embalming

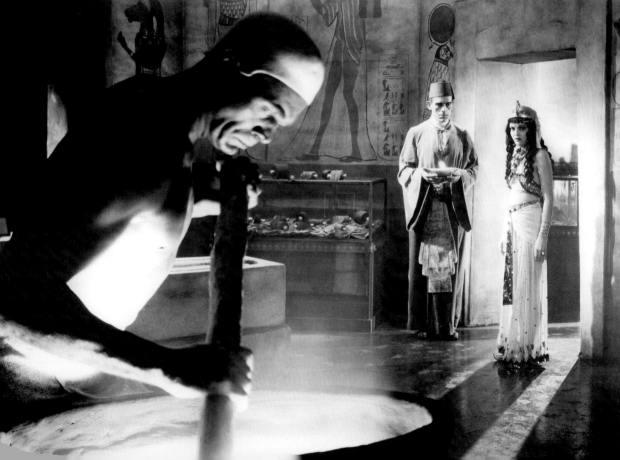

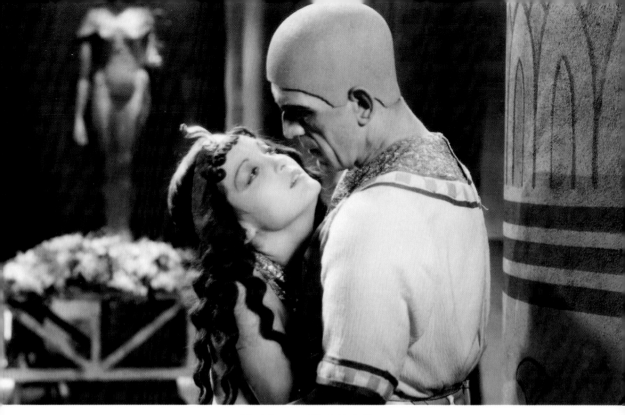

Zita Johann and Boris Karloff

bandaged hand reaching into the frame to claim the reanimating scroll. The archeologist goes mad, wildly laughing—"He went for a little walk … you should have seen his face!"—and the last signs we see of born-again Imhotep are a pair of trailing bandages as the undead thing shuffles out the door.

Universal's makeup wizard, Jack Pierce, once more subjected Karloff to a grueling ordeal, even more arduous than what the actor had endured for *Frankenstein*. Fortunately, he needed only wear the head-to-toe wrappings for a single day of shooting. For the rest of the filming days, Pierce wrinkled Karloff's face far more subtly,

using thin applications of spirit gum and tissue that furrowed his actual skin. Nonetheless, it all had to be removed each night with toxic solvents, an exceedingly unpleasant process.

In 1940, Universal embarked on a series of loosely connected sequels with *The Mummy's Hand*. Tim Tyler played the mummy, now known as Kharis, but in the next film, *The Mummy's Tomb* (1942), Lon Chaney Jr. took over the role—as well as the reputation of being Universal's go-to monster man. During the war years he not only played the Mummy but additionally took on the Wolf Man, the Frankenstein monster, and Dracula's son. He

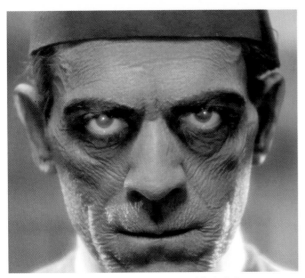

Karloff as the semirejuvenated Ardath Bey

returned as Kharis in *The Mummy's Ghost* and *The Mummy's Curse* (both 1944). In 1955, for no discernible reason, the Mummy's name was changed to "Klaris" for the comedy *Abbott and Costello Meet the Mummy*. In 1959 Universal distributed the Hammer Films remake, starring Christopher Lee, and in 1999 restored the name "Imhotep" for Stephen Sommers's *The Mummy*, which became a successful mini franchise that included *The Mummy Returns* (2001) and *The Mummy: Tomb of the Dragon Emperor* (2008). Brendan Fraser starred in all three films. In 2017, Universal resurrected *The Mummy* yet again, turning the tables by serving up a female mummy with malignant designs on Tom Cruise. The film was intended to be the inaugural component of a branding initiative called Dark Universe that would reboot and recombine the Universal monsters in a superhero-like franchise. No second film has yet materialized.

If you enjoyed *The Mummy* (1932), you might also like:

THE AWAKENING

ORION PICTURES, 1980

Charlton Heston plays an archeologist whose wife delivers a stillborn child during an archeological dig, but when the tomb of an ancient Egyptian queen is opened, the baby girl is miraculously restored to life. Eighteen years later, she discovers the truth about her strange birth and hears the legends claiming that the dead queen has the power to reincarnate herself. The human vehicle she has in mind is clear. Violent murders begin to encircle the father and daughter, and the archeologist's attempt to resurrect and truly kill the queen go terribly, terribly wrong. *The Awakening* is the third of four screen adaptations of Bram Stoker's 1903 novel *The Jewel of Seven Stars*, making it Stoker's most-adapted book after *Dracula*. The earlier versions were also British productions, beginning with *The Curse of the Mummy's Tomb* (1970), part of the BBC-TV series *Mystery and Imagination*, and Hammer's theatrical feature *Blood from the Mummy's Tomb* (1971). *The Awakening* was followed by an American direct-to-video release, *Bram Stoker's Legend of the Mummy* (1998), starring Louis Gossett Jr.

Charlton Heston in *The Awakening*

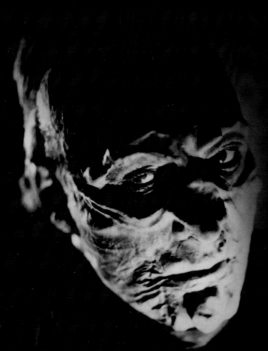

MYSTERY OF THE WAX MUSEUM

HIS VICTIMS DIED . . . BUT HE PRESERVED THEIR BEAUTY FOREVER IN WAX.

Warner Bros./First National, 1933
Two-strip Technicolor, 77 minutes

DIRECTOR
MICHAEL CURTIZ

PRODUCERS
HENRY BLANKE AND HAL B. WALLIS

SCREENPLAY
DON MULLALY AND CARL ERICKSON, FROM THE PLAY *THE WAX MUSEUM*, BY CHARLES S. BELDEN

STARRING

IVAN IGOR	LIONEL ATWILL
CHARLOTTE DUNCAN	FAY WRAY
FLORENCE DEMPSEY	GLENDA FARRELL
JIM	FRANK MCHUGH
RALPH BURTON	ALLEN VINCENT
GEORGE WINTON	GAVIN GORDON
JOE WORTH	EDWIN MAXWELL
DR. RASMUSSEN	HOLMES HERBERT
MR. GALATALIN	CLAUDE KING
SPARROW/PROFESSOR DARCY	ARTHUR EDMUND CAREWE
POLICE CAPTAIN	DEWITT JENNINGS
HUGO	MATTHEW BETZ

There is a good reason that doubles, dolls, and effigies of all kinds figure prominently in horror stories. According to psychoanalysts like Sigmund Freud and Otto Rank, perfect human simulacra, or doppelgängers, arise spontaneously in the primal imagination as defense mechanisms against danger and death. If one self is killed, the other will survive. Motion pictures are another way to create duplicate people that originally had a palpably creepy edge. Some early commentators on the medium worried that film might be nothing less than the arrival of living death. It is in horror movies that this pervading sense of the uncanny still speaks to us.

Before movies, people went to wax museums to experience a pleasurable shudder in the presence of human replicas. The main attraction was often a Chamber of Horrors that re-created historical atrocities as well as tabloid tableaux of gruesome modern crimes. The world's most famous wax museum was Madame Tussaud's in London, which made headlines in 1925 when it was spectacularly destroyed by fire. The incident stuck in the mind of one playwright, Charles S. Belden, author of an unproduced play called *The Wax Museum*, in which he imagined a sculptor named Ivan Igor who survives a similar conflagration hideously disfigured and mentally unhinged. He rebuilds his exhibit with embalmed corpses coated in wax.

Warner Bros. acquired the rights to the play at the height of Hollywood's 1931–1932 lucrative "monsterfication," led by Universal.

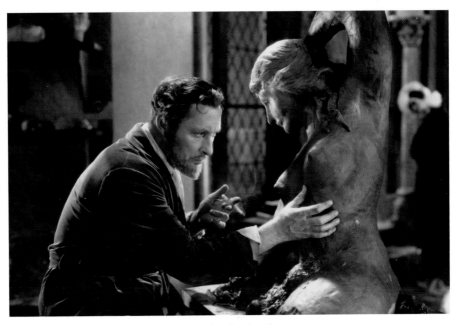

Lionel Atwill as Ivan Igor

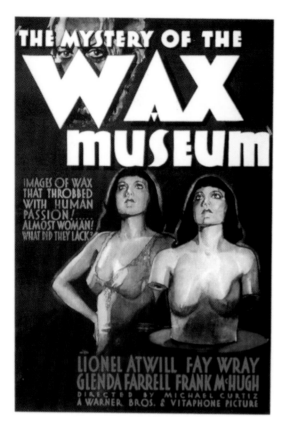

IMAGES OF WAX
THAT THROBBED
WITH HUMAN
PASSION!....
ALMOST WOMAN!
WHAT DID THEY LACK?

LIONEL ATWILL FAY WRAY
GLENDA FARRELL FRANK McHUGH
DIRECTED BY MICHAEL CURTIZ
A WARNER BROS. & VITAPHONE PICTURE

Paramount had already scored considerable success with *Dr. Jekyll and Mr. Hyde* and *Island of Lost Souls*, while MGM had failed to capitalize on the horror craze with Tod Browning's gamble, *Freaks*, which backfired badly, repelling audiences and critics with its display of real human deformity. But on the whole, horror still seemed a good bet. Warners produced *Doctor X*, based on a hit Broadway horror play, casting Lionel Atwill, Fay Wray, and Arthur Edmund Carewe. The formula performed well enough at the box office that the same actors were immediately assigned to *Mystery of the Wax Museum*.

Both films were shot in two-strip Technicolor, a film process that effectively suggested a full-color image without actually requiring that one be entirely created (a similar, cost-saving process was already well-established in magazine illustration and printing). The heightened realism worked the same magic on audiences as did wax figures—the more lifelike the illusion, the more riveting it became.

The film opens in 1921 London. Ivan Igor (Atwill) is a talented waxworks artist committed to elevating his craft into a respected art form, but his museum is failing badly because he refuses to pander to public taste by installing the obligatory horror exhibits. His business partner sets fire to the premises to collect insurance money, leaving the sculptor to die in the flames. But Igor somehow survives, now in a wheelchair, and twelve years later he reappears in New York City with a new exhibit, this one calibrated to appeal to morbid popular taste with scenes of murder, torture, and execution. When he meets Charlotte Duncan (Wray), the girlfriend of his studio assistant, he immediately sees the image of his most beloved lost creation, a statue of Marie Antoinette, and becomes obsessed with her. Charlotte's roommate, Florence Dempsey (Glenda Farrell), a wisecracking reporter, notices that Igor's sculpture of Joan of Arc bears a startling resemblance to another woman named Joan—a recent suicide whose body was stolen from the morgue—and starts to smell a story.

Lionel Atwill and Fay Wray

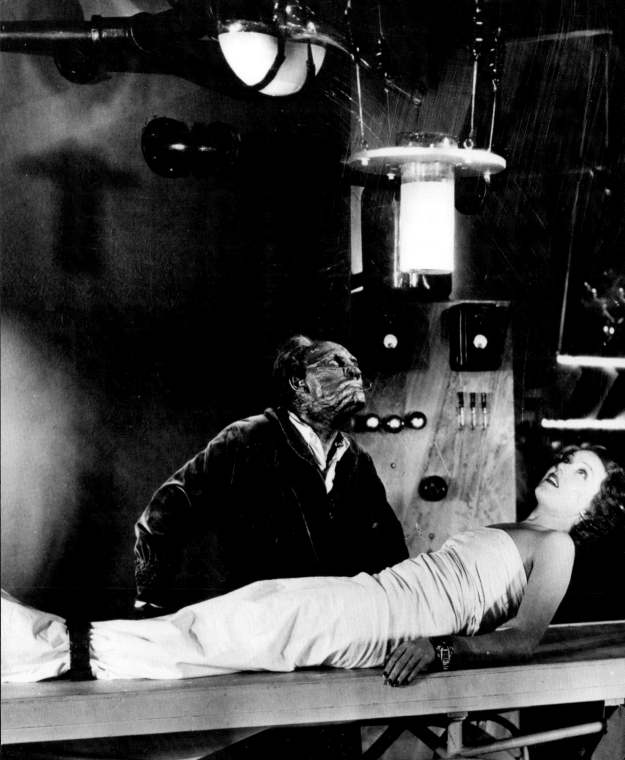

In 1953, when 3-D movies were as much of a novelty as color was in the early 1930s, Warner remade *Mystery of the Wax Museum* as *House of Wax*. Curiously enough, the director, Andre de Toth, was blind in one eye and incapable of seeing in 3-D, but this may have been an asset, forcing him to concentrate on the drama rather than on self-conscious camera effects. Crane Wilbur's screenplay remained remarkably faithful to the 1933 script; numerous scenes in the finished film are virtual re-creations of their predecessors.

Wilbur changed the setting to Victorian New York and streamlined the story by removing the newspaper characters and subplot. In the renamed role of Professor Jarrod, Vincent Price, previously a versatile and well-regarded character actor, solidified his reputation as Hollywood's new king of horror with a celebrity equal to that of Karloff and Lugosi before him. For the rest of his career, *House of Wax* would provide Price with a template for many other fright films about mad geniuses who exact hideous (and often very clever) revenges, perhaps most notably in *The Abominable Dr. Phibes* (1971)—tagline: "Love means never having to say you're ugly"—and *Theater of Blood* (1973). The ingenue roles were well handled by Phyllis Kirk, in the Fay Wray part, and Carolyn Jones, who a decade later would achieve her greatest fame as television's Morticia Addams.

The film's most famous scene shows Atwill, rising from his wheelchair and perfectly able to walk, advancing on Wray and telling her how he plans to re-create his Marie Antoinette by embalming her in wax, preserving her beauty forever. She strikes him in the face and is stunned when his features crack away. His greatest creation has been his own wax image—underneath the mask is a hideously scarred visage. Wray recounted to numerous interviewers how director Michael Curtiz shot the scene before she had ever seen the burn makeup, and how she simply froze on camera when confronting it for the first time. Her stunned pause before she screams is retained in the finished film.

One of the more memorable anecdotes about the making of *House of Wax* came from actor Paul Picerni. At the film's climax, his

character is yanked from a guillotine moments before decapitation. Director de Toth insisted on doing the scene in a single take on a real guillotine with no safety considerations or constraints; for one thing, he wanted the actor himself to control the drop. Picerni refused and was consequently suspended. He returned to the set only after a compromise was made: a removable steel bar was installed to block the blade's descent.

House of Wax was without question the most successful stereoscopic (and stereophonic) movie of its time. Audiences experienced a degree of sensory immersion unlike anything they had seen in a movie theater or could hope to see on 1950s television. Their sense of awestruck wonder is best summed up by Phyllis Kirk's amazed question when she has her first uncanny encounter with a disorienting, wax-bound world: "Why does it have to seem so real?"

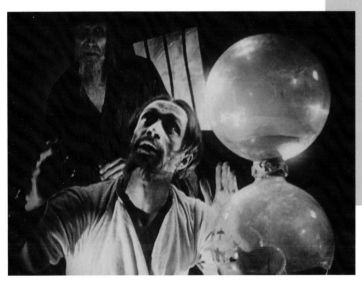

If you enjoyed *Mystery of the Wax Museum* **(1933), you might also like:**

WAXWORKS
NEPTUNE-FILM A.G./UFA, 1924 (GERMANY)

Paul Leni's final German film before coming to America to direct Universal's acclaimed haunted-house mystery *The Cat and the Canary* (1927), *Waxworks* is a trilogy of related tales recounting the efforts of a poet (William Dieterle) to document the stories behind exhibits in a wax museum. The poet himself takes a role in each story. The first is a semi-farcical account of a baker, his wife, and a high-risk run-in with the caliph of Baghdad. The second is a tall tale about Ivan the Terrible in which the tyrant is made to believe that the span of his life is controlled by the sands of an hourglass, which he must keep turning, end over end, never allowing it to run out, in order to stay alive. The third, creepiest episode is a dream sequence about the poet and the waxworks owner's daughter in danger from the animated wax figure of Spring-Heeled Jack—that is, Jack the Ripper—who pursues them through the museum's shadowy corridors. The film draws together impressive talent from other key works of German expressionism: actors Werner Krauss and Conrad Veidt from *The Cabinet of Dr. Caligari*, and Henrik Galeen, screenwriter of both *Nosferatu* (1922) and *The Golem* (1920).

Conrad Veidt as Ivan the Terrible in *Waxworks*

THE WOLF MAN

HOLLYWOOD DISCOVERS ITS MOST FAMOUS BEAST WITHIN.

Universal, 1941
Black and white, 70 minutes

DIRECTOR
GEORGE WAGGNER

PRODUCERS
GEORGE WAGGNER AND JACK J. GROSS

SCREENPLAY
CURT SIODMAK

STARRING

LAWRENCE TALBOT	LON CHANEY JR.
SIR JOHN TALBOT	CLAUDE RAINS
GWEN CONLIFFE	EVELYN ANKERS
DR. LLOYD	WARREN WILLIAM
COL. PAUL MONTFORD	RALPH BELLAMY
FRANK ANDREWS	PATRIC KNOWLES
BELA	BELA LUGOSI
MALEVA	MARIA OUSPENSKAYA

niversal's *The Wolf Man*, ten years in the planning, was originally intended as a vehicle for Boris Karloff, to follow the enormous success of *Frankenstein*. Filmmaker Robert Florey, who had first been slated to direct *Frankenstein* from his own script, would next direct *Murders in the Rue Morgue* while simultaneously developing a story treatment called *The Wolf Man*. The story had strong expressionist flourishes and was certainly screen worthy, but the studio feared religious objections, especially to a scene depicting a werewolf transformation that took place not merely in a church, but inside a confessional. The Catholic Diocese of Los Angeles had given Universal considerable grief over *Frankenstein*, prompting the studio to add a prologue underscoring the point that the film was cautionary and in no way encouraged acts of divine presumption.

The studio finally tangled with lycanthropy in *Werewolf of London* (1935), and once more, censorship considerations forced changes in the film. Jack Pierce created the now familiar Lon Chaney makeup for *Werewolf* star Henry Hull, but Joseph Breen of the Motion Picture Producers and Distributors Association, the new chief enforcer of the Production Code, warned Universal not to use "repulsive or horrifying physical details" or "the actual transvection from man to wolf." In the end, Hull wore a minimally disguising, almost feline makeup. The film disappointed at the box office.

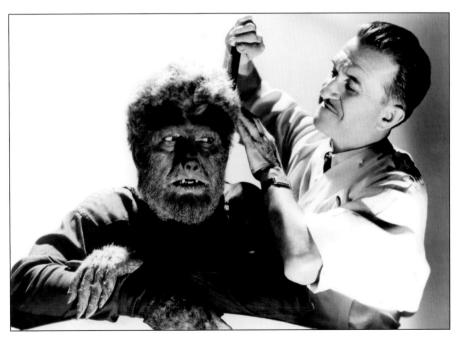

Makeup artist Jack Pierce puts the final touches on Lon Chaney Jr.

The same year, Lon Chaney Jr. became the professional pseudonym (very reluctantly adopted) by the elder Chaney's actor son, Creighton, under pressure from agents and producers to capitalize on a stellar Hollywood name. Afterward, his casting fortunes decidedly improved, and in 1939 he received a well-deserved supporting-actor Academy Award nomination for the role of Lenny, a mentally challenged ranch hand who is unaware of his own strength, for United Artists in *Of Mice and Men*. Lenny unintentionally kills a young woman, sealing his own fate, a plot element that echoed one of the most famous and pathos-filled scenes in *Frankenstein*. Studios hadn't previously imagined the younger Chaney in monster parts, but the character of Lenny, with his frightening brute strength, shared a decidedly similar casting category. Chaney Jr. tested for RKO's *The Hunchback of Notre Dame*, another prestige film, and was provisionally offered the part when it seemed that Charles Laughton, a British citizen, might be unavailable because of foreign tax problems with the IRS. But the issue was settled, and Laughton played the part.

Universal didn't have prestige roles for Chaney Jr., but it could offer him steady work in its horror programmers. He played the robotic title role in *Man Made Monster* (1941), still billed as "Jr.," but was finally able to shed the qualifying suffix later the same year for *The Wolf Man*.

The only thing left from the 1931 Florey treatment was the title; German expatriate screenwriter Curt Siodmak was entrusted with concocting a believable European werewolf

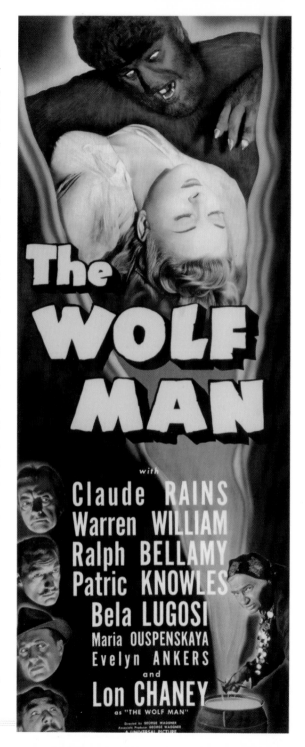

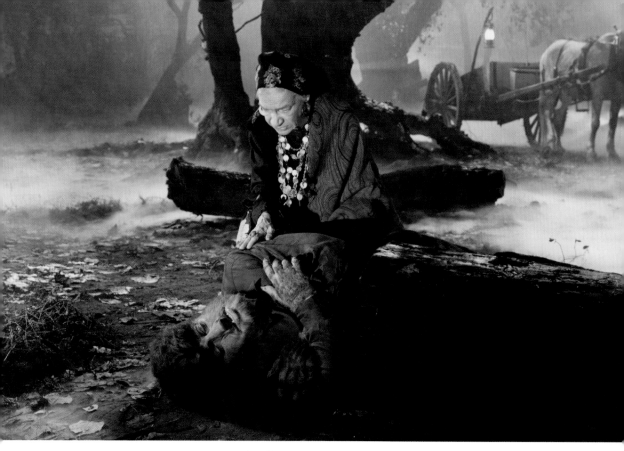

Lon Chaney Jr. and Maria Ouspenskaya

mythology. He was so successful that people often mistake the "gypsy poem" he wrote as a relic of actual folklore:

EVEN A MAN WHO IS PURE IN HEART
AND SAYS HIS PRAYERS BY NIGHT
MAY BECOME A WOLF WHEN THE WOLFBANE BLOOMS
AND THE AUTUMN MOON IS BRIGHT.

Surprisingly, the *full* moon is never mentioned, or even shown, anywhere in *The Wolf Man*. The gypsy's verse refers only to a bright *autumn* moon, and nothing of its phases. Werewolf legends date to antiquity, and only in some traditions is a full moon required; many werewolves have the power to transform at will in much of the mythology.

In the story, Lawrence "Larry" Talbot (Chaney Jr.), Welsh born but American raised, returns to his family's ancestral estate to reconcile with his estranged father, Sir John Talbot (Claude Rains). He becomes romantically attracted to a local shopkeeper, Gwen Conliffe (Evelyn Ankers), and accompanies her and

Lon Chaney Jr. and Evelyn Ankers

a friend, Jenny, to a Romany fair, where Jenny has her palm read by a gypsy named Bela (Bela Lugosi). Bela sees the shape of a pentagram in Jenny's hand and immediately warns her to leave. She flees, but not before Bela turns into a wolf and pursues her to a grisly end. Larry struggles with the wolf, killing it with a walking stick bearing a silver wolf's-head handle. But the animal wounds Larry in the chest, upon which a foreboding star appears. Bela's mother, Maleva (Maria Ouspenskaya), explains to Larry that he is now cursed, just as her son was cursed.

The story moves with the relentless momentum of a Greek tragedy as Larry, gripped by his fate, is transformed into a half man/half wolf and commits a series of murders. In the end he attacks Gwen, but he is killed by his father with the same silver-headed cane he used to kill the gypsy woman's son.

Curt Siodmak was himself a Dresden-born Jew who had fled the rise of Hitler and knew full well the portent of the pentagram and how the sign of a star could brand one for death. Additionally, the wolf was an ancient Teutonic

Claude Rains and Lon Chaney Jr.

If you enjoyed *The Wolf Man* (1941), you might also like:

AN AMERICAN WEREWOLF IN LONDON

POLYGRAM PICTURES, 1981

A pair of backpackers from America, David Kessler (David Naughton) and Jack Goodman (Griffin Dunne), are hiking the north-country moors of England when they are attacked in the moonlight by a ferocious beast. Jack dies, and David is hospitalized in London, where he becomes romantically involved with a nurse, Alex Price (Jenny Agutter). Throughout the film, which effectively juggles horror with black comedy, Jack's ghost appears to David (in outrageous, ever-increasing states of decomposition) and explains to David that he has contracted the curse of werewolfery from his wounds. David runs from his girlfriend, but there's no escaping his curse. Rick Baker won the first competitive Oscar for Best Makeup, and pop star Michael Jackson was so impressed by the film that he hired both Baker and director Landis for his landmark music video, "Thriller."

symbol of war, fully embraced by the Nazis, many of whom also embraced occultism. Under George Waggner's direction, and the moody cinematography by Joseph Valentine, war metaphors took a backseat to top-notch turns by an impressive roster of stars, especially Chaney Jr., whose convincingly tormented performance has often been attributed to his own private demons.

The character of the Wolf Man was unique among the Universal monsters in being played by only one actor over the course of five films, with no consideration of recasting. Chaney Jr. returned to the role in *Frankenstein Meets the Wolf Man* (1943), *House of Frankenstein* (1944), *House of Dracula* (1945), and *Abbott and Costello Meet Frankenstein* (1948). In all these films, a full moon is essential to bring forth the beast within, and the reference to the moon in the gypsy's poem is officially changed from "when the autumn moon is bright" to "when the moon is full and bright" whenever the lines are recited.

David Naughton experiences growing pains in *An America Werewolf in London*.

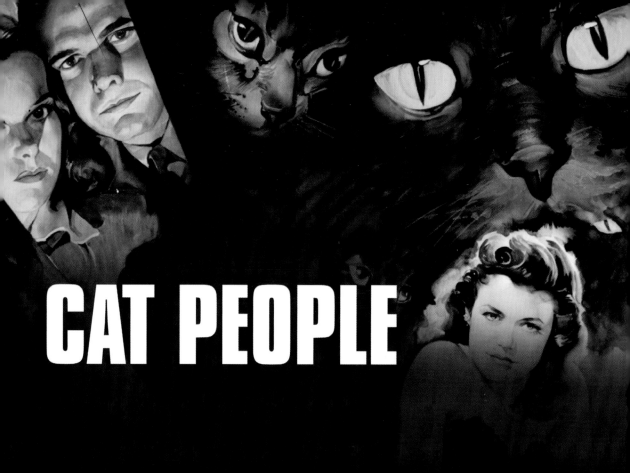

CAT PEOPLE

ELEGANT EROTIC HORROR PROWLS A CITY'S SHADOWS.

RKO Radio Pictures, 1942
Black and white, 74 minutes

DIRECTOR
JACQUES TOURNEUR

PRODUCER
VAL LEWTON

SCREENPLAY
DEWITT BODEEN

STARRING
IRENA DUBROVNA REED SIMONE SIMON
OLIVER REED KENT SMITH
DR. LOUIS JUDD TOM CONWAY
ALICE MOORE JANE RANDOLPH
THE COMMODORE JACK HOLT
THE CAT WOMAN ELIZABETH RUSSELL

rena Dubrovna (Simone Simon), a fashion artist born in Serbia and recently arrived in Manhattan, is approached by shipping engineer Oliver Reed (Kent Smith) as she sketches a black panther at the Central Park Zoo. She asks him to tea at her apartment, where he learns of her obsessive fear that she has inherited a curse from her mother and the devil-worshipping inhabitants of their Serbian village, and will turn into a deadly werecat if she ever gives in to passion for a man. Oliver is more intrigued than frightened and soon asks her to marry him, but her fear prevents the marriage from being consummated. Oliver convinces her to consult a psychiatrist, Dr. Louis Judd (Tom Conway), while Oliver seeks solace in a close relationship with his assistant, Alice Moore (Jane Randolph), who makes no secret of her attraction to him. Irena reads Alice's intentions correctly and begins to resent her intensely. And soon, Dr. Judd seems to have an unethically personal reason to cure Irena of her sex phobia.

One night, while Alice is swimming in a darkened indoor pool, a ferocious, growling beast stalks her from the shadows. She screams, and Irena turns on the lights, saying she is only looking for Oliver. She leaves, and Alice discovers her bathrobe shredded, as if by claws. Despite being warned by Alice, Dr. Judd contrives to gain access to the Reeds' apartment, and when he tries to force his sexual "cure," whether or not Irena's cat fantasies are real becomes frighteningly apparent. But in the end we are still left wondering: Was the panther in the zoo Irena's alter ego? Or was she the panther's?

Cat People was a completely sensible attempt by RKO to capitalize on the success of Universal's *The Wolf Man*, and DeWitt Bodeen's intelligent,

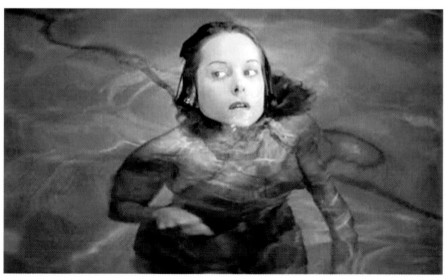

Alice is trapped in a pool by a growling, unseen animal.

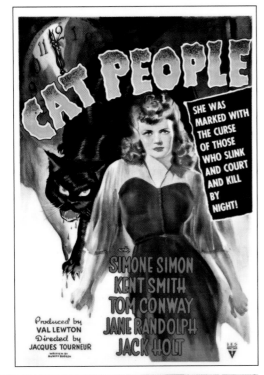

tightly structured script lived up to its inspiration. It was the first of a half dozen thrillers Val Lewton produced for the studio during the war years, gaining him the critical reputation of an auteur usually reserved for directors, not producers. Lewton shrewdly stretched his limited budget by suggesting instead of showing the horrific elements, letting shadows and the audience's imagination do the heavy lifting. As Lewton told the *Los Angeles Times*, "We tossed away the horror formula right from the start. No masklike faces hardly human, with gnashing teeth and hair standing on end." The quote should leave no doubt that he had indeed seen and evaluated *The Wolf Man*. Lewton continued: "But take a sweet love story, or a story of sexual antagonisms, about people like the rest of us, not freaks, and cut in your horror here and there, by suggestion, and you've got something. Anyhow, we think you have."

Cat People is every bit as engrossing as *The Wolf Man*, with almost no reliance on special effects or marathon makeup ordeals. The famous swimming pool sequence does include the animated silhouette of a prowling black panther moving in the shadows, but it is almost subliminal and arguably not even needed. As *Variety* commented, "Fans of horror subjects will find *Cat People* a distinctive piece of entertainment. Its marrow-chilling potentialities for lovers of the eerie build to believable peaks of spine-tingling, hair-raising suspense without once resorting to fake melodramatics or overstaging."

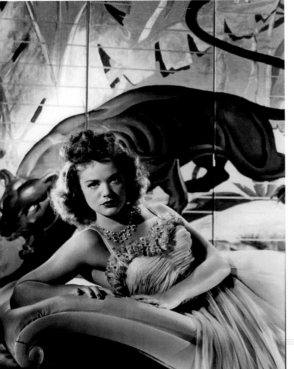

Irena in her strikingly decorated Manhattan apartment

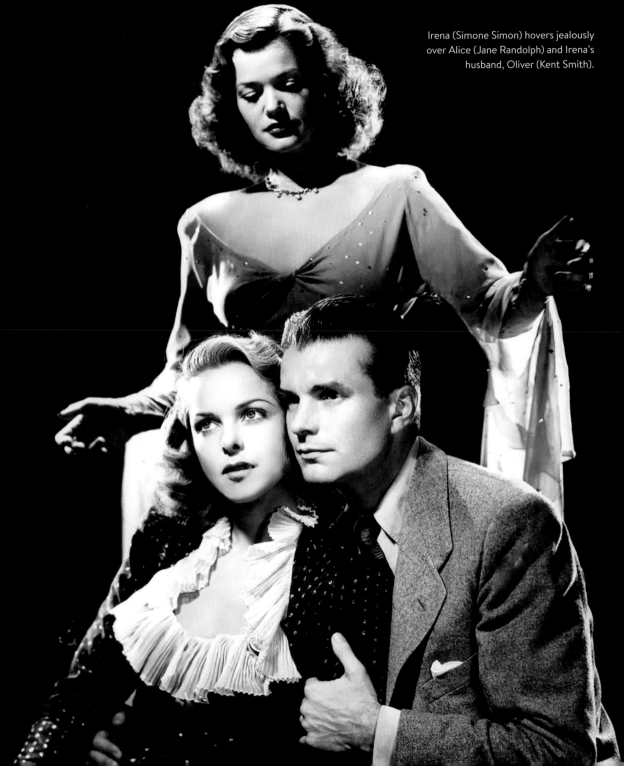

Irena (Simone Simon) hovers jealously over Alice (Jane Randolph) and Irena's husband, Oliver (Kent Smith).

Some of the producer's attraction to the strange subject may have been personal. Friends and associates confirmed that Lewton himself had a phobia of cats, and, like Irena, disliked being touched. His wife recalled that he was "very unhappy about cats," and a catfight heard at night outside their house could leave him "nervous and frightened." She speculated that his discomfort "stemmed from an old folktale he remembered from Russia," where he was born in 1904. RKO's executive vice president of production, Charles Koerner, had already audience-tested the title *Cat People*, without a story or description, before he assigned it to Lewton for development.

Lewton's follow-ups at RKO included *I Walked with a Zombie* (1943), *The Leopard Man* (1943), and *The Seventh Victim* (1943). In 1944 he produced *The Curse of the Cat People*, a very loose sequel starring Simone Simon, with Kent Smith and Jane Randolph as the now married couple from the earlier film whose young daughter discovers an imaginary friend in the shape of Irena's ghost. In 1945 Lewton produced two excellent pictures with Boris Karloff, *The Body Snatcher* and *Isle of the Dead*. Lewton's 1946 film *Bedlam*, also with Karloff, was his final picture for RKO. He produced three nongenre films for Paramount, MGM, and Universal before his tragic early death in 1951, at the age of 46.

Judd makes his move and seals his fate.

A GIRL WALKS HOME ALONE AT NIGHT

KINO LORBER, 2014

Vampirism has been successfully employed as a metaphor for drug addiction in a number of films, but here the vampire functions as the perfect costar for dealers and users alike, ruthlessly unpleasant characters absolutely made for each other—some from the drug underground, and one from the supernatural underworld. A Persian-language film set in the fictional Iranian town Bad City, *A Girl Walks Home Alone at Night* was shot on a black-and-white microbudget on location in Kern County, California. The noirish visuals bring to mind the camerawork of Val Lewton as the stealthy succubus (Sheila Vand) commands the film with her methodical nocturnal prowling. The manner in which the vampire stalks her prey—from the opposite side of the street, mirroring her intended victim's every step and move—is one of the creepiest things you'll ever see. And be forewarned: while there's plenty of Lewton-like understatement in those velvety shadows, *A Girl Walks Home Alone at Night* doesn't shrink from explicit violence if it helps nail a scene. A tip: if a vampire in a black chador ever starts seducing you, please avoid putting a finger in her mouth.

Sheila Vand as the Girl in *A Girl Walks Home Alone at Night*

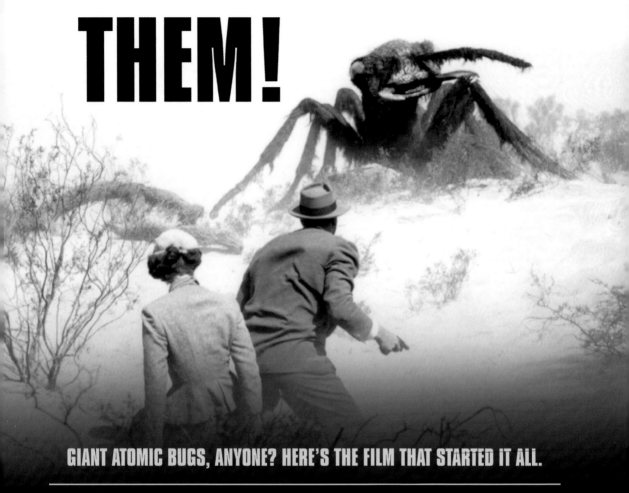

THEM!

GIANT ATOMIC BUGS, ANYONE? HERE'S THE FILM THAT STARTED IT ALL.

Warner Bros., 1954
Black and white, 94 minutes

DIRECTOR
GORDON DOUGLAS

PRODUCER
DAVID WEISBART

SCREENPLAY
TED SHERDEMAN, FROM A STORY BY GEORGE WORTHING
YATES, ADAPTED BY RUSSELL HUGHES

STARRING

POLICE SERGEANT BEN PETERSON	JAMES WHITMORE
DR. HAROLD MEDFORD	EDMUND GWENN
DR. PATRICIA MEDFORD	JOAN WELDON
ROBERT GRAHAM	JAMES ARNESS
BRIG. GEN. ROBERT O'BRIEN	ONSLOW STEVENS
MAJ. KIBBEE	SEAN MCCLORY
TROOPER ED BLACKBURN	CHRIS DRAKE
THE ELLINSON GIRL	SANDY DESCHER
ALAN CROTTY	FESS PARKER

A sergeant with the New Mexico State Police, Ben Peterson (James Whitmore), discovers a dazed little girl wandering in the desert near the site of the first atomic bomb test in Alamogordo. Almost catatonic with shock, she is apparently the sole survivor of a violent attack on her family's vacation trailer. Nearby, the proprietor of a similarly destroyed general store is found dead, an autopsy revealing that he was the victim of a lethal amount of formic acid, which had somehow been pumped into his body. An unusual animal track found in the area is examined by a pair of Department of Agriculture scientists, Dr. Harold Medford (Edmund Gwenn) and his daughter, Dr. Patricia Medford (Joan Weldon). On a hunch, they expose the traumatized girl to the smell of formic acid, and she reacts violently, screaming, *"Them! Them!"* Formic acid, the researchers know, is the main component of ant venom. Given the huge size of the strange track, they realize they are likely dealing with an eight-foot-long monster ant, a mutation caused by the radiation from atomic testing.

Their suspicions are confirmed during a trip to the desert with FBI agent Robert Graham (James Arness), where they encounter exactly the kind of ant they had hypothesized. The elder Medford instructs Graham and Peterson to disable the creature by shooting off its antennae,

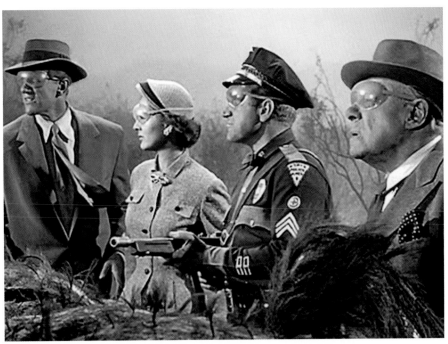

James Arness, Joan Weldon, James Whitmore, and Edmund Gwenn

then kill it with machine gun fire. A helicopter crew discovers a giant anthill into which cyanide gas bombs are thrown, wiping out the colony. However, there is evidence that two recently hatched queen ants have escaped, with the potential to reproduce their species exponentially.

When a queen begins to reproduce in the hold of a freighter in the Pacific, the ship is summarily sunk by the military. Meanwhile, the authorities follow the trail of the remaining queen to Los Angeles, where the sprawling storm drain system of the dry Los Angeles River provides a ready-made nest for the giant ants. An exciting race against the clock ensues. Will the new nest hatch another queen? Will two young boys trapped by the ants be able to escape? Has the Atomic Age taught humanity any new lessons?

First envisioned as a large-budget film shot in color and 3-D, the initial treatment of *Them!* by George Worthing Yates imagined giant ants colonizing the New York City subway system. It would have been impossibly expensive to realize, and the setting was changed to the far more

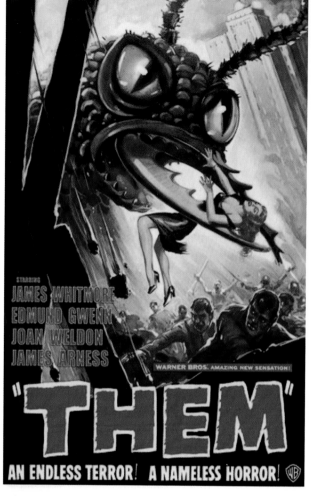

ABOVE Original one-sheet poster
LEFT Main title frame enlargement with color effect

manageable landscape of Los Angeles, where a vast system of storm drains provided a perfectly functional substitute that could be had on the cheap.

The plan for 3-D was the first cost-cutting casualty, followed by color, then plans for wide-screen black and white. The last remnant of the film's original, eye-popping ambition was its main title card, on which "THEM!" was emblazoned in vivid red and blue. The color frames had to be manually spliced into each show print of the first theatrical release. Later prints reverted to black and white, but the color effect was finally restored with the first home video release.

Them! was the inaugural event in a 1950s

ABOVE Sandy Descher as the traumatized survivor of an ant attack **BELOW** Discovery of the main nest

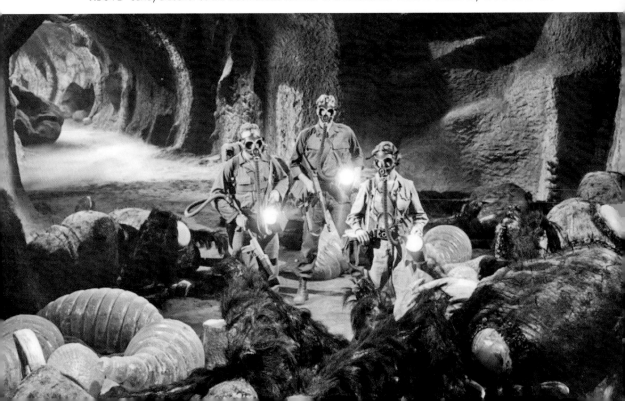

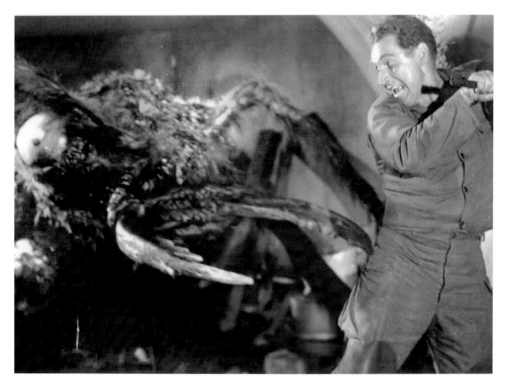

James Whitmore, trapped in a drainage tunnel, struggles to escape.

American growth industry: the giant atomic monster movie. The honor is sometimes mistakenly bestowed on the Japanese *Gojira*, also produced in 1954, only released domestically in a revised 1956 version called *Godzilla, King of the Monsters!* Godzilla, however, was never an atomic monster per se, but instead an ancient, dormant creature awakened (and angered) by the atomic attacks on Hiroshima and Nagasaki.

The dangerous effects of radioactive fallout had, by the early fifties, permeated popular consciousness. There were no fanciful examples of giantism connected to atomic energy, but the use of X-ray and gamma rays was successful in creating marigolds and snapdragons with enormous flowers in the 1940s and 1950s. Of course, the really big elephant in midcentury America was the looming anxiety about the nuclear arms race and possible apocalyptic destruction. But the fear was far more easily processed in a roundabout way through substitute confrontations with giant ants, spiders, praying mantises, and fifty-foot women. Notable atomic-mutation pictures of the 1950s included *Tarantula* (1955), *The Black Scorpion* (1957), *The Deadly Mantis* (1957), *Beginning of the End* (1957), *The Cyclops* (1957), and *The Amazing Colossal Man* (1957).

EARTH VS. THE SPIDER

AMERICAN INTERNATIONAL, 1958

Made on a much smaller budget than Warner Bros.' *Them!* or Universal's *Tarantula*, American International's *Earth vs. the Spider*—its title truncated to *The Spider* ("It Must Eat You to Live!") for most advertisements and posters—is an enjoyable little picture that makes the point that giant bugs had become so commonplace in the mid-century American mind that it was unnecessary to dwell on *why* an arachnid would grow to such an enormous size. The audience would presume it had something to do with radiation, though the captured critter never makes it to the university that could determine a true diagnosis. Discovered in a cave near a small town in the desert, the monster is brought down with a massive dose of DDT, its carcass temporarily stored in the local high school gymnasium. There, in the film's most ludicrously entertaining scene, vibrations from a rock band and dancing "teens" (most looking at least a decade older) bring it back to life for a big rampage. The ensuing awful special effects are a major part of the fun.

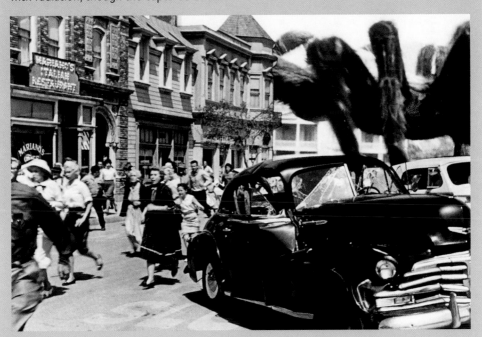

A giant tarantula wreaks small-town havoc in *Earth vs. the Spider*.

CREATURE FROM THE BLACK LAGOON

"BEAUTY AND THE BEAST," WATER-BALLET EDITION.

Universal-International, 1954
Black and white, 79 minutes

DIRECTOR
JACK ARNOLD

PRODUCER
WILLIAM ALLAND

SCREENPLAY
HARRY ESSEX AND ARTHUR ROSS, FROM A STORY BY
MAURICE ZIMM

STARRING

DAVID REED	RICHARD CARLSON
KAY LAWRENCE	JULIE ADAMS (AS JULIA ADAMS)
MARK WILLIAMS	RICHARD DENNING
CARL MAIA	ANTONIO MORENO
LUCAS	NESTOR PAIVA
DR. THOMPSON	WHIT BISSELL
ZEE	BERNIE GOZIER
CHICO	HENRY ESCALANTE
THE GILL MAN (IN WATER)	RICOU BROWNING
THE GILL MAN (ON LAND)	BEN CHAPMAN

After a strange fossil of a clawed, webbed hand is discovered deep in the Amazon, a follow-up expedition of American marine researchers, led by Dr. David Reed (Richard Carlson) and Dr. Mark Williams (Richard Denning), along with Reed's coworker and girlfriend, Kay Lawrence (Julie Adams), arrives at the site of the find to search for the rest of the fossilized creature, which seems to be a missing link between sea beasts and land animals. Lurking nearby is an amphibious humanoid, obviously a living example of the fossilized specimen, which begins stalking the group and kills a pair of men from the original discovery team. The creature takes a special interest in Kay, and in the film's most celebrated scene, it swims beneath her in the river, mirroring her movements in a suggestive underwater pas de deux. Believing that the remainder of the missing fossil skeleton must have been swept downstream, the group follows a tributary to its end, an ominously named basin called the Black Lagoon, where the Gill Man makes his intentions for Kay terrifyingly clear.

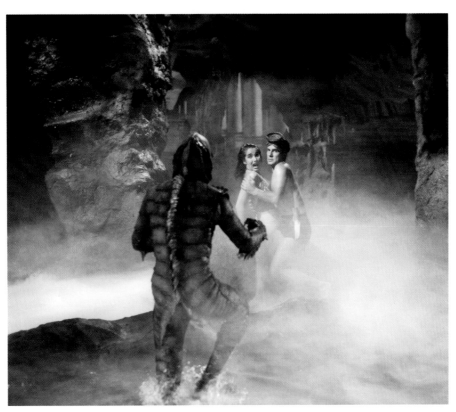

Ben Chapman, Julie Adams, and Richard Carlson

Director Jack Arnold was asked by Universal-International to helm *Creature from the Black Lagoon* after the box-office success of his previous directorial assignment, *It Came from Outer Space* (1953). Both films were initially released in 3-D, but the process was especially well suited to underwater visuals, wherein swimming figures seemed to float out of the screen and over the audience. Arnold is considered one of Hollywood's most important auteurs of 1950s science fiction, his 1957 film *The Incredible Shrinking Man* deemed a masterpiece of its kind.

It's ironic indeed that some of the clearest freshwater springs in North America were chosen as the settings for a "black lagoon," primarily Wakulla Springs, near Tallahassee, Florida, with some additional underwater scenes shot at Silver Springs, near Ocala. Rice Creek, near Palatka, Florida, was chosen for several above-water scenes. Production was split between Florida and Universal City, California, where aboveground sets were constructed around the studio's much-utilized, man-made lake.

Bud Westmore, who succeeded master monster maker Jack Pierce as Universal's head of makeup, was given official credit for the creature suit, but the de facto designer of the monster's final look was studio artist Millicent Patrick, who vastly improved an earlier concept that had the smooth appearance of a salamander. Patrick's sketches were transformed by *Wizard of Oz* veteran Jack Kevan into a bodysuit molded of sponge rubber. The headpiece was sculpted by Chris Mueller Jr.

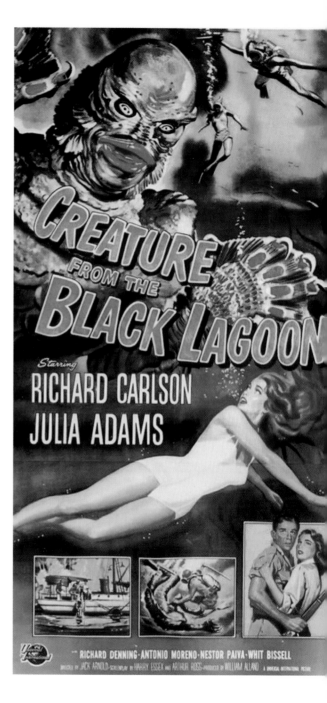

Ricou Browning played the swimming Gill Man in three films,
seen here in *Revenge of the Creature*.

Two actors played the Gill Man: Ben Chapman, a former nightclub performer, played the creature on land. Ricou Browning, a producer of underwater and topside water shows at tourist venues throughout Florida, was the swimming creature with the Florida location unit. Chapman appeared in only a handful of other feature films, including *Jungle Moon Men* (1955), and made occasional television appearances. In his later life he was a regular presence at autograph shows and fan conventions. Browning repeated his scaly swimming duties for the two *Creature* sequels: *Revenge of the Creature* (1955) and *The Creature Walks Among Us* (1956). Further credits include being cocreator of the movie *Flipper* (1963) and director and associate producer for the follow-up 1964–1967 television series. Browning also directed the underwater sequences for *Thunderball* (1965). In 2019, he commemorated the sixty-fifth anniversary of

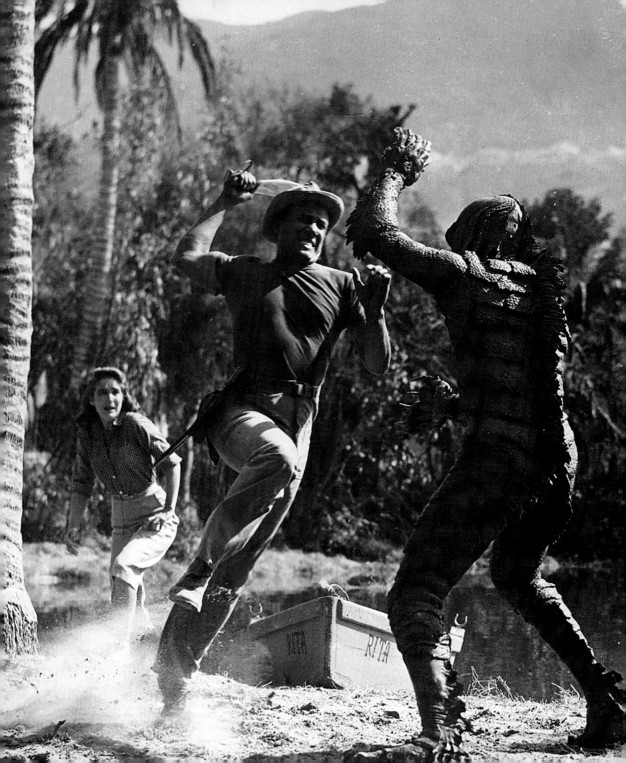

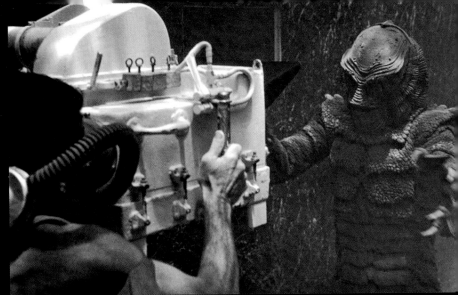

LEFT The Creature emerges from the water for a land fight. ABOVE Underwater shooting
BELOW Ben Chapman, who played the Creature on land, with Julie Adams

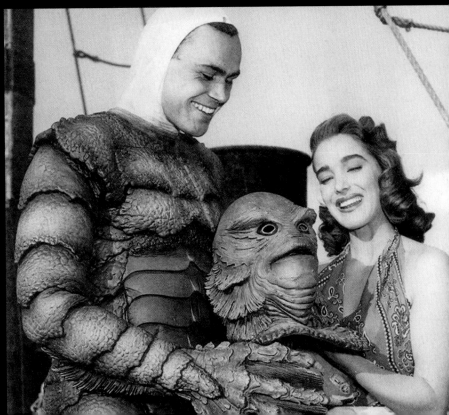

Creature's release at a well-attended special event called Gill-a-Bration, at Silver Springs State Park. Julie Adams, who died that same year at the age of ninety-two, enjoyed a long career in television, and, like Browning and Chapman, was in great demand whenever fans of the Universal monsters gathered.

In 1964, the rubber suit was dusted off for the guest character of Uncle Gilbert on an episode of television's *The Munsters*, filmed on the Universal lot, and a highly inaccurate and impressionistic "Gill Man" suit also appeared in *The Monster Squad* (1987). But to date, the creature has not yet anchored another feature film. A remake has been announced no less than nine times by Universal, and several full scripts developed for an impressive roster of directors, including Jack Arnold, John Carpenter, Peter Jackson, and Ivan Reitman, but the production has never escaped an apparently jinxed underwater cage of preproduction shackles. *Creature from the Black Lagoon* remains the only classic Universal monster franchise that has never enjoyed a major remake or series reboot.

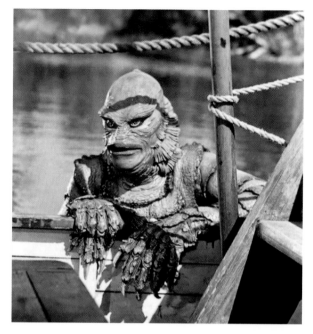

ABOVE Ben Chapman **BELOW** Julie Adams, Richard Carlson, and Antonio Moreno

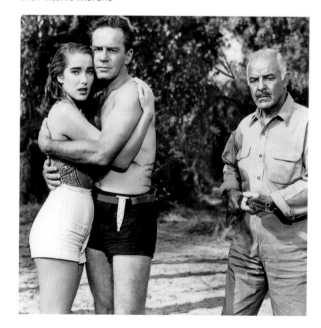

THE SHAPE OF WATER

FOX SEARCHLIGHT, 2017

In 2002, Guillermo del Toro came close to realizing a project he had dreamed of since childhood: directing a remake of *Creature from the Black Lagoon*, in which the watery monster would be sympathetic, the story seen finally from *his* perspective. Most important, the Gill Man and the girl would finally get together. His vision wasn't at all what Universal had in mind, and this stab at a remake was shelved with all the others. Nearly ten years later, del Toro revived the project as an homage rather than a remake, with stunning results. In Cold War–era Baltimore, Elisa (Sally Hawkins, in an Oscar-nominated performance) is a mute cleaning woman at a top-secret research facility who forms a wordless bond with a humanoid amphibian (Doug Jones) that is at the center of a high-stakes intelligence tug-of-war between American and Soviet forces. The bond evolves into a full-blown romance as Elisa contrives with a pair of friends to liberate the creature—threatened with euthanasia—from captivity. Sculptor Mike Hill's bodysuit for Jones brilliantly evokes the spirit of Universal's lagoon monster (miraculously, without violating its trademark). Like most of del Toro's work, *The Shape of Water*, which won Academy Awards for Best Picture and Best Director, has enormous heart and emotional depth. If you think a musical number resembling a Fred Astaire/Ginger Rogers routine performed by a woman and an amphibian might make you laugh, it's only because you haven't yet seen the film.

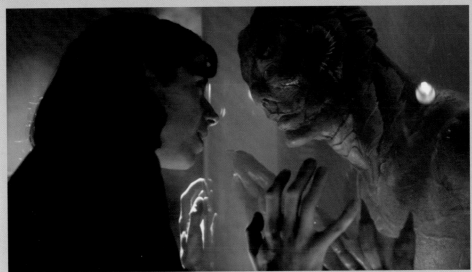

Sally Hawkins and Doug Jones in *The Shape of Water*

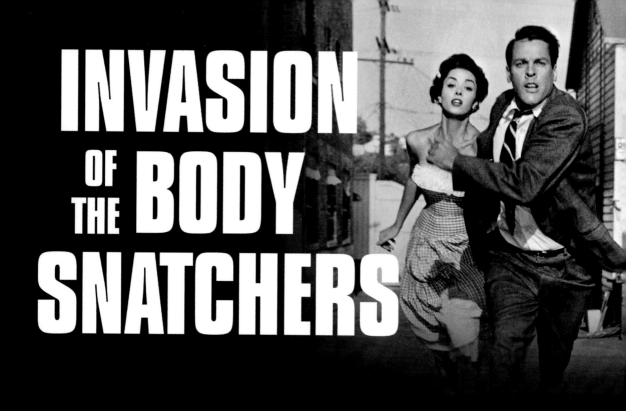

INVASION OF THE BODY SNATCHERS

THE SCI-FI CLASSIC THAT BROUGHT TOGETHER PODS AND MONSTERS.

Allied Artists, 1956
Black and white, 80 minutes

DIRECTOR
DON SIEGEL

PRODUCERS
WALTER MIRISCH AND WALTER WANGER

SCREENPLAY
DANIEL MAINWARING, RICHARD COLLINS (UNCREDITED),
BASED ON THE MAGAZINE SERIAL *THE BODY SNATCHERS*,
BY JACK FINNEY

STARRING

DR. MILES J. BENNELL	KEVIN MCCARTHY
BECKY DRISCOLL	DANA WYNTER
DR. DAN "DANNY" KAUFFMAN	LARRY GATES
JACK BELICEC	KING DONOVAN
THEODORA "TEDDY" BELICEC	CAROLYN JONES
WILMA LENTZ	VIRGINIA CHRISTINE
UNCLE IRA LENTZ	TOM FADDEN
DR. ED PURSEY	EVERETT GLASS
MAC LOMAX	DABBS GREER

n the emergency room of a hospital in the town of Santa Mira, California, a man seemingly driven mad by a traumatic experience he can barely describe finally calms down sufficiently to tell his story to an attending psychiatrist. The man identifies himself as Dr. Miles Bennell (Kevin McCarthy), a family practitioner who recently began seeing patients suffering from the same delusion—that their loved ones are being mysteriously replaced by identical, living replicas. He meets a former girlfriend, Becky Driscoll (Dana Wynter). Both are recently divorced, and a rekindled relationship seems likely. But the epidemic of supposed imposters creates a distraction.

Miles's friend Jack Belicec (King Donovan) and his wife, Teddy (Carolyn Jones), are disturbed by the mysterious appearance on their rec-room pool table of a not exactly dead, yet not exactly living, humanoid form. It seems to be a precise replica of Jack, though incompletely developed. A similar body that looks like Becky is found in her basement, and soon all four characters find more duplicates of themselves emerging from giant seedpods that have been placed in Miles's greenhouse. They realize that the pods are the source of the townsfolk's obsession with "replacement" friends and family members. The population is indeed being rapidly duplicated by emotionless alien doppelgängers who plan to impose a universal, tranquilized conformity on the human race. As one of the pod people explains, "Your new bodies are growing in there. They're taking you over, cell for cell, atom for

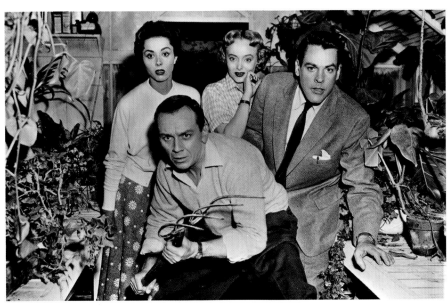

King Donovan (with pitchfork), Dana Wynter, Carolyn Jones, and Kevin McCarthy search for alien pods hidden in a greenhouse.

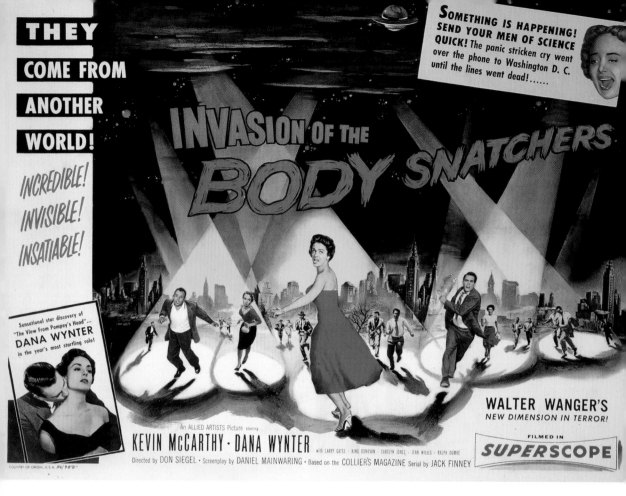

atom. There's no pain. Suddenly, while you're asleep, they'll absorb your mind, your memories . . . and you're reborn into an untroubled world."

Based on a magazine serial by Jack Finney (later published as a novel), *Invasion of the Body Snatchers* is often described as a Red Scare allegory, but in truth it is a much more subtle exploration of the pervasive feeling in 1950s America that the world after the war had fundamentally changed, making everyone question common assumptions about American identity. Communism, of course,

had long been painted as a soulless juggernaut that threatened to crush individualism. But many features of midcentury American life were also deemed as dehumanizing. The mass exodus to the suburbs and their assembly-line housing developments left many people alienated and adrift in a strange new land that valued blind materialism and social conformity over all else. More and more, Americans didn't know their neighbors. Who knew what they might really be? During the Korean War, frightening stories

of American prisoners being brainwashed were widely reported in the media, driving home the idea that selfhood and identity were unstable and malleable. In the 1950s, prescription tranquilizers were the fastest-growing category of pharmaceuticals, a ready gateway to the "untroubled world" described by the body snatchers.

Don Siegel himself once told an interviewer that he was not presenting a political allegory, but rather expressing his own jaded, if not downright bleak, assessment of society—namely, that "the majority of people unfortunately are pods, existing without any intellectual pretensions and incapable of love." And it is just such a downbeat worldview that colors the film's chilling climax,

when Miles kisses the sleep-deprived Becky, and she looks upon him with eyes that are, suddenly, not of this Earth.

Siegel was known for films with naturalistic performances shot on location, a far cry from the typical studio-bound sci-fi of the period. Both Siegel and producer Walter Wanger were eager to create something more ambitious than just another alien invader film, and they succeeded. In Daniel Mainwaring's intelligent, well-crafted script, Miles and Becky are believable and appealing characters with interesting backstories; we become invested in their lives immediately. Although almost the entire film was shot on location, as the story progresses the vérité aspects

Miles sets fire to one of the pods.

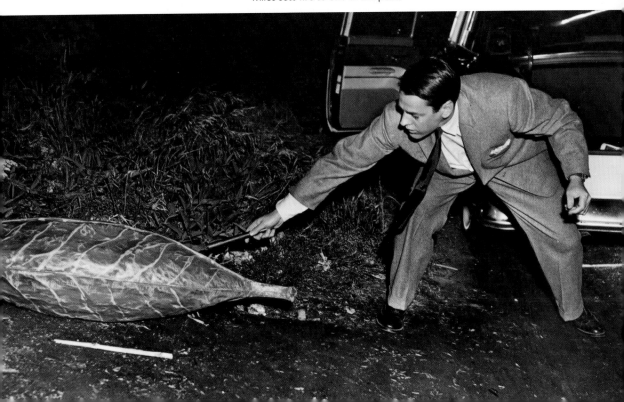

give way to more controlled, stylized compositions with an almost expressionistic use of light and shadow. No attempt is made to render the fantastic invasion rationally comprehensible. For example, the exact physical process of alien body replacement is never really clarified, making it all the more distressing and disorienting when it happens. Does the new body come to life and physically dispose of the old one? Is the victim possessed by a kind of mental projection? Or do both bodies somehow merge into a single organism? None of these questions are answered, or even addressed. As a result, the film is all the more frightening.

The hospital prologue and a bookend epilogue were added at the studio's insistence, six months after principal photography had wrapped. A preview audience's reaction reinforced the studio's opinion that the film was just too much of a nightmare with its dizzying final scene of Miles stopping cars in the Cahuenga Pass, warning, "They're here! You're next!" Neither Wanger nor Siegel was pleased with the device, in which the car-stopping scene dissolves back to the emergency room, where another patient arrives, confirming Miles's wild tale, and someone finally calls the FBI.

No one originally involved with the film liked the title—the only decent alternate suggested was *Sleep No More*—but the picture is now so deeply embedded as an artifact of popular culture that it's hard to imagine it being called anything but *Invasion of the Body Snatchers*. Even people who have never seen the film have a pretty good idea of what a "pod person" is.

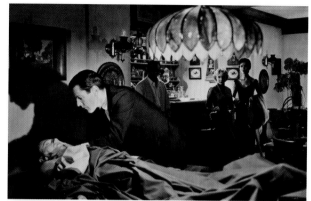

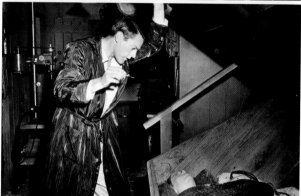

TOP Miles examines a strange simulacrum of his friend Jack that has materialized on his pool table. **MIDDLE** Miles makes an unnerving discovery in Becky's basement. **BOTTOM** Miles stops traffic, trying to warn the world.

INVADERS FROM MARS

20TH CENTURY FOX, 1953

A full three years before *Invasion of the Body Snatchers*, child actor Jimmy Hunt had trouble convincing people that his screen parents weren't his parents anymore, and it all had to do with an alien invasion. Hillary Brooke and Leif Erickson are genuinely chilling as the icy emissaries from beyond in *Invaders from Mars*, shedding their warm mom and pop personas after being gulped down by a nearby sandpit, where aliens have buried a saucer, and having a mind-controlling implant installed at the base of their brains. *Invaders* mixes unintentional laughs (yes, this is the film featuring aliens with visible zippers up their backs) and a truly disturbing unease. Untold numbers of the first wave of baby boomers had their dreams seriously hijacked by the repeated image of one unsuspecting character after another being led to the edge of the hungry sandpit to the swelling accompaniment of a ghostly chorus, then being sucked unceremoniously into the dirt. As the transformed mom, Hillary Brooke looks much like Dana Wynter at the end of *Invasion of the Body Snatchers*: both actresses adopt the haughty, haute couture expression of living death so prevalent in 1950s fashion magazines, a look to which American women were expected to obediently aspire.

Leif Erickson and Hillary Brooke: Pod parents without the pods in *Invaders from Mars*

THE CURSE OF FRANKENSTEIN

THE FILM THAT RAISED A NEGLECTED GENRE FROM THE DEAD.

Hammer Films/Warner Bros., 1957
Color, 82 minutes

DIRECTOR
TERENCE FISHER

PRODUCERS
MICHAEL CARRERAS, ANTHONY HINDS,
AND ANTHONY NELSON KEYS

SCREENPLAY
JIMMY SANGSTER, FROM THE NOVEL BY
MARY WOLLSTONECRAFT SHELLEY

STARRING

VICTOR FRANKENSTEIN	PETER CUSHING
ELIZABETH	HAZEL COURT
PAUL KREMPE	ROBERT URQUHART
THE CREATURE	CHRISTOPHER LEE
YOUNG VICTOR	MELVYN HAYES
JUSTINE	VALERIE GAUNT
PROFESSOR BERNSTEIN	PAUL HARDTMUTH
GRANDFATHER	FRED JOHNSON

I n Tim Burton's *Ed Wood* (1994), an out-of-work Bela Lugosi (Martin Landau, in an Academy Award–winning performance) bemoans the decline of classic horror in the postwar era. "Nobody wants vampires anymore. Now all they want is giant bugs!" This was indeed the case at the time, and Lugosi didn't live to see the international revival of gothic cinema that would begin only three months after his death. Hammer Films in England began production in November 1956 on *The Curse of Frankenstein*, the first straightforward screen adaptation of Mary Shelley's novel since 1931.

Using visceral, instead of electrical, shocks, *The Curse of Frankenstein* jolted a dormant genre back to unstoppable life. Nineteen fifty-seven was a highly consequential year for scary movies. The "big bug" formula was reaching a saturation point on American screens, and Universal was simultaneously releasing its classic chillers to television for the first time. An exponentially larger audience than had ever seen the original films in theaters was having its first exposure to an older form of frightening entertainment, and was highly receptive to it.

Hammer, a long-established British studio

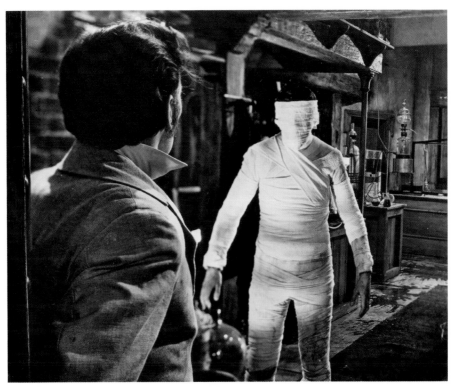

Victor watches the Creature taking its first steps.

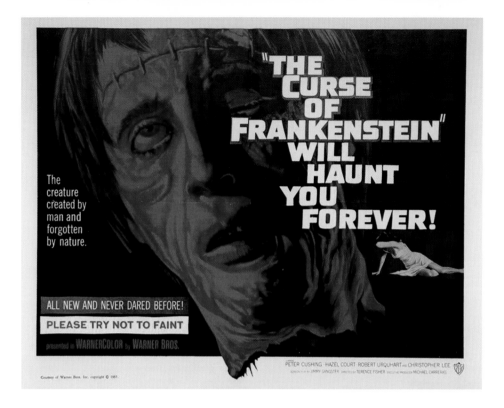

The creature created by man and forgotten by nature.

"THE CURSE OF FRANKENSTEIN" WILL HAUNT YOU FOREVER!

ALL NEW AND NEVER DARED BEFORE!

PLEASE TRY NOT TO FAINT

presented in WARNERCOLOR by WARNER BROS.

PETER CUSHING · HAZEL COURT · ROBERT URQUHART and CHRISTOPHER LEE
SCREEN PLAY BY JIMMY SANGSTER · DIRECTED BY TERENCE FISHER · EXECUTIVE PRODUCER MICHAEL CARRERAS

Courtesy of Warner Bros. Inc. copyright © 1957.

known for its low-budget thrillers, received stern admonishments from lawyers at Universal that it could not copy Universal's classic film in any way, especially Boris Karloff's iconic portrayal and his distinctive makeup. Since Shelley's novel had been published in 1818, the story was safely in the public domain; anyone was free to adapt it to the screen. In deference to Universal, whose original *Frankenstein* was a key attraction of its *Shock Theatre* television package, Hammer augmented its title to avoid any confusion.

The Curse of Frankenstein was writer Jimmy Sangster's third produced screenplay, but his background in production management prepared him well to transform a sprawling novel into a cost-effective chamber piece. To achieve a lush period look, the production department pushed its ingenuity and resourcefulness and took full advantage of the access it had to Bray Studio's huge store of nineteenth-century costumes, antiques, props, and recycled set pieces. More often than not, a thrown-together assemblage of furniture looked true to life and historical.

Victor Frankenstein (Peter Cushing), a child prodigy born into a wealthy Swiss family, grows into more than the equal of his tutor, Paul Krempe (Robert Urquhart), and the two men become research partners, delving deeply into the mysteries of life and death. After one of their experiments succeeds in reviving a dead

puppy, Victor becomes obsessed with bringing to life an ideal human being assembled from the choicest parts of corpses—the hands of a great pianist, perhaps, or possibly the brain of a genius. Unknown to Paul, he invites a distinguished old professor as a houseguest, then kills him for his superior brain. Paul is horrified when he learns the truth about the professor's "accident," and in an ensuing struggle in Victor's laboratory, the brain is damaged, but Victor persists in his quest to play God. They bring the patchwork body to life, but far from being a perfect specimen, the creation is a shambling travesty of a human being, clearly brain damaged, its face a mass of scar tissue. The monster (Christopher Lee) escapes into the woods, killing a blind man and his grandson. Paul and Victor give chase, Paul shoots the creature in the head, and they bury the thing in the forest.

Meanwhile, Elizabeth (Hazel Court), Victor's fiancée by family arrangement since childhood, comes to live with him after her guardian dies. She is eager to plan their wedding. But Victor is distracted by a tawdry affair he is pursuing with his maid, Justine (Valerie Gaunt), and in any case is too self-preoccupied to comprehend the concerns and feelings of others. Victor has surreptitiously dug up the monster and restored it to life. When Justine poses a threat to the marriage by claiming she is pregnant, it is a simple matter to silence her with the monster, but Victor's transgressions against God and nature are not so easily resolved.

With *The Curse of Frankenstein*, Hammer introduced the formula that would serve it

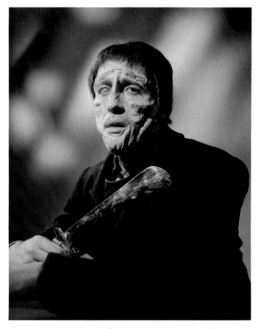

ABOVE Christopher Lee as the Creature
BELOW Peter Cushing as Victor Frankenstein

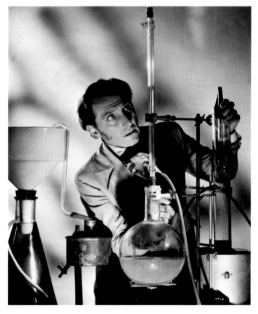

well through the next two decades: in addition to the trademark presences of Peter Cushing and Christopher Lee, there were gothic horror, explicit gore, and generous helpings of sex. Skirmishes with the British Board of Film Censors became a cat-and-mouse ritual as the studio reveled in its transgressions against propriety and taste. The critics were uniformly aghast. Among the many images in *The Curse of Frankenstein* that raised objections were a close-up of severed hands, a freshly disembodied eyeball seen through a magnifying glass, blood welling up from a shotgun wound to a head, and other pleasantries. Compared to today's gorefest standards, these effects are actually quite restrained, but at the time they were radical departures from accepted screen decorum.

Hammer produced six sequels starring Peter Cushing, including *The Revenge of Frankenstein* (1958), *The Evil of Frankenstein* (1964), *Frankenstein Created Woman* (1967), *Frankenstein Must Be Destroyed* (1969), and *Frankenstein and the Monster from Hell* (1974). Another film in the series, *The Horror of Frankenstein* (1970), featuring Ralph Bates as Victor, is generally considered to be an undistinguished misfire and a completely unnecessary attempt to remake the original film.

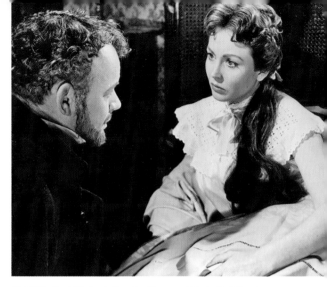

ABOVE Paul (Robert Urquhart) warns Elizabeth (Hazel Court) of Victor's madness. **BELOW** Elizabeth recklessly enters Victor's secret domain.

If you enjoyed *The Curse of Frankenstein* (1957), you might also like:

MARY SHELLEY'S FRANKENSTEIN

TRISTAR PICTURES, 1994

Producers and directors who have had good luck with either *Dracula* or *Frankenstein* invariably gravitate to the unproduced property as a natural follow-up, with Universal and Hammer being the most prominent examples. After scoring an international box-office sensation with *Bram Stoker's Dracula* (1992), Francis Ford Coppola unsurprisingly lent his imprimatur to *Mary Shelley's Frankenstein* (1994), this time handing over the directorial assignment to Kenneth Branagh, who would also star as Victor Frankenstein. As the monster, Robert De Niro was the biggest star to ever take on the role, but the two headliners often display a basic clash of styles, and the film is an uneasy mix of Romantic-era Sturm und Drang (Branagh) and an inconsistent naturalism (De Niro's modern acting style). The big set pieces make it worth your while: the creation scene turns the birth metaphor into something wildly literal as both stars are nearly swept away by a tsunami of amniotic fluid. The doomed Elizabeth (Helena Bonham Carter) dies on her wedding night, as usual, but here is reborn as the monster's mate in a plot twist long rumored to have been contemplated by James Whale for *Bride of Frankenstein* but never used.

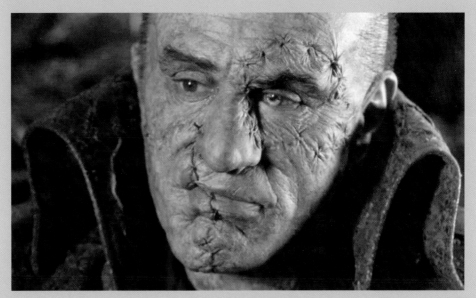

Robert De Niro in *Mary Shelley's Frankenstein*

HORROR
OF
DRACULA

A STREAMLINED APPROACH TO A CLASSIC TALE
TRANSFORMED VAMPIRE MOVIES FOREVER.

Hammer Films, 1958
Color, 82 minutes

DIRECTOR
TERENCE FISHER

PRODUCERS
MICHAEL CARRERAS, ANTHONY HINDS,
AND ANTHONY NELSON KEYS

SCREENPLAY
JIMMY SANGSTER, FROM THE NOVEL *DRACULA*,
BY BRAM STOKER

STARRING
DOCTOR VAN HELSING PETER CUSHING
COUNT DRACULA CHRISTOPHER LEE
ARTHUR HOLMWOOD MICHAEL GOUGH
MINA HOLMWOOD MELISSA STRIBLING
LUCY HOLMWOOD CAROL MARSH
GERDA . OLGA DICKIE
JONATHAN HARKER JOHN VAN EYSSEN
VAMPIRE WOMAN VALERIE GAUNT
TANIA . JANINA FAYE

orror of Dracula (known simply as *Dracula* in the UK) is both a landmark adaptation of Bram Stoker's novel and the film that locked in place the Hammer Films formula for fright—a style that changed the course of scary cinema. *The Curse of Frankenstein* had been a huge international success, and Hammer rapidly reassembled a winning team: director Terence Fisher, screenwriter Jimmy Sangster, and actors Peter Cushing and Christopher Lee.

Upon reading Sangster's script, the British Board of Film Censors made no attempt to hide its contempt. "The uncouth, uneducated, disgusting and vulgar style of Mr. Jimmy Sangster cannot quite obscure the remnants of a good horror story," the board wrote to producer Anthony Hinds, "although they do give one the gravest misgivings about treatment. . . . The curse of the thing is Technicolor blood." Why, the censors wondered, "should vampires be messier feeders than anyone else?"

Sangster actually takes a shrewd scalpel to the original story, collapsing the geographical sweep of Stoker's novel, which takes place in multiple locations and countries (as well as at sea), and setting the story economically in an unnamed European principality in 1885. Dr. Seward's asylum is completely removed, Seward's role is reduced to a walk-on (the part was larger in the script), and the usually iconic character of Seward's patient Renfield is excised.

As in many adaptations of *Dracula*, the characters and their relationships are arbitrarily

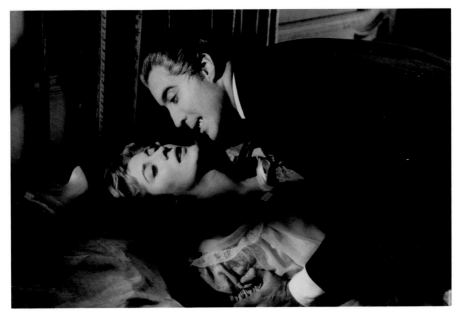

Dracula's bedroom scene with Mina (Melissa Stribling) was originally vetoed by British censors.

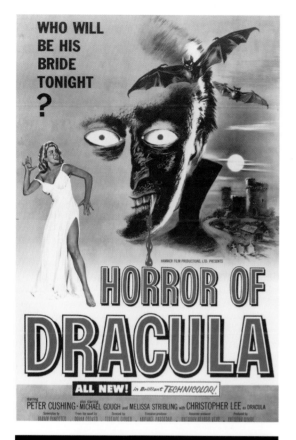

WHO WILL BE HIS BRIDE TONIGHT?

HAMMER FILM PRODUCTIONS, LTD. PRESENTS

HORROR OF DRACULA

ALL NEW! in Brilliant TECHNICOLOR!

starring PETER CUSHING · also starring MICHAEL GOUGH and MELISSA STRIBLING with CHRISTOPHER LEE as DRACULA

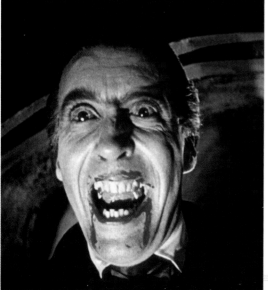

shuffled and reconfigured. Stoker's Mina is Lucy's friend in the novel, but in the film they are sisters-in-law. And here Lucy is engaged to Jonathan Harker, Mina's fiancé and later husband in the book. Unlike in the novel, Harker is not a solicitor who travels to Dracula's castle to sell him real estate, but rather a vampire hunter who penetrates the count's home in the guise of a librarian hired to organize and catalog Dracula's books.

The count (Christopher Lee) is, to all outward appearances, an urbane and attractive aristocrat as well as a gracious host. A young woman (Valerie Gaunt) in Grecian-style attire furtively approaches Harker (John Van Eyssen) in the library, pleading for help to escape Dracula. Harker agrees to protect her, and she throws her arms around him, seemingly in gratitude, but really to bite his neck with fang-like incisors. As Harker pulls away in shock, Dracula suddenly enters the room in one of the most startling and famous close-ups in horror movie history. His eyes are wide and bloodshot, his open mouth and bared fangs smeared and dripping with gore. He leaps over the library's table, grabs the woman by the arm and throws her to the floor. They snarl like wild animals in a territorial standoff. Harker tries to pull them apart and is nearly strangled by Dracula, who finally renders the vampire woman unconscious and carries her off. Harker knows that her bite has condemned him to undeath,

LEFT Dracula's first full-color, full-fanged close-up was a game-changer for horror movies.
RIGHT Count Dracula (Christopher Lee) carries off his vampire bride (Valerie Gaunt).

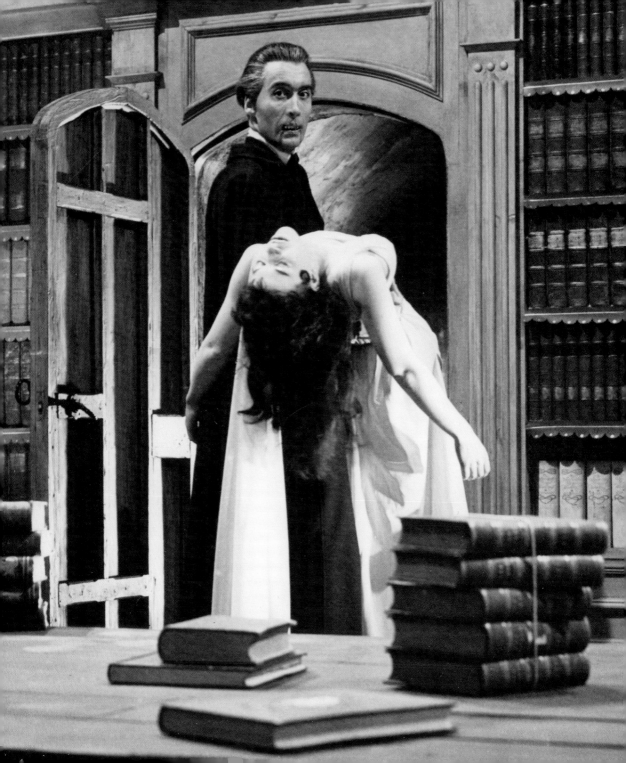

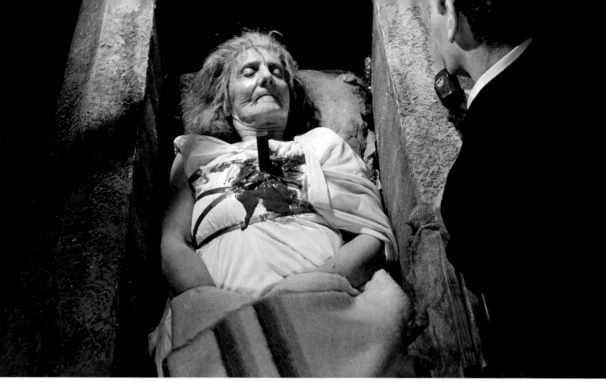

ABOVE After the stake, Dracula's bride shows her true age.
BELOW Dracula's long-censored disintegration scene has now been completely restored.

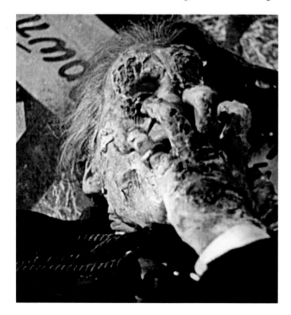

but he sets himself to the grim task for which he has come.

In a subterranean crypt, Harker finds two open sarcophagi that are the vampires' daylight resting places. He first pounds a stake through the heart of the woman, whose face and form revert to those of a withered crone. The sun sets and Dracula awakes, already out of his sarcophagus before Harker can reach him. The vampire, Harker realizes, has won. The silhouette of Dracula blocks the crypt's entrance before the heavy door clangs shut and everything is darkness.

The remainder of the film very roughly follows Stoker's plotline. Another vampire hunter,

Doctor Van Helsing (Peter Cushing), looks for Harker at Castle Dracula and finds him converted into a vampire. Van Helsing releases Harker's soul with the hammer and stake, and discovers among Harker's belongings that Dracula has taken Harker's keepsake photograph of his fiancée, Lucy (Carol Marsh). Dracula is already visiting Lucy, transforming her into a foul creature of the night like himself. Dracula turns his malign attention to Arthur's wife, Mina, and abducts her back to his castle to replace the bride that Harker killed. Van Helsing confronts Dracula in the castle library and rips down a set of heavy curtains, allowing morning light to flood the room and reduce the vampire to dust.

British cultural critic Christopher Frayling has made a compelling argument that *Horror of Dracula* may function as an unintentional allegory about the pleasures and pitfalls of adultery—for both men and women—in postwar Britain. The "horror" of Dracula is that of a demon lover who can violate marriage beds with impunity. Like infidelity, Dracula is dangerous but disturbingly attractive. Christopher Lee was the first screen Dracula with convincing sexual magnetism, though his steely erotic purposefulness also makes him a troubling and problematic personification of sexual assault. Lee, of course, became the leading screen interpreter of Dracula in the post-Lugosi period, returning to the role in Hammer's *Dracula, Prince of Darkness* (1966), *Dracula Has Risen from the Grave* (1968), *Taste the Blood of Dracula* (1970), *Scars of Dracula* (1970), *Dracula A.D. 1972* (1972), and *The Satanic Rites of Dracula* (1973).

If you enjoyed *Horror of Dracula* (1958), you might also like:

THE DEVIL RIDES OUT

HAMMER FILMS, 1968

A rare Hammer production that failed to recover its expenses, *The Devil Rides Out*—also known as *The Devil's Bride*—had sufficient admirers to eventually elevate it to cult status, a perfect perch from which to appreciate a vintage tale of a satanic coven. Hammer had sat on the property for five years, worried that the censors would go on the offensive over a story of satanism and black magic, but the dawning of the Age of Aquarius in the late 1960s loosened many taboos. Adapted by Richard Matheson from a novel by Dennis Wheatley and set attractively in the 1920s, the film stars Christopher Lee as a world-famous authority on the occult who does battle with Mocata, a satanic high priest. Mocata is played by Charles Gray, best known to fright fans as the campy narrator of *The Rocky Horror Picture Show*, but here he is genuinely frightening. Had Gray pursued more roles of this type, he might easily have been a major horror star—a new Vincent Price or Lionel Atwill.

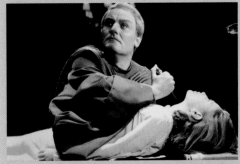

Mocata (Charles Gray) prepares a sacrifice to Satan in *The Devil Rides Out.*

HOUSE ON HAUNTED HILL

WANT TO SUCCESSFULLY HAUNT A HOUSE?
FIRST, YOU'VE GOT TO HAVE A GIMMICK. . . .

Allied Artists, 1959
Black and white, 75 minutes

DIRECTOR
WILLIAM CASTLE

PRODUCERS
WILLIAM CASTLE AND ROBB WHITE

SCREENPLAY
ROBB WHITE

STARRING

FREDERICK LOREN	VINCENT PRICE
ANNABELLE LOREN	CAROL OHMART
LANCE SCHROEDER	RICHARD LONG
DR. DAVID TRENT	ALAN MARSHAL
NORA MANNING	CAROLYN CRAIG
WATSON PRITCHARD	ELISHA COOK JR.
RUTH BRIDGERS	JULIE MITCHUM
MRS. SLYDES	LEONA ANDERSON
JONAS	HOWARD HOFFMAN

ouse on Haunted Hill may be one of the most preposterous movies ever made—and one of the most enjoyable. It was produced by William Castle, who, as a youngster in New York named Bill Schloss, went to see Bela Lugosi in the original Broadway production of *Dracula* and was deeply impressed by the gimmicky ballyhoo employed by the Fulton Theater. An ambulance was parked in front of the theater, with an ominous sign posted on it: "A NURSE WILL BE IN ATTENDANCE AT ALL PERFORMANCES." Indeed, a "registered nurse" patrolled the aisles with smelling salts, which were usually administered to at least one audience member, who seemed to always scream on cue at the second-act curtain, when Dracula sinks his fangs into the heroine's throat.

The burgeoning showman never forgot the stunt, and he concocted something similar for his first film, a grim little thriller called *Macabre* (1958): he convinced Lloyd's of London to insure everyone in the world who saw the film against death by fright. For his next picture, in addition to another brash gimmick, he prioritized the casting of a major horror star. Following *House of Wax* (1953), *The Mad Magician* (1954), and *The Fly* (1958), there was no one in Hollywood who embodied the category like Vincent Price. Castle couldn't afford Price's salary demand for *House on Haunted Hill*, but he wanted the actor so badly that he offered him a percentage of the profits. Price later called it one of his shrewdest negotiations and pointed to a priceless impressionist painting in his art collection to show just how lucrative the world of low-budget horror movies could be.

House on Haunted Hill is certainly no work of art, but it is a demented masterwork of its

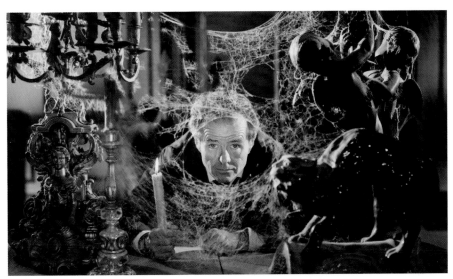

The brooding owner, Watson Pritchard (Elisha Cook Jr.)

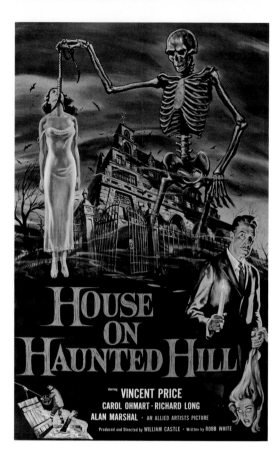

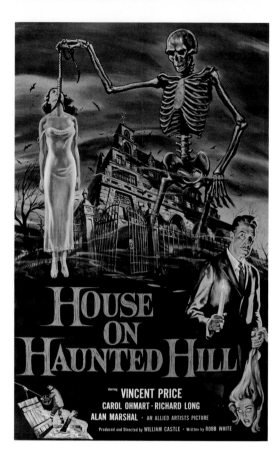

Lance Schroeder (Richard Long), a test pilot; Ruth Bridgers (Julie Mitchum, sister of Robert), a newspaper columnist; Dr. David Trent (Alan Marshal), a psychiatric specialist in the treatment of hysteria; Nora Manning (Carolyn Craig), a low-level employee at one of Loren's companies; and Watson Pritchard (Elisha Cook Jr.), the property's owner, who seems equally possessed by alcohol as by the malignant spirits of the house itself.

The guests are given a challenge: they will be locked in the house with no means of exit, but those who survive the night will receive a payment of $10,000 each. As party favors, they are given loaded pistols. The rest of the film consists of one creepy set piece after another. For no good reason, a chandelier crashes to the floor, narrowly missing Nora. There's a vat of acid in the cellar, left over from one of the murders. During a pair of Lady Macbeth–like interludes, Ruth experiences blood dripping onto her hands from the ceiling. In a scene that remains startling even after repeated viewings, Nora encounters an unearthly, grimacing old woman who seems to float through the cellar. Not long after, she discovers a severed head in her overnight case. She screams, very loudly. After Annabelle is discovered hanging from a noose in a stairwell, Nora sees her apparition hovering outside her window as the end of the hanging rope snakes into the room and coils around her feet. Everyone suspects everybody, especially their host, and they all finally decide to stay in their rooms until

kind: a movie so ridiculous, so full of nonsensical plot twists, and demanding so much suspension of disbelief from the viewer that it transcends its own deficiencies, rising to the sublime plane of unadulterated camp. Frederick Loren (Price) is a millionaire who, to please his detested wife, Annabelle (Carol Ohmart), invites five strangers (who he has determined are all desperate for money) to an overnight party at a house where several murders have been committed and that is believed to be haunted. The guests comprise

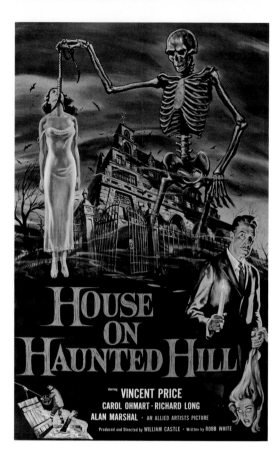

ABOVE Original one-sheet poster RIGHT Vincent Price as Frederick Loren, your host on Haunted Hill

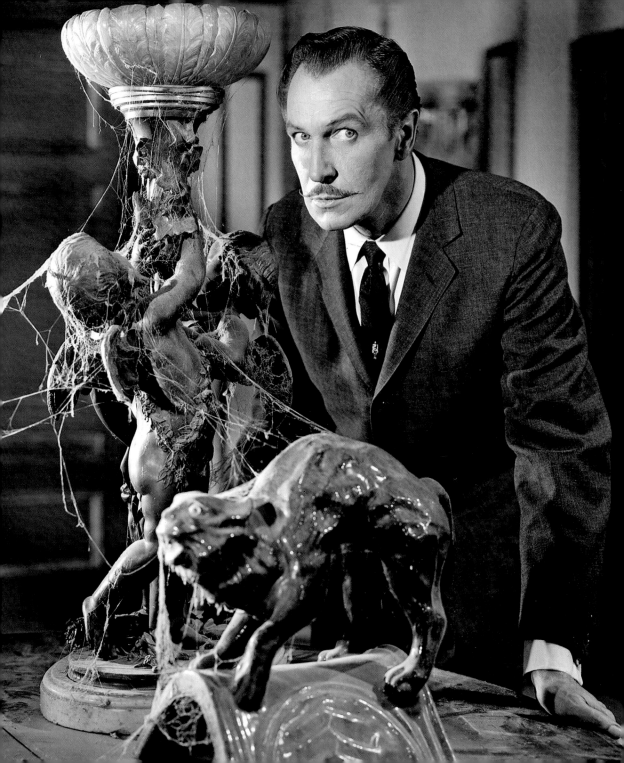

morning. No one, of course, adheres to the resolution. It would be too logical to do so.

It will be no spoiler to reveal that there's nothing truly supernatural going on—*House on Haunted Hill* follows the venerable formula of "old dark house" mystery stories in which spooky goings-on are inevitably revealed to be costumed criminal conspiracies. But the reveal here asks you to ignore a number of elephant-sized issues. To produce all the effects we have seen, this hundred-year-old house would have needed an infrastructure and behind-the-scenes personnel on the scale of a major theme park.

The gimmick in *House on Haunted Hill* was a new film process called Emergo, in which, the trailers and ads breathlessly promised, a ghost would actually *emerge* from the screen and soar over the audience. It all transpires in the final reel, for less than a half minute. After Price appears with the puppeteer controls by which he has just manipulated a weaponized skeleton, a life-sized duplicate of the same would suddenly drop from the side of the screen and jiggle its way over the audience. Later that year, for *The Tingler*, Price and Castle teamed up with an even more ambitious gimmick, Percepto, which involved individual theater seats being equipped with electrical buzzers meant to be the noise of a centipede-like creature that feeds on fear, set loose in the darkened theater and very, very hungry.

TOP Annabelle Loren (Carol Ohmart) wonders if the scares may have gone too far. **MIDDLE** Nora has a close encounter with a silent, gliding specter. **BOTTOM** The caretakers: Jonas Slydes and Mrs. Slydes (Howard Hoffman and Leona Anderson)

Carol Ohmart as Annabelle Loren

If you enjoyed *House on Haunted Hill* (1959), you might also like:

THE OLD DARK HOUSE

UNIVERSAL PICTURES, 1932

Five travelers caught in a storm seek shelter for the night at a spooky mansion in Wales, a horror movie cliché that's been lampooned to death. There's no deception or conspiracy going on; the Femm family is just as crazy as it seems. Horace Femm (Ernest Thesiger, one of director James Whale's theatrical friends and mentors, in a role that anticipates his pièce de résistance performance as Dr. Pretorius in *Bride of Frankenstein*) is a prissy eccentric. His formidably malevolent sister Rebecca (Eva Moore) warns their guests that their hulking, disfigured butler, Morgan (Boris Karloff), can be quite dangerous when drunk. He more than lives up to the warning.

Whale recruited Gloria Stuart (Old Rose in *Titanic*) from the Pasadena Playhouse for one of her early Hollywood films. Charles Laughton (along with his wife, Elsa Lanchester), another of Whale's friends from the British theater, also appeared in the film. Whale would soon engage his West End acquaintance Claude Rains for the title role in Universal's *The Invisible Man* (1933), another film flavored and informed by the director's darkly humorous sensibility.

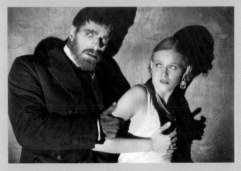

Boris Karloff and Gloria Stuart in *The Old Dark House*

BLACK SUNDAY

FROM THE DARK SIDE OF ITALY, A PARADIGM SHIFT IN SHOCK.

American International, 1960
Black and white, 87 minutes

DIRECTOR
MARIO BAVA

PRODUCERS
MASSIMO DE RITA, LOU RUSOFF

SCREENPLAY
ENNIO DE CONCINI, MARIO SERANDREI, MARIO BAVA
(UNCREDITED), GEORGE HIGGINS (ENGLISH DIALOGUE),
BASED ON THE STORY "THE VIY," BY NIKOLAI GOGOL

STARRING
PRINCESS ASA VAJDA/KATIA VAJDA BARBARA STEELE
DR. ANDREJ GOROBEC JOHN RICHARDSON
DR. CHOMA KRUVAJAN ANDREA CHECCHI
PRINCE VAJDA IVO GARRANI
IGOR JAVUTICH/JAVUTO ARTURO DOMINICI
PRINCE CONSTANTINE VAJDA ENRICO OLIVIERI

orror filmmakers are always pushing the boundaries of taste and propriety, but occasionally a film appears that so openly and successfully blows past established standards that a new paradigm of creative possibilities is instantly established. Mario Bava's *Black Sunday*—also known as *Mask of the Demon*—is without question one of those films. By fusing the black-and-white elegance of the Hollywood horror classics with the explicit gore and necrophilia-laced sexuality of the Hammer films, it offered an unusually intense entertainment experience, the likes of which audiences had never seen on-screen and could never hope to see on television—at least not the television of the 1960s.

Black Sunday was Bava's first official directorial credit, although as an established and well-regarded cinematographer he had ghost-directed another landmark Italian vampire film, *I Vampiri* (1957), when the nominal director walked off the set. The film's dramatic prologue takes place in seventeenth-century Moldavia, where a witch, Asa Vajda (Barbara Steele), and her lover, Javutich (Arturo Dominici), are sentenced to death by Asa's brother for the crime of sorcery. Asa places a curse on her family's descendants before a metal mask lined with spikes is hammered onto the face of her paramour, then onto hers. The curse brings on a torrential downpour, which effectively prevents her from being burned at the stake. She is entombed in a crypt

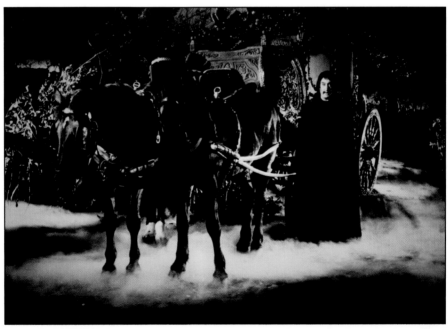

Asa's undead lover Javuto (Arturo Dominici) offers reliable transportation to the dark side.

instead, the awful devil's mask visible through a glass window that additionally gives the witch a never-ending view of a protective stone crucifix atop the sarcophagus.

Two hundred years pass. A pair of doctors, Choma Kruvajan (Andrea Checchi) and Andrej Gorobec (John Richardson), are traveling through the region when their carriage breaks a wheel. While it is being repaired, they discover the ancient crypt containing the tomb of Asa, the death mask still visible through the pane of glass. A bat swoops down at Kruvajan, causing him to break the glass as well as the stone cross. Removing the death mask, he cuts his hand on

the glass, and blood drips onto the brittle shell of the witch's ruined face.

Outside, the physicians encounter Katia Vajda (again, Barbara Steele), one of Asa's cursed lineage. Gorobec finds her grave beauty immediately attractive. As the men escort Katia from the crypt to a nearby inn, Asa is brought partially back to life in her tomb by the power of Kruvajan's blood. She reaches out telepathically to Javutich in his unmarked grave and reanimates him. The walking corpse then makes its way to the castle of Prince Vajda, Katia's father, who repels Javutich with a crucifix. The creature switches its attention to Kruvajan, leading him back to

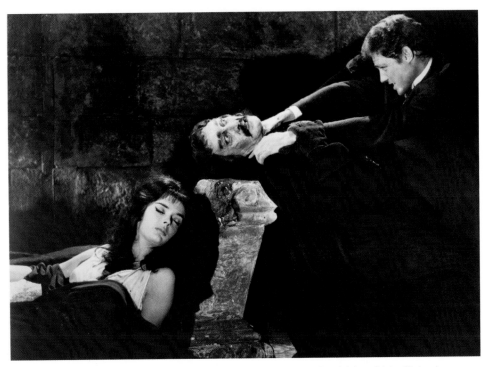

LEFT Original Italian poster **ABOVE** Barbara Steele, Arturo Dominici, and John Richardson

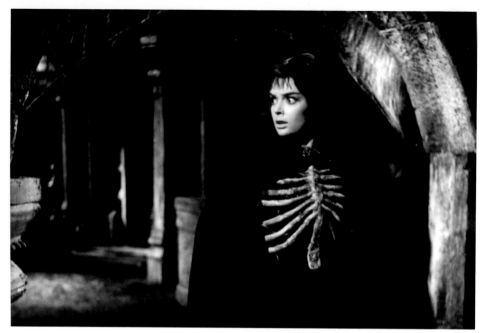

Beneath her cloak, Asa's rejuvenation is far from complete.

Asa's tomb, which explodes, fully exposing the vampire sorceress, who takes more of his blood, making him her slave. Her main goal is to steal the life energy of her look-alike, Katia, and thereby achieve true immortality.

Many viewers are confused about whether *Black Sunday* is a film about vampires or a film about witchcraft. In fact, it is both, since the oral folklore tradition of eastern Europe did not always make sharp distinctions between malevolent supernatural beings. Literature and cinema are largely responsible for the segregation of such creatures into discrete categories.

British censors refused to give the film an exhibitor's certificate, and it remained banned until 1968. In the United States, American International Pictures trimmed a few scenes of the most explicit kind (blood spurting from the hammered mask, fluid squirting from a pierced vampire eyeball, etc.) and completely replaced the soundtrack with American dubbing and a new score by Les Baxter (superseding Roberto Nicolosi's original composition). The studio also finally changed the title from *Mask of the Demon* to *Black Sunday*. The new title added a note of religious transgression, and the film's mystique of being forbidden (and therefore exciting) was a publicity bonus all its own. Curious enough, the Catholic Legion of Decency did not give *Black Sunday* its notorious "Condemned" rating, or any rating at all. Since the film was part of an AIP low-budget double bill that also included Roger Corman's *Little Shop of Horrors*, and wasn't given mainstream promotion, it is entirely possible

that the legion simply ignored it, considering it beneath contempt—or not worth the trouble of condemning.

Black Sunday established Barbara Steele as an instantly recognizable icon of horror cinema; her extensive screen work includes *The Pit and the Pendulum* (1961), *The Horrible Dr. Hichcock* (1962), *Shivers* (1975), *Piranha* (1978), and the 1991 television revival of *Dark Shadows*.

ABOVE Princess Asa (Barbara Steele) meets her death wearing the spiked Mask of Satan.
BELOW Asa returns from the dead, her face still bearing the scars of her demonic punishment.

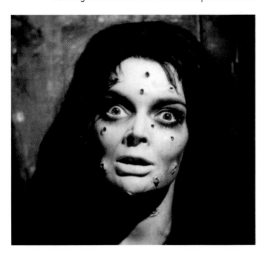

If you enjoyed *Black Sunday* (1960), you might also like:

SUSPIRIA
INTERNATIONAL CLASSICS/ 20TH CENTURY FOX, 1977

Italian horror cinema is a joy unto itself, and following *Black Sunday* there could be no better introduction than Bava's fellow grand master of the genre, Dario Argento, and this lurid mini masterpiece. Films of this type from Italy are sometimes unfairly dismissed as "spaghetti horror," but Argento, like Bava, is an accomplished technician in the arts of fear, suspense, and finely calibrated visual shock.

Suspiria follows a young American ballerina, Suzy Bannion (Jessica Harper), as she travels to an exclusive German dance academy to perfect her skills. Instead she encounters a cult-like atmosphere, grotesque murders, and finally a witchcraft coven presided over by the academy's director, Madame Blanc (Joan Bennett), whose motivations, despite her name, are decidedly noir. The film is aided immeasurably by the relentlessly nerve-rattling music of the progressive Italian rock band Goblin.

Jessica Harper in *Suspiria*

THE PIT AND THE PENDULUM

EDGAR ALLAN POE, SWINGING WITH THE SIXTIES.

American International, 1961
Color, 80 minutes

PRODUCER/DIRECTOR
ROGER CORMAN

SCREENPLAY
RICHARD MATHESON, BASED ON THE STORY BY
EDGAR ALLAN POE

STARRING

NICHOLAS MEDINA/SEBASTIAN MEDINA	VINCENT PRICE
FRANCIS BARNARD	JOHN KERR
ELIZABETH BARNARD MEDINA	BARBARA STEELE
CATHERINE MEDINA	LUANA ANDERS
DOCTOR CHARLES LEON	ANTONY CARBONE
MAXIMILLIAN	PATRICK WESTWOOD

ilm studios have long understood that the name Edgar Allan Poe has considerable marquee potential, but finding a way to adapt Poe's singular sensibility to the screen has always been problematic. Although he could plot a good detective story (and is often credited with having invented the genre), Poe's most famous tales tend to be claustrophobic mood pieces. In 1960, Roger Corman enlisted Richard Matheson to script *House of Usher*, the first in a series of highly successful Poe adaptations starring Vincent Price. Poe's "The Fall of the House of Usher" had a conventional story arc that didn't need much padding to work as a screenplay. "The Pit and the Pendulum," however, centered on a single, nameless character trapped in a harrowing but essentially static situation. Price's daughter and biographer Victoria Price quoted Matheson at first calling the challenge "ridiculous . . . we took a little short story about a guy lying on a table with this huge razor-sharp blade swinging over him, and had to make a whole story out of it." A viable script would need to build an outside world, and its inhabitants as well. Fortunately, Richard Matheson was a writer thoroughly up to the task.

Francis Barnard (John Kerr) is an English gentleman of the sixteenth century visiting Spain to clarify the details of the unexpected and unexplained death of his sister Elizabeth (Barbara Steele), who was briefly married to Don Nicholas Medina (Vincent Price). The

Vincent Price and Barbara Steele

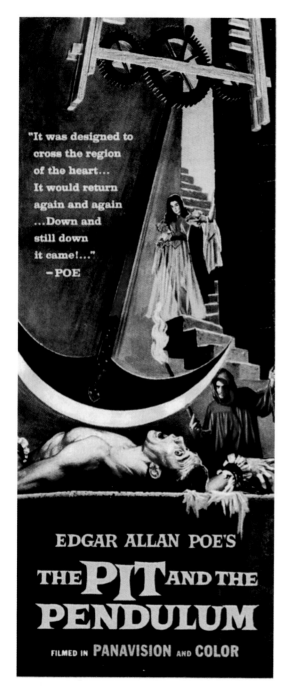

"It was designed to cross the region of the heart... It would return again and again ...Down and still down it came!..."
—POE

EDGAR ALLAN POE'S
THE **PIT** AND THE **PENDULUM**
FILMED IN **PANAVISION** AND **COLOR**

don's father, Sebastian, was a notorious participant in the Spanish Inquisition, and the family's castle retains all the infamous instruments of torture. Nicholas offers evasive and unconvincing reasons for his wife's demise, angering Francis. The Medina family physician, Dr. Leon (Antony Carbone), finally tells Francis that his sister died of fright after becoming morbidly obsessed with the torture chamber, then growing mentally unbalanced, and ultimately falling victim to heart failure.

Francis remains skeptical, and Nicholas's sister, Catherine (Luana Anders), tells him about Nicholas's traumatic childhood, and how he watched his father murder his unfaithful wife, Isabella, by entombing her behind a brick wall while she was still living. Nicholas is fixated on the idea that Elizabeth also may have been interred alive and is now haunting him. He insists that her tomb be opened. The withered, painfully contorted corpse clearly indicates that she was indeed the victim of premature burial and died trying to claw her way out.

The fear of being buried alive was a real, if largely unjustified, anxiety in the early nineteenth century, when Poe was drawn to the theme. Well-to-do families were known to equip their burial sites with elaborate emergency systems and escape hatches. Since the odds of being interred prematurely were vanishingly small, it seems clear that people who fell victim to the obsession were baroquely bargaining with the idea of death itself. Poe's stories "The Premature

Insert card for *The Pit and the Pendulum*

ABOVE John Kerr and Vincent Price, getting into the swing of things BELOW Vincent Price, John Kerr, and Luana Anders

Burial" and "The Fall of the House of Usher" feature characters who worry about being buried alive or actually suffer the fate, like Roderick Usher's unfortunate sister Madeline. An obsession with dying and dead women informs Poe's imagination generally, as it does Matheson's script for *The Pit and the Pendulum*.

Matheson reveals Elizabeth not to be dead at all, but plotting with her lover, Dr. Leon, to drive Nicholas mad and gain control of his estate. They succeed in pushing him over the edge, but controlling any aspect of him is another matter entirely. In his mind he becomes his own sadistic father, eager to resurrect the ne plus ultra of diabolical torture: slow death beneath a huge, swinging pendulum blade, lowered degree by degree via merciless clockwork.

Like *House of Usher*, *The Pit and the Pendulum* benefits from sumptuous art direction, making use of antique-filled rooms decorated with paintings and murals rendered in the distinctly midcentury-modern style of the 1960s—an unconventionally theatrical conceit that adds considerably to the dreamlike atmosphere. The neo-impressionistic, hooded Inquisition figures painted on the torture chamber's walls effectively blur distinctions between the familiar present and an unfamiliar and very dangerous past.

Victoria Price recalled Roger Corman as "an expert at creating masterful films on limited budgets and very short shooting schedules," but "somewhat less adept at directing his actors, and Vincent's performance in *The Pit and the Pendulum* was regarded as being somewhat more over the top than his restrained turn in *House*

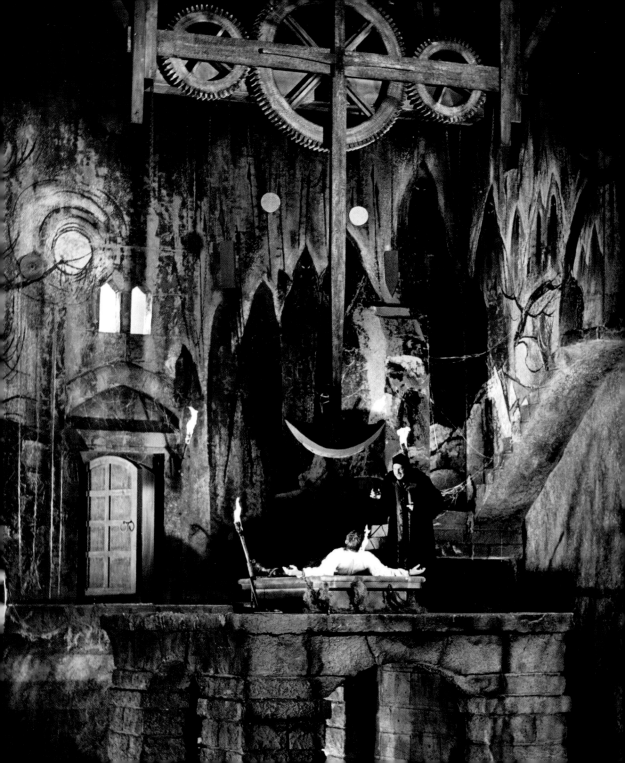

of *Usher.*" *The Hollywood Reporter* called Price's acting "characteristically rococo" in the film, and it was true that his screen persona was steadily drifting toward the unabashed hamminess his fans adored and that eventually became his career trademark.

Corman's rewarding screen romance with Edgar Allan Poe continued with *The Premature Burial* (1962), *Tales of Terror* (1962), *The Raven* (1963), *The Masque of the Red Death* (1964), and *Tomb of Ligeia* (1964). Vincent Price starred in all the films except *The Premature Burial*, which was headlined by Ray Milland.

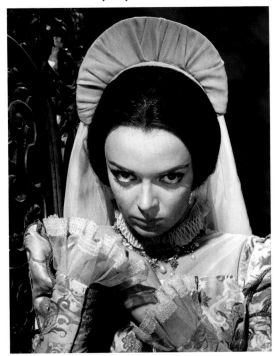

ABOVE Barbara Steele as Elizabeth Medina
LEFT Daniel Haller's impressively expressionistic torture-chamber set

If you enjoyed *The Pit and the Pendulum* (1961), you might also like:

MURDERS IN THE RUE MORGUE
UNIVERSAL PICTURES, 1932

Murders in the Rue Morgue is based on one of Edgar Allan Poe's stories that had a more or less conventional, police-procedural framework and therefore didn't require a story and characters made up of whole cloth, like so many films based on Poe. Nonetheless, many Hollywood liberties were taken, but in this case they are more enjoyable than distracting. Director Robert Florey was assigned to the film after losing *Frankenstein* to James Whale, and it clearly reflects his ambitious expressionist intentions for that film. *Murders in the Rue Morgue* may, in fact, be one of Hollywood's purest homages to German expressionism, visually and thematically. The script veers considerably away from Poe with its lurid story of Dr. Mirakle (Bela Lugosi), a sideshow mountebank who exhibits a "human" ape named Erik but behind the scenes is carrying out a murderous scheme to mix Erik's blood with that of a woman.

Bela Lugosi and Arlene Francis in
Murders in the Rue Morgue

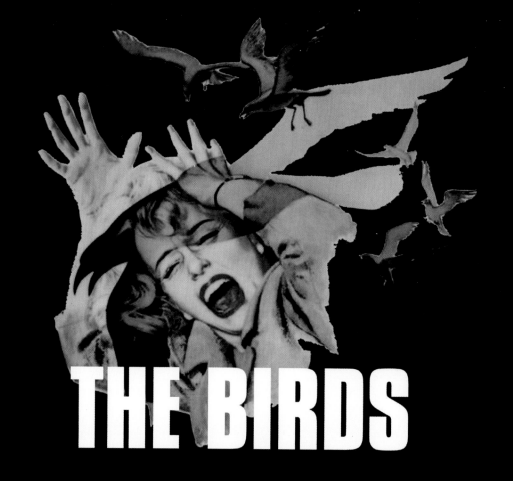

THE BIRDS

STARTING WITH A PAIR OF LOVEBIRDS . . .
AND ENDING WITH AN AVIAN APOCALYPSE.

Universal, 1963
Color, 119 minutes

PRODUCER/DIRECTOR
ALFRED HITCHCOCK

SCREENPLAY
EVAN HUNTER, FROM THE STORY BY DAPHNE DU MAURIER

STARRING

MITCH BRENNER	ROD TAYLOR
LYDIA BRENNER	JESSICA TANDY
ANNIE HAYWORTH	SUZANNE PLESHETTE
MELANIE DANIELS	TIPPI HEDREN
CATHY BRENNER	VERONICA CARTWRIGHT
MRS. BUNDY	ETHEL GRIFFIES

elanie Daniels (Tippi Hedren), a spoiled and impetuous San Francisco socialite, poses as a pet-shop employee to gain the attention of Mitch Brenner (Rod Taylor), a handsome criminal defense attorney who has come to the shop, ostensibly to purchase a pair of lovebirds for his preteen sister's birthday. In reality, Mitch knows exactly who Melanie is and turns the tables on her prank, angering her, but she refuses to let him have the last word. She buys the lovebirds herself and personally delivers them to his family's house north of the city in the seaside town of Bodega Bay. She sneaks the birds onto the waterfront property by way of an outboard motorboat, and as she returns to the wharf across the bay, she is attacked by a seagull and sustains a small cut to her forehead. Mitch, who spotted her leaving the house, applies first aid to her injury and formally invites her back to the house. Melanie meets his formidable yet clinging mother, Lydia (Jessica Tandy), and his kid sister, Cathy (Veronica Cartwright). She makes the acquaintance of Mitch's ex-girlfriend, schoolteacher Annie Hayworth (Suzanne Pleshette), who has clearly not relinquished her flame. Nonetheless, she welcomes Melanie as a houseguest, only to have their evening interrupted by another strangely behaving gull that crashes into Annie's front door, killing itself.

The bird attacks escalate, and Hitchcock

The death of Annie Hayworth (Suzanne Pleshette)

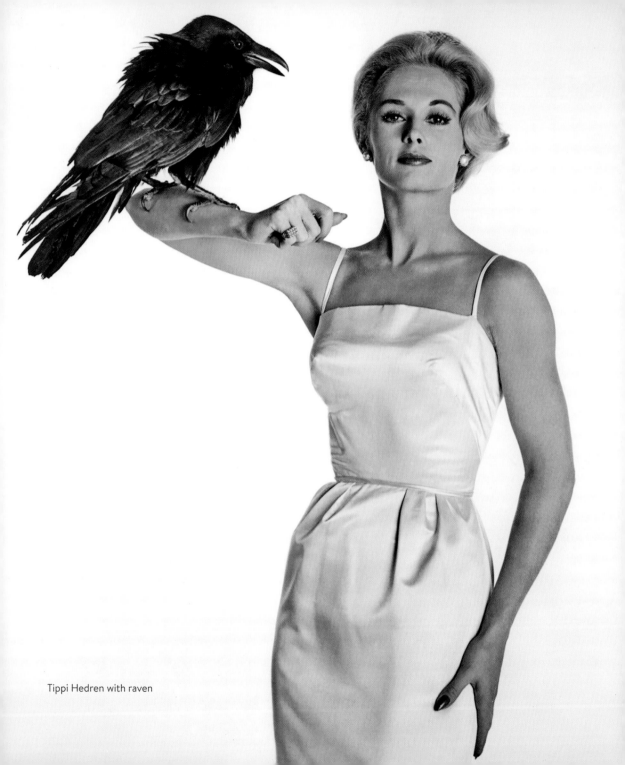

Tippi Hedren with raven

builds one quietly unforgettable set piece after another. One is Lydia's discovery of a hideous fatality, played out in complete silence until she finishes her traumatic drive home. In the next, Lydia begs Melanie to check that Cathy is safe at school. As Melanie sits on a bench outside the schoolhouse, calmly smoking a cigarette and waiting for school to let out, a huge number of crows assemble on the playground equipment behind her. The growing menace is paradoxically underscored not by menacing music—the film has no formal score—but by the children's singing a rollicking nursery ditty. At a restaurant near the harbor, Melanie's stories are met with incredulity by an elderly ornithologist, who assures her that birds aren't intelligent enough to stage a mass attack. She is soon proved wrong.

Melanie and the Brenners barricade themselves in the family house and endure wave after wave of attacks. During a lull in the assaults, Melanie ventures upstairs alone, where sounds seem to be emanating from the attic. She enters the room and sees that the house's roof has been partly pulled away. Immediately, in the film's most hair-raising attack, the birds swoop down, a coup de theatre equivalent of the shower scene in *Psycho*. It's a remarkably sadistic sequence, and also masochistic: as the birds peck Melanie into unconsciousness, she moans the name "Mitch" repeatedly, almost ecstatically. Hedren believed that Hitchcock used the scene to literally punish her after she rejected his physical advances, the culmination of a long campaign of harassment on and off the set. Hedren's startling ordeal was ultimately revealed in her autobiography as well

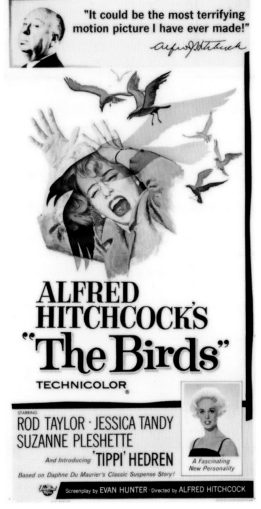

as in the HBO film *The Girl* (2012), starring Sienna Miller as Hedren and Toby Jones as Hitchcock.

When *The Birds* was first released, audiences were puzzled over its inconclusive ending, but mostly by the lack of any explanation of why the birds turned on the human race in the first place. Everything about the film's publicity suggested a revenge-of-nature story along the lines of the

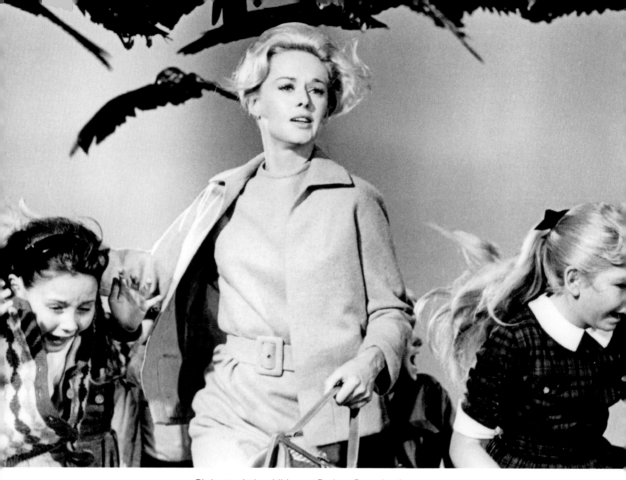

Birds attack the children at Bodega Bay school.

1950s big bug invasions, but *The Birds* did not fit easily into any category or critical container. Attempts to read the story as an allegory of environmentalism fall flat; the idea that the birds reflect and channel the emotions of the central characters, especially repressed and unconscious feelings, makes a good deal more sense. In any event, the world's master manipulator of movie audiences wasn't trying to sell a subtext; rather, Hitchcock may have accomplished the greatest feat of his career by holding an audience riveted and breathless, through the sheer imposition of cinematic will and technique, with a story that can never be rationally explained. Someone asked him during the filming of *The Birds* why on earth Tippi Hedren goes up to the attic alone. "Because that's where I *want* her to go," he replied. It's an answer that explains a lot.

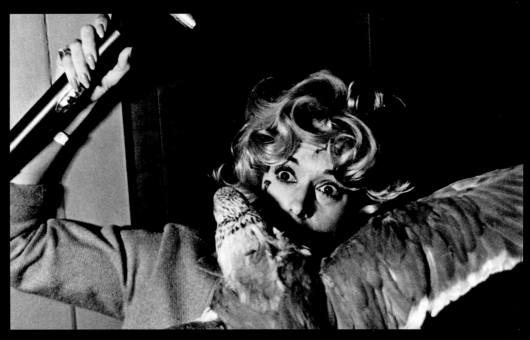

ABOVE Melanie's fateful trip to the attic **BELOW** Jessica Tandy, Tippi Hedren, and Rod Taylor

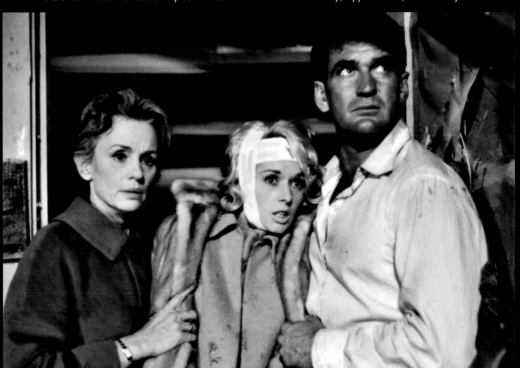

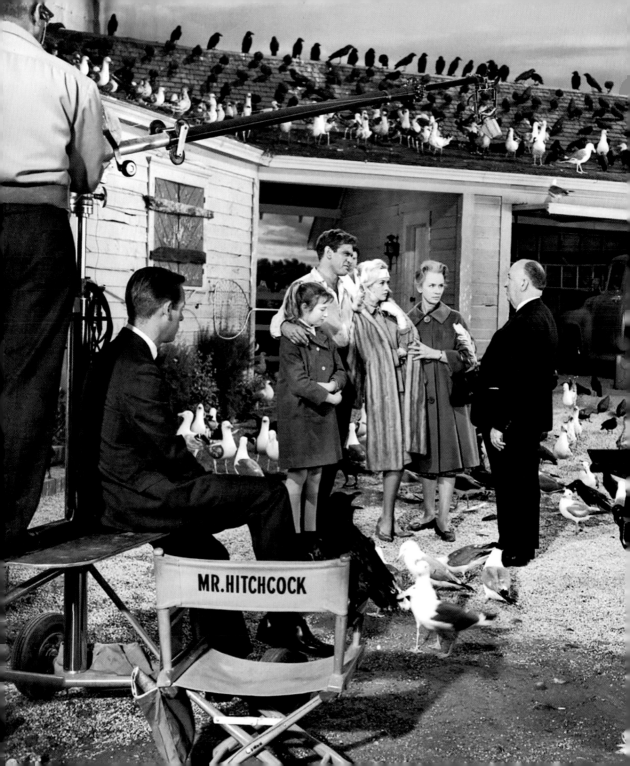

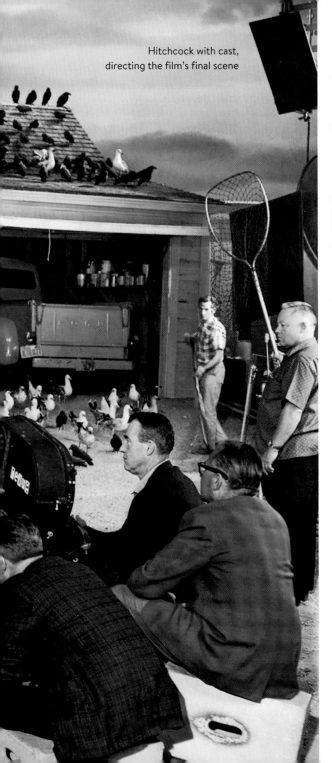

Hitchcock with cast, directing the film's final scene

If you enjoyed *The Birds* (1963), you might also like:

CUJO

WARNER BROS./TAFT ENTERTAINMENT, 1983

If the cause of animal aggression is never explained in *The Birds*, in *Cujo* there is no mystery at all. Cujo is a beloved family pet, an affable Saint Bernard and close companion to young Brett Camber (Billy Jacoby). One day, Cujo chases a rabbit into a cave and is bitten on his nose by a rabid bat. Rabies doesn't manifest immediately, and no one suspects the horror that is about to overcome the dog. Brett's father is a mechanic who works on autos on his isolated rural property. The Trenton family, Donna and her husband, Vic (Dee Wallace and Daniel Hugh-Kelly), are having repeated car trouble—as well as infidelity issues. Donna visits the Cambers' auto repair shop with her son Tad (Danny Pintauro), only to find that the family isn't there, and Cujo has gone mad. The car fails completely, and mother and son are trapped in their Pinto, in danger of dehydration and heatstroke. Efforts at escape are ultimately successful, though not without unrelenting peril and suspense. The film is every bit as manipulative as *The Birds*, but with no distracting enigmas or ambiguity.

Cujo, a once gentle dog

THE HAUNTING

CAN A HOUSE BE EVIL FROM THE BEGINNING? CAN A HOUSE BE BORN BAD?

Metro-Goldwyn-Mayer, 1963
Black and white, 112 minutes

PRODUCER/DIRECTOR
ROBERT WISE

ASSOCIATE PRODUCER
DENIS JOHNSON

SCREENPLAY
NELSON GIDDING, BASED ON THE NOVEL *THE HAUNTING OF HILL HOUSE*, BY SHIRLEY JACKSON

STARRING
ELEANOR LANCE JULIE HARRIS
THEODORA CLAIRE BLOOM
DR. JOHN MARKWAY RICHARD JOHNSON
LUKE SANDERSON RUSS TAMBLYN
MRS. SANDERSON FAY COMPTON
GRACE MARKWAY LOIS MAXWELL
MRS. DUDLEY ROSALIE CRUTCHLEY
MR. DUDLEY VALENTINE DYALL

r. John Markway, a New England para- normal investigator, leases the forbidding edifice known as Hill House, a purport- edly haunted mansion constructed in Massachusetts in the late nineteenth century, and cursed by tragedy from the beginning. The original owner built it for his wife, but she died in a carriage accident while arriving at the house for her first visit. The owner's second wife was killed falling down the stairs, and his daughter became a lifelong recluse whose caretaker/nurse inherited the property, only to hang herself from a towering spiral staircase in the library. Hill House has now stood empty for many years.

In addition to the owner's son, Luke Sanderson (Russ Tamblyn), present as a con- dition of the lease, and not for any interest in the supernatural, Markway is joined by an experienced psychic, Theodora (Claire Bloom), also called Theo; and by Eleanor Lance (Julie Harris), a meek, quirky, and possibly unstable woman who nonetheless is on record for having experienced credible poltergeist phenomena as a child. Eleanor, we learn, always sleeps on her left

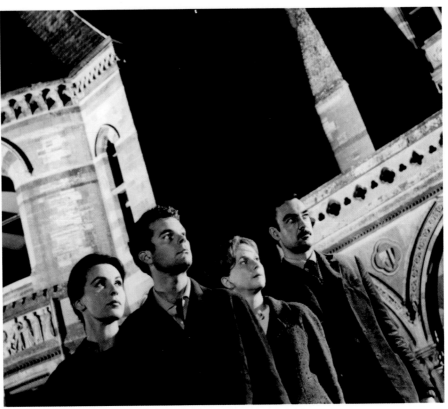

Claire Bloom, Russ Tamblyn, Julie Harris, and Richard Johnson

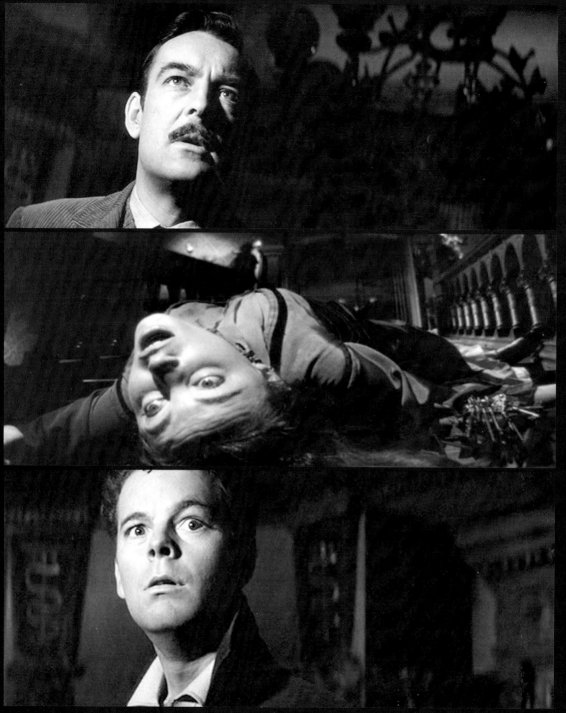

TOP Richard Johnson **MIDDLE** Lois Maxwell **BOTTOM** Russ Tamblyn

side because "I read somewhere that it wears your heart out quicker." She is currently wrestling with guilt over the death of her invalid mother, to whose care her adult life has been largely dedicated. Now she lives as a barely tolerated spinster with her sister and brother-in-law, sleeping on their sofa. They blame her for her mother's death.

On the very first night at Hill House, the women are terrified by sounds outside Theo's room—a thunderous banging and the reverberating laughter of a young girl. The next day, the team locates a mysterious cold spot outside the nursery, and another night of unexplained noises follows. Most disturbing to Eleanor is a menacing graffito scrawled across a wall: "HELP ELEANOR COME HOME." Theo moves into Eleanor's room, where they share the same bed. In the middle of the night, voices are heard again: the muffled, indistinct sound of a man, the laughter of a woman, and the crying of a young girl. Eleanor asks Theo to hold her hand and feels a powerful grip in return. Eleanor shouts at whatever entity is causing the girl such terrible pain to stop. When Theo turns on the light, we see that Eleanor has been sleeping on a couch across the room from Theo. Eleanor stares at her hand in terror. *Whose hand has she been holding?*

When Robert Wise agreed to direct *The Haunting*, he wondered if the story might be told as an expression of Eleanor's deteriorating mental state rather than as a supernatural occurrence. He consulted with novelist Shirley Jackson herself, who told him she intended the events in the book to be entirely supernatural, but she made no objection to Wise's idea. The finished film seems

to be a deft compromise. Could it be that malignant spirits and mental illness coexist, and that some entity is feeding on—and simultaneously fueling—Eleanor's psychological problems?

However you decide to interpret the tale, *The Haunting* is without question one of the finest ghost stories ever filmed. Wise once said he intended the picture to be something of an homage to Val Lewton, for whom he directed *The Curse of the Cat People* (1944) and *The Body Snatcher* (1945). Both films allowed audiences to

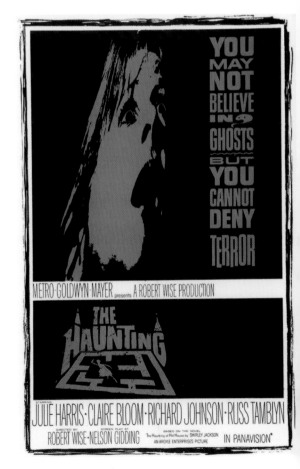

complete in their own imaginations frightening things hidden in shadows. *The Haunting* does Lewton one better with truly extraordinary black-and-white cinematography by Davis Boulton, who uses a camera that moves, prowls, and swoops in ways you might reasonably expect from a ghost.

The female leads give exceptionally nuanced, meticulously detailed performances. Harris's Eleanor, a totally convincing characterization of a child-woman adrift, immediately conjures her famous and poignantly similar role as Frankie in *A Member of the Wedding* (1952). Claire Bloom's Theo actually has, or convincingly fakes, an ability to read minds, and she finds a number of mischievous things to do with the power (yes, exactly what all of us would do). The treatment of the character's lesbianism is surprisingly straightforward for a 1963 movie. Bloom's aggressively chic wardrobe was specially created by Mary Quant, an iconic designer of the 1960s.

Wise is most remembered for big, mainstream films like *The Sound of Music* and *West Side Story*, but *The Haunting* shows him to be as inventive, risk-taking, and forward-looking as a young Orson Welles, for whom he had edited *Citizen Kane* twenty-two years earlier. *The Haunting* contains many visual echoes of *Kane*, especially in the moody Xanadu prologue.

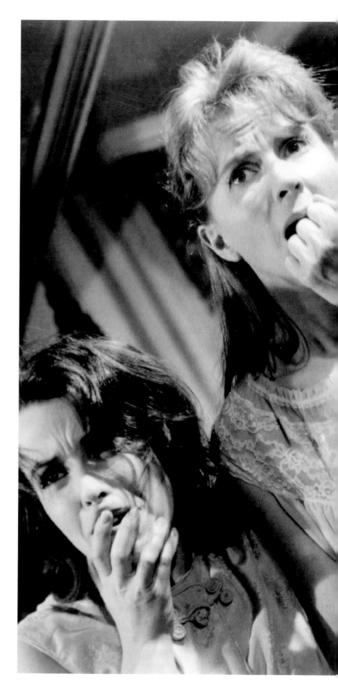

Claire Bloom and Julie Harris

THE UNINVITED

PARAMOUNT PICTURES, 1944

Roderick and Pamela (Ray Milland and Ruth Hussey), a composer and his sister, are delighted to be offered a good price for the old, abandoned Windward House on the southwest coast of England. Despite a cryptic warning from the owner, they go ahead with the purchase. Not surprising to readers of this book, they find that the house is haunted. The film unfolds as both a ghostly tale and a mystery, with complex characterizations and an impressive cast.

The story is told in an understated manner that both recalls the films of Val Lewton and anticipates Robert Wise's successful homage in *The Haunting*. Except for a final manifestation—itself understated—the ghost is not explicitly shown, but it none-theless makes its presence quite palpable. *The Uninvited* very deservedly has achieved the status of a classic, and a very classy one at that.

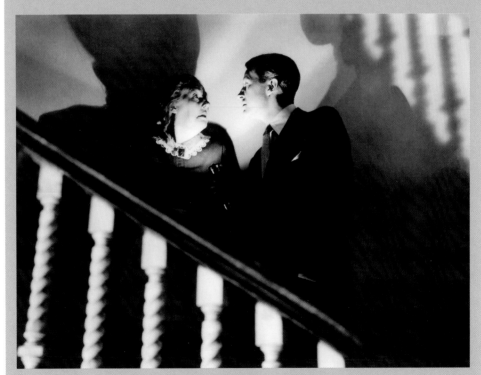

Ray Milland and Dorothy Stickney in *The Uninvited*

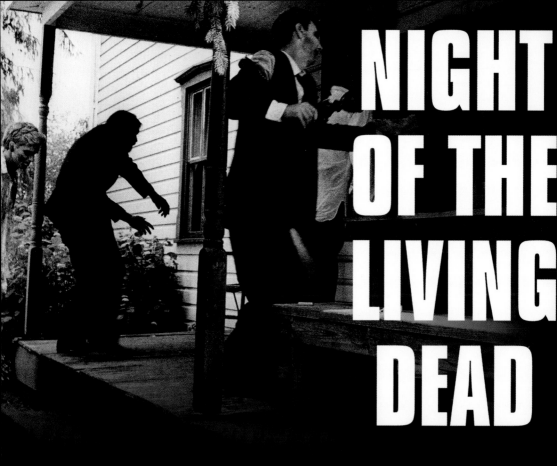

NIGHT OF THE LIVING DEAD

THE HUNGRY DEAD RETURN AND THE MODERN ZOMBIE MOVIE IS BORN.

Image Ten Productions, 1968
Black and white, 96 minutes

DIRECTOR
GEORGE ROMERO

PRODUCERS
KARL HARDMAN, RUSSELL STREINER

SCREENPLAY
JOHN A. RUSSO AND GEORGE ROMERO

STARRING
BEN . DUANE JONES
BARBRA . JUDITH O'DEA
HARRY COOPER KARL HARDMAN
HELEN COOPER MARILYN EASTMAN
TOM . KEITH WAYNE
JUDY . JUDITH RIDLEY
KAREN COOPER KYRA SCHON
JOHNNY . RUSSELL STREINER
CEMETERY GHOUL BILL HEINZMAN

eorge Romero's *Night of the Living Dead* is the most famous and influential zombie movie, even though the word "zombie" isn't uttered even once in the course of the film. One of the most legendary independent films ever made, it was shot on a shoestring around Pittsburgh, using as its primary set a house already scheduled to be torn down. The living dead would get the first crack at real demolition.

One cloudy Pennsylvania afternoon, sister and brother Barbra and Johnny (Judith O'Dea and Russell Streiner) visit their father's grave in a rural cemetery. A strange, lurching man appears, unnerving Barbra but prompting Johnny to mockingly imitate Boris Karloff, intoning "They're coming to get you, Barbra. . . ." The man becomes violent, striking Johnny's head on a grave marker and instantly killing him. The nightmarish figure chases Barbra to her car and tries to break in. Hysterical, Barbra wrecks the car and flees on foot, eventually coming to a farmhouse, where she discovers a woman's rotting corpse at the top of a staircase. Strange, menacing figures, including the cemetery walker, begin to surround the house. A man named Ben (Duane Jones) appears, behaving normally and rationally. He prevents Barbra from fleeing and barricades the doors and windows.

Barbra exhibits all the symptoms of profound mental shock. Ben finds a radio and a rifle, then discovers a family, Harry and Helen Cooper (Karl Hardman and Marilyn Eastman) and their injured daughter, Karen (Kyra Schon), hiding in

Romero's zombies, played by nonactors, were unnervingly normal looking.

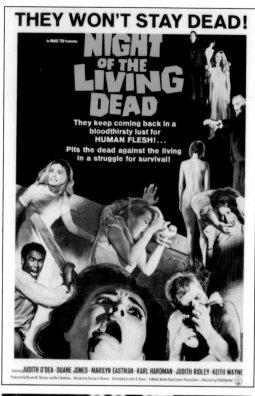

the cellar. A teenage couple, Tom (Keith Wayne) and Judy (Judith Ridley), have also taken refuge after hearing radio reports of mass murder.

As more barricades are erected throughout the house, a broadcast report finally offers an explanation for all the bizarre violence. The recently dead have returned to life and are eating the flesh of the living. There is speculation that radioactive fallout from a returning space probe may be to blame, but nothing is known with certainty. The "ghouls" can be killed by a bullet to the head or by being burned. Karen needs immediate medical care, and a plan is made for Tom and Judy to drive her to an emergency facility announced on the radio. While they attempt to refuel at the farm's gas pump, Ben and Harry keep the walking dead at bay with Molotov cocktails, but a mishap occurs and the vehicle's fuel tank explodes, killing the teens and attracting the animated corpses, who make a grisly feast of the freshly charred meat.

It's no spoiler to say this is a film that ends badly for every character. Since Ben was played by a black actor, his downbeat fate in the last scene drew outraged comment in 1968, a critical year in the civil rights movement. Martin Luther King Jr., after all, had been killed just six months before the film was released, and the mood of the country was still very raw. A daily backdrop of senseless death was provided by the Vietnam War, a never-ending conflict that, for millions of people, was as incomprehensible as

The Pittsburgh world premiere of *Night of the Living Dead*.

a zombie apocalypse. Protests and riots, like the one that occurred at the Democratic National Convention in Chicago that year, gave further credence to the idea that the social structure might be breaking down. The real world may not have been far removed from George Romero's horror fantasy after all. As *Village Voice* film critic J. Hoberman noted, the film "was made in the most violent year in American history since the Civil War. It's shot like cinema vérité, as though it were the evening news. It never wavered from its desire to terrorize the audience and offer no hope at the end."

Romero intended no social commentary at all; he had, for instance, cast Duane Jones for his acting talent and not to send any message about race. But because the sociopolitical climate of 1968 was so unstable, many audiences regarded simply viewing the film as a kind of protest, a transgressive gesture against the stubborn status quo represented by the parents, film critics, and even editorial writers who railed against the

Harry and Helen Cooper (Karl Hardman and Marilyn Eastman) and their injured daughter Karen (Kyra Schon) hole up in the farmhouse basement.

"They're coming to get you, Barbra. . . ." Russell Streiner and Judith O'Dea
have their first experience with the walking dead in a cemetery.

film. *Variety*'s reviewer wrote that "the film casts serious aspersions on the integrity of its makers, distrib[utor] Walter Reade, the film industry as a whole, and exhibitors who book the pic, as well as raising doubts about the future of the regional theatre movement and the moral health of film-goers who cheerfully opt for unrelieved sadism." The movie would have the last laugh, however. Far from establishing a new low in cinema, as was charged, it instead became one of the most imitated films in movie history, partially because it entered the public domain when the Walter Reade Organization failed to properly register its copyright. *Night of the Living Dead* was chosen for the permanent collection of the Museum of Modern Art and added by the Library of Congress to its National Film Registry for motion pictures deemed "culturally, historically or aesthetically significant."

Romero went on to trailblaze the zombie genre with increasingly gruesome and sharply satirical films like *Dawn of the Dead* (1978), which introduced the shopping mall zombie, and the ultra gorefest *Day of the Dead* (1985). He died in 2017, after having an almost incalculable impact on fantastic filmmaking around the world. If imitation is indeed the sincerest form of flattery, then George Romero must be one of the most lionized directors in the history of cinema.

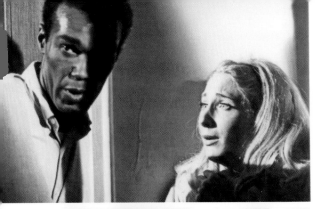

CARNIVAL OF SOULS
HERTS-LION INTERNATIONAL, 1962

In *Carnival of Souls*, which predates *Night of the Living Dead* by six years, a church organist in Kansas (Candace Hilligoss) survives a watery car crash with no memory of what happened. She decides to get a fresh start in Salt Lake City, where her life becomes a series of increasingly unsettling encounters with a pale, corpse-like man who is obviously following her. But why? *Carnival of Souls* is not a puzzle to be solved as much as it is an experience for its own sake. The cinematography is often stunningly inventive, and what's beautiful versus what's terrifying becomes inextricably blurred together. The story has the flavor of an extra-long *Twilight Zone* episode, which is not a bad thing at all. The twist ending is not really a surprise; you will likely anticipate it early on, but the pleasure of the film comes from its steady supply of moody set pieces, haunting organ music, and much better acting than what we too often stumble across in low-budget horror.

Ghostly inhabitants of *Carnival of Souls*

TOP Duane Jones and Judith O'Dea **MIDDLE** The clawing, hungry dead batter every barricade. **BOTTOM** Karen turns carnivorous, killing and eating her father.

ROSEMARY'S BABY

MIDCENTURY MOTHERHOOD: A BLESSING OR A CURSE?

Paramount, 1968
Color, 137 minutes

DIRECTOR
ROMAN POLANSKI

PRODUCER
WILLIAM CASTLE

SCREENPLAY
ROMAN POLANSKI, FROM THE NOVEL BY IRA LEVIN

STARRING

ROSEMARY WOODHOUSE	MIA FARROW
GUY WOODHOUSE	JOHN CASSAVETES
MINNIE CASTEVET	RUTH GORDON
ROMAN CASTEVET	SIDNEY BLACKMER
HUTCH	MAURICE EVANS
DR. SAPIRSTEIN	RALPH BELLAMY
TERRY	VICTORIA VETRI
LAURA-LOUISE	PATSY KELLY
MR. NICKLAS	ELISHA COOK JR.
ELISE DUNSTAN	EMMALINE HENRY
DR. HILL	CHARLES GRODIN

Guy and Rosemary Woodhouse (John Cassavetes and Mia Farrow) are a newly married young couple in New York who manage to snare a rental apartment in the Bramford, a coveted gothic landmark on the Upper West Side. Guy is an actor who has just had an astonishing break in a Broadway play, due to the horrible misfortune of the original actor, who has gone mysteriously blind. Financial success makes it easier for the couple to consider parenthood. Their colorfully eccentric neighbors, Minnie and Roman Castevet (Ruth Gordon and Sidney Blackmer), take the couple under their wing, encouraging Rosemary's fertility with good luck charms, herbal concoctions, and health drinks. On the night they intend to conceive, Rosemary has a vivid nightmare in which she is raped by a demonic entity while the Castevets and a group of menacing strangers look on, all of them naked.

Rosemary becomes pregnant, but her term is difficult. Gradually she begins to suspect a conspiracy about her unborn child involving the Castevets and her husband. Has Guy made some kind of evil pact to advance his acting career? And what plans do the Castevets have for Rosemary and her baby? Is her obstetrician part of the plot?

Released in June of 1968, *Rosemary's Baby* was eagerly anticipated and well received (though not by the Catholic Legion of Decency, which, unsurprisingly, branded it with a "Condemned" rating). Ruth Gordon won both an Academy Award and a Golden Globe Award as Best

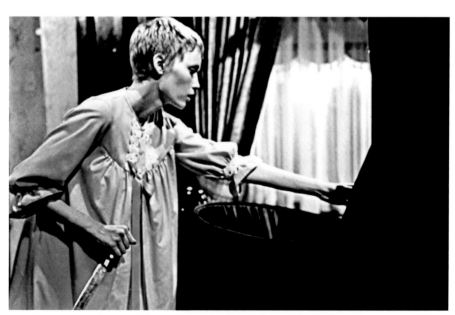

Rosemary finally beholds the baby the witches stole from her.

ABOVE Rosemary has a nightmare in which she is impregnated by a demon that has her husband's eyes.
BELOW Their neighbors, Minnie and Roman Castevet (Ruth Gordon and Sidney Blackmer),
take a hovering interest in their parenthood plans.

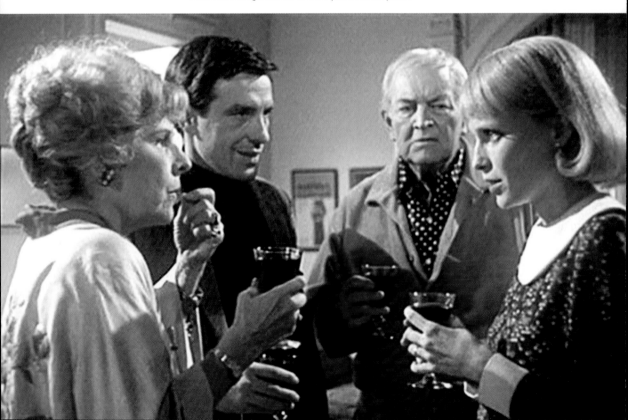

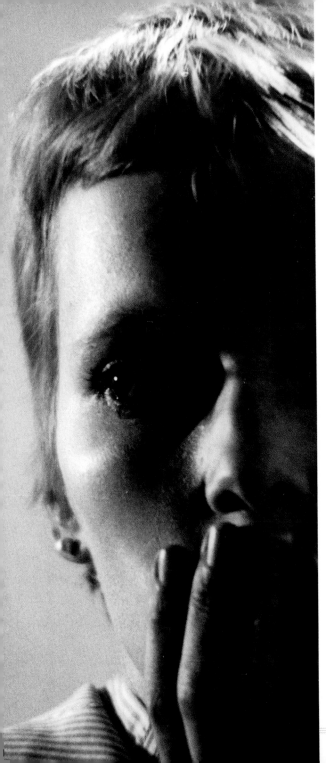

Mia Farrow

Supporting Actress; Mia Farrow earned a BAFTA nomination as Best Actress.

The producer of *Rosemary's Baby* was, of all people, William Castle, who showed the page proofs of the unpublished novel to Paramount's production head, Robert Evans. Since the last thing Evans wanted was a gimmicky follow-up to *House on Haunted Hill* or *The Tingler*, he wisely stipulated that Castle could produce, but not direct. Evans had little difficulty convincing Roman Polanski to direct his first American film after critical success in Europe with *Knife in the Water* (1962) and *Repulsion* (1965). Among the actresses considered for Rosemary were Tuesday Weld, Sharon Tate, and Patty Duke. John Cassavetes was cast as Guy after Robert Redford proved unavailable. Polanski adapted Ira Levin's best-selling novel himself, and his screenplay is one of the most faithful adaptations, beat for beat, of any twentieth-century novel. People who loved the book were not unhappy with the movie.

If you ask people what *Rosemary's Baby* is about, most will automatically say "witchcraft," but that's only part of the story. The film's cultural context—the 1960s—was a time of momentous shifts in everything having to do with women and reproduction, not to mention a public fascination with the occult that took a cue from the Age of Aquarius. Rosemary consumed her magical herbal preparations while millions of American women were getting used to the idea of birth control pills. Inexpensive and easily available chemical contraception was supposed

to empower and liberate women, but it also gave men new leverage over women, since the fear of pregnancy was one of the last standing reasons a woman could invoke to refuse sex in an era that was less sensitive than ours is to ideas like "no means no." Rosemary's reproductive choices are all being made for her, and mostly by men. Since witchcraft doesn't exist, an objective analysis of *Rosemary's Baby* can easily conclude that the story is "really" about women's reproductive anxieties and reproductive choices, not satanic conspiracies. However, as is the usual case with horror films, a devilish disguise allows us to process our worst apprehensions without having to look at them too directly.

Rosemary's Baby is considered part of Polanski's "Apartment Trilogy," the other films being *Repulsion* and *The Tenant* (1976). In each one, the contained space of an apartment becomes an evocative symbol of madness, evil, and gnawing paranoia.

The 1968 film spawned one sequel and one remake. The television movie *Look What's Happened to Rosemary's Baby* (1976) featured Patty Duke in the role for which she had been considered in 1968, Ruth Gordon reprising the part of Minnie, and Stephen McHattie as Adrian, Satan's seed, all grown up. In 2014, NBC remade the original film as a two-part miniseries, modernized and set in Paris. Zoe Saldana starred as Rosemary, Patrick J. Adams as Guy, and Carole Bouquet and Jason Isaacs played the Castevets.

TOP The coven closes in. **BOTTOM** Her real-life pregnancy is a paranoid ordeal.

If you enjoyed *Rosemary's Baby* (1968), you might also like:

THE BLACK CAT

UNIVERSAL PICTURES, 1934

Boris Karloff and Bela Lugosi established their reputation as Universal's double threat of horror in 1931, but the studio didn't get around to casting them together until 1934. It was worth the wait. Although publicity for the film traded shamelessly on the idea that *The Black Cat* had something to do with Edgar Allan Poe, it was instead a completely original revenge story about a great architect (Karloff) and a world-famous psychiatrist (Lugosi), who fought in World War I. The ordeal spared their bodies but destroyed their souls. As Karloff puts it, "Are we any less victims of the war than those whose bodies were torn asunder? Are we not both the living dead?" In the end, revenge is served piping hot, and one of the stars gets skinned alive in a scene that's still startling for its pre-Code sadistic abandon. The black-magic ceremony presided over by Karloff was one of the first depictions of devil worship in any Hollywood film.

Boris Karloff and Bela Lugosi in *The Black Cat*

THE EXORCIST

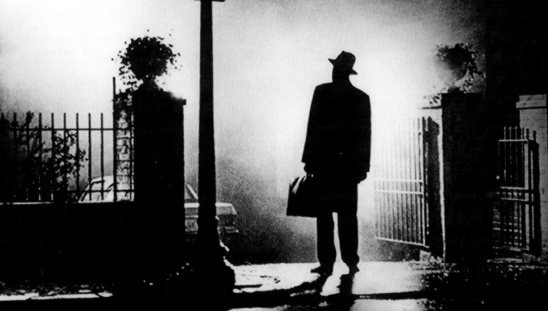

A FILM THAT SET HEADS SPINNING IN MORE WAYS THAN ONE.

Warner Bros., 1973
Color, 122 minutes

DIRECTOR
WILLIAM FRIEDKIN

PRODUCERS
WILLIAM PETER BLATTY, NOEL MARSHALL, DAVID SALVEN

SCREENPLAY
WILLIAM PETER BLATTY, FROM HIS NOVEL

STARRING

CHRIS MACNEIL	ELLEN BURSTYN
FATHER MERRIN	MAX VON SYDOW
REGAN	LINDA BLAIR
LT. WILLIAM KINDERMAN	LEE J. COBB
SHARON	KITTY WINN
BURKE DENNINGS	JACK MACGOWRAN
FATHER KARRAS	JASON MILLER
FATHER DYER	WILLIAM O'MALLEY

welve-year-old Regan MacNeil (Linda Blair), the daughter of Hollywood actress Chris MacNeil (Ellen Burstyn), accompanies her mother to Washington, D.C., for a location film shoot. For the duration of production, they stay in a comfortable rented house overlooking Georgetown. As the film opens, it's Halloween, with costumed children carrying candy bags down the upscale, leaf-strewn streets. Chris and Regan aren't shown celebrating the holiday in any way; to all appearances they are a happy single mother and her daughter, living a well-adjusted postdivorce life that is untouched by anything fanciful or strange. That changes after Regan plays with a Ouija board and begins to communicate with a seemingly imaginary friend, Captain Howdy. She exhibits startling personality changes, spouts obscenities, urinates on the floor in front of her mother's party guest, and even masturbates with a crucifix. She speaks in a deep, guttural voice. When her bed starts shaking uncontrollably, she undergoes neurological tests, but no diagnosis can be made.

The director of the film in which Chris is appearing, Burke Dennings (Jack MacGowran), babysits for Regan, who is under strong sedation. He is found dead, apparently after falling from Regan's bedroom window. His death is assumed to have been caused by his heavy use of alcohol, but nonetheless it comes to the attention of a

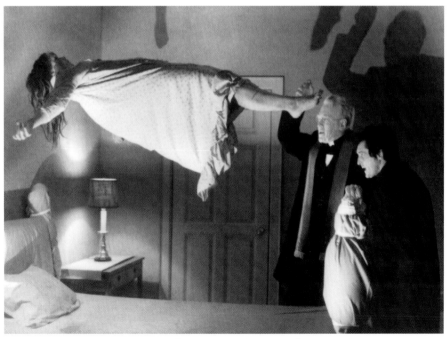

Levitation is only one of the uncanny phenomena the priests witness.

police investigator, Lt. William Kinderman (Lee J. Cobb), who is unconvinced by the "obvious" explanation.

Meanwhile, Regan's doctors are at an impasse. They are sure her symptoms are psychological in origin, but can find no cure. They finally recommend that Chris consider a ritual exorcism, not because they believe she is possessed, but because cures in similar cases may have been achieved through the sheer power of suggestion. Chris consults Father Damien Karras, a psychiatrist who is dealing with demons of his own related to guilt over the recent death of his mother. Karras is first appalled by the idea, but after he meets Regan, who speaks in French and Latin, moves objects, and drenches the priest in green projectile vomit, he calls in an elderly veteran priest, Father Lankester Merrin (Max von Sydow), who has actually performed an exorcism.

It may only be a slight exaggeration to say that no best-selling novel since *Gone with the Wind* generated more public anticipation for a film adaptation than William Peter Blatty's *The Exorcist*. The book was a can't-put-it-down sensation of the highest magnitude, and the first thing many people asked themselves after finishing it was *How in hell are they going to make a movie out of this?* Copies passed from hand to hand, almost furtively. It was the kind of book to be kept in the nightstand drawer instead of on the coffee table.

William Friedkin had numerous clashes with Paramount executives over casting. The studio wanted Marlon Brando as Father Merrin,

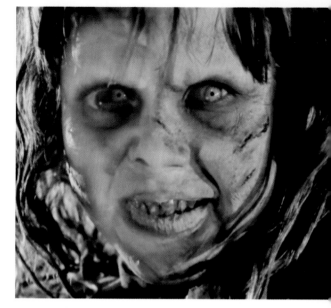

ABOVE Regan spouts obscenities in a guttural voice.
BELOW Chris MacNeil (Ellen Burstyn) is alarmed by escalating behavior changes in her twelve-year-old daughter, Regan (Linda Blair).

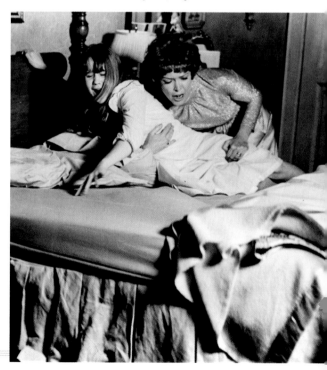

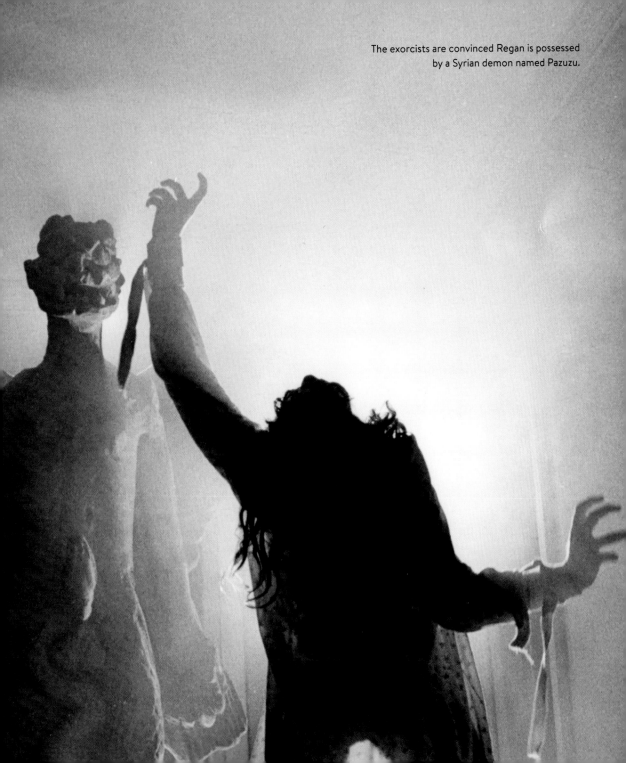

The exorcists are convinced Regan is possessed by a Syrian demon named Pazuzu.

When medicine and psychiatry fail, two Catholic priests, Lankester Merrin (Max von Sydow) and Damien Karras (Jason Miller), attempt a ritual exorcism.

and Friedkin refused; Brando's star power would swamp the film. Paul Newman and Jack Nicholson were considered for Father Karras. Stacy Keach was hired and then had his contract bought to make room for Jason Miller, an East Coast actor and playwright with no film experience. For Chris MacNeil, Audrey Hepburn and Anne Bancroft both proved unavailable. Blatty strongly pushed for Shirley MacLaine, but Friedkin pointed out that she had already done a film on the same subject, *The Possession of Joel Delaney* (1972). Paramount was unhappy with the cast's marquee wattage—or lack of it.

There was a lot of talent on display, but there were no big stars. Nonetheless, the film became a legendary blockbuster.

Many felt the production might actually be cursed. Jack MacGowran died during filming before his on-screen demise could be shot. The movie's cost expanded to twice the original budget. A bedroom had to be constructed in a refrigerated enclosure in order to create the appearance of a supernatural cold zone, where a performer's breath would be visible. Today's digital solutions were impossible, so complicated practical effects presented one expensive challenge after another.

Linda Blair's startling appearance is one of the best-known works of the legendary makeup artist Dick Smith.

Dick Smith's unforgettable makeup for Linda Blair almost overshadows the masterfully imperceptible old-age illusion he worked on Max von Sydow, who was in his forties, not seventies, at the time of filming.

The immense popularity of *The Exorcist* underscores the degree to which horror movies, with their stark portrayals of good versus evil, routine depictions of demons and hell, and demonstrations of death and resurrection, may fill an unmet craving for religious experience in an increasingly despiritualized world.

If you enjoyed *The Exorcist* (1973), you might also like:

THE CONJURING
WARNER BROS., 2013

Like *The Exorcist*, James Wan's *The Conjuring* is based on a purportedly true story of demonic possession, this one investigated by veteran paranormal detectives Ed and Lorraine Warren (Patrick Wilson and Vera Farmiga). The film interweaves the larger story of the Warrens' activities with the harrowing ordeal of Roger and Carolyn Perron (Ron Livingston and Lili Taylor) and their five daughters, who move into a Rhode Island farmhouse and quickly realize they are not alone. The devilish presence is discovered to be a New England witch named Bathsheba Sherman, who sacrificed her newborn child and hanged herself in 1863 and is now intent on forcing another mother to follow in her bloody footsteps. Carolyn wakes up to find Bathsheba pinning her to the bed, vomiting blood into her mouth to complete the possession. It's only one of the carefully calibrated visual shocks delivered by director Wan, who continued to chronicle the Warrens' demonological exploits in *The Conjuring 2* (2016). *The Conjuring 3*, directed by Michael Chaves, is in the works at the time of this writing.

Vera Farmiga conducts an exorcism in *The Conjuring*.

YOUNG FRANKENSTEIN

THE WORLD'S MOST LEGENDARY MONSTER, BUT NOT THE SAME OLD SONG AND DANCE.

20th Century Fox, 1974
Black and white, 105 minutes

DIRECTOR
MEL BROOKS

PRODUCER
MICHAEL GRUSKOFF

SCREENPLAY
GENE WILDER AND MEL BROOKS, BASED ON CHAR-
ACTERS FROM THE NOVEL *FRANKENSTEIN*, BY MARY
WOLLSTONECRAFT SHELLEY

STARRING

DR. FREDERICK FRANKENSTEIN	GENE WILDER
THE MONSTER	PETER BOYLE
IGOR	MARTY FELDMAN
ELIZABETH	MADELINE KAHN
FRAU BLÜCHER	CLORIS LEACHMAN
INGA	TERI GARR
INSPECTOR KEMP	KENNETH MARS

Although both films are recognized as comedy classics, Mel Brooks's *Young Frankenstein* did more for horror movies than *Blazing Saddles* did for Westerns. *Blazing Saddles* is an inspired but eclectic assemblage and send-up of genre conventions, but *Young Frankenstein* is more carefully constructed around a single, time-honored storyline.

Dr. Frederick Frankenstein (Gene Wilder), who teaches at an American medical college, resents any reference to or publicity about his notorious grandfather, Victor Frankenstein, the man who made a monster, and who really paid for it. In order to put further distance between himself and his forebear, Frederick pronounces the family name "Fronkenschteen," though few people honor his preference (everyone, after all, knows who, or what, Frankenstein is). When Frederick's great-grandfather dies in Transylvania, he learns that he has inherited his family's castle, and he immediately sets out to see the estate.

Arriving at the Transylvania train station, Frederick meets a hunchbacked, pop-eyed servant from the castle named Igor (Marty Feldman), who pronounces his name "Eyegore." The estate is looked after by a formidable housekeeper, Frau Blücher (Cloris Leachman), the very utterance of whose name sends horses rearing and whinnying in terror. Frederick

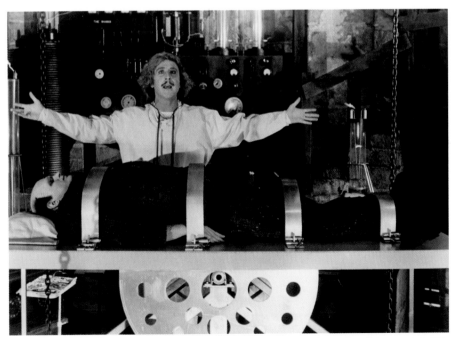

Frederick Frankenstein (Gene Wilder) exults in his recently acquired mastery of the secrets of life.

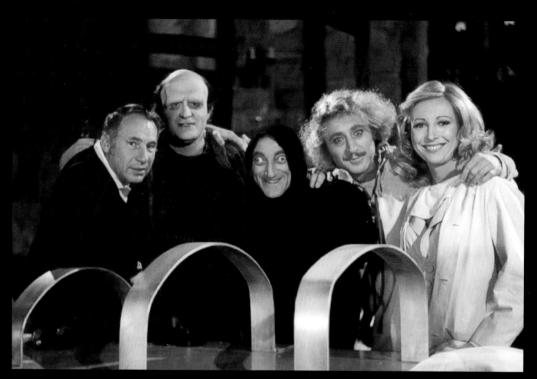

ABOVE Left to right: Mel Brooks, Peter Boyle, Marty Feldman, Gene Wilder, and Teri Garr
BELOW Marty Feldman as Igor, who can be a tad butterfingered around brain jars

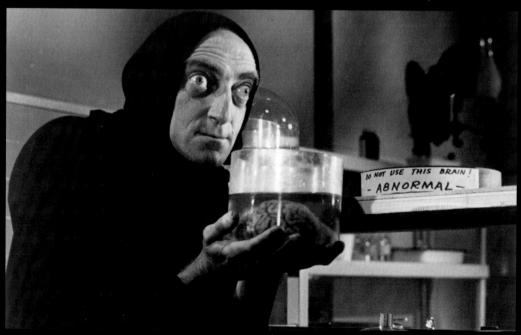

discovers his grandfather's secret laboratory and personal journal—self-effacingly titled "How I Did It"—which reveals the ultimate secrets of life. Thunderstruck, Frederick decides he must continue the experiments, and soon, with the help of Igor and a curvaceous laboratory assistant named Inga (Teri Garr), he is piecing together parts of corpses he intends to reanimate with the brain of a brilliant, recently deceased professor. Igor, however, botches the brain theft and substitutes another cerebral specimen clearly labeled "ABNORMAL." The result is a confused but nonetheless endearing monster (Peter Boyle). Boyle's makeup manages to strongly evoke the indelible look of Boris Karloff without really copying it. Among the differences is a zipper on the neck, an interesting (and very funny) update on the sutures and clamps usually employed to keep the head in place.

Frederick's betrothed, Elizabeth (Madeline Kahn), arrives, putting a bit of a strain on Frederick's ongoing affair with Inga, though not too much, since Elizabeth is a glamorous but fairly refrigerated fiancée. She does eventually warm up to the monster—letting down her hair and electrifying it with permanent-wave lightning bolts—amid multiple, hammered-home references to the creature's enviously enormous endowment.

Simultaneously a loving homage and an irreverent spoof, *Young Frankenstein* follows the sturdy template of the Universal films that starred Boris Karloff (*Frankenstein, Bride of Frankenstein,* and *Son of Frankenstein*). Wilder and Brooks's script revisits and hilariously upends one classic

scene after another, including the "It's alive!" creation sequence, the monster's encounters with a blind hermit (Gene Hackman), and its meeting with a little girl, which ends on a note of slapstick instead of tragedy. Some of the gags are enjoyable groaners exhumed from the catacombs of vaudeville; others are off-color winks to a modern audience; and some—like the top-hat-and-tails rendition of "Puttin' on the Ritz" performed by Wilder and Boyle for a medical conference—are hilariously original and, once seen, unforgettable. The film has consistently and understandably been included on numerous lists of the best motion picture comedies ever

made. Produced on a budget of $2.78 million, it grossed $86.2 million in first-release rentals.

20th Century Fox pressed Brooks to shoot the film in color, but he wisely resisted. The evocative, velvety black-and-white art direction and cinematography by Dale Hennesy and Gerald Hirschfeld result in one of the most meticulously re-created visions of a bygone Hollywood style ever attempted, if not the most successfully realized. A cartoonier visual approach might well have been adopted, but it's doubtful it would have pressed the nostalgia buttons as effectively. The air of hyperrealistic fun and fantasy is further enhanced by the presence of some of Kenneth Strickfaden's original, crackling electrical equipment used at Universal in the 1930s, which was still available and operating in 1974.

Brooks retooled the film as a popular Broadway musical in 2007. While it didn't achieve the success of Brooks's previous movie-into-musical hit, *The Producers*, *Young Frankenstein* ran for two years in New York, had two successful American tours, and was revised and revived in 2017 for a well-received eleven-month run in London.

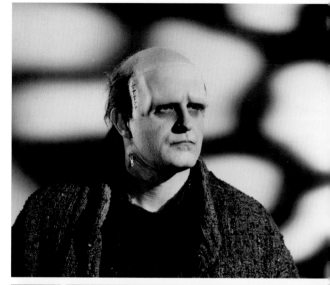

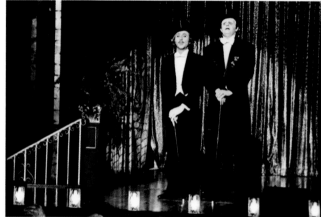

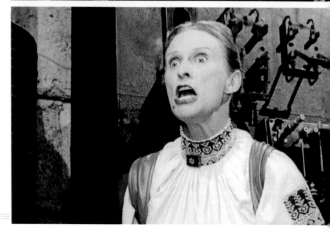

TOP Peter Boyle as the monster **MIDDLE** The film's pièce de résistance, "Puttin' on the Ritz" **BOTTOM** Cloris Leachman as the terrifying Frau Blücher

ABBOTT AND COSTELLO MEET FRANKENSTEIN

UNIVERSAL-INTERNATIONAL, 1948

Horror movie characters and themes have a predictable life cycle. Terrifying and uncanny upon their first public exposure, with increased familiarity they inevitably begin a popular-culture pendulum swing toward comedy before returning to their scary starting point. Part of this is sociological and part of it is physiological: laughing and screaming, after all, are closely related reflexes, both providing a much-needed escape valve for tension and anxiety. *Abbott and Costello Meet Frankenstein* is particularly beloved by the same fans who never stopped loving the original, frightening incarnations of Dracula, the Wolf Man, and Frankenstein's monster. Lon Chaney Jr., Bela Lugosi, and Glenn Strange all give their farewell screen performances to their most famous roles, so there's a bittersweet edge to the film as well. And if the monsters seem pale reflections of their former, truly terrifying selves, at least they're being good sports about it. The plot—if you need one for this kind of romp—revolves around Dracula's weird wish to transplant Lou Costello's brain into the head of the Frankenstein monster, for reasons that are never really explained.

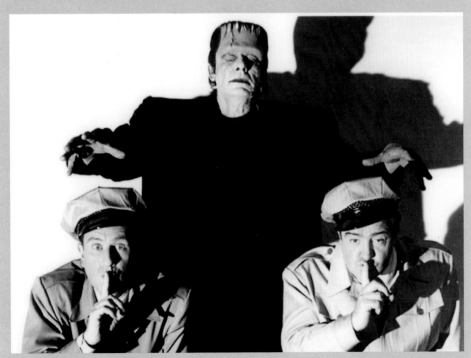

Bud Abbott, Glenn Strange, and Lou Costello in *Abbott and Costello Meet Frankenstein*

HALLOWEEN

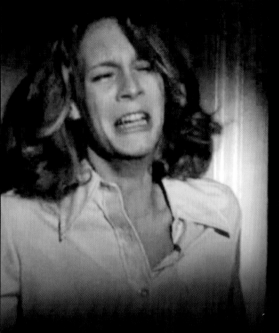

THE MOVIE THAT MADE OCTOBER 31 GOOSEBUMPY AGAIN.

Compass International, 1978
Color, 91 minutes

DIRECTOR
JOHN CARPENTER

PRODUCERS
DEBRA HILL, IRWIN YABLANS, MOUSTAPHA AKKAD (UNCRED-ITED), JOHN CARPENTER (UNCREDITED)

SCREENPLAY
JOHN CARPENTER AND DEBRA HILL

STARRING

LOOMIS	DONALD PLEASENCE
LAURIE	JAMIE LEE CURTIS
ANNIE	NANCY KYES
LYNDA	P. J. SOLES
BRACKETT	CHARLES CYPHERS
LINDSEY	KYLE RICHARDS
TOMMY	BRIAN ANDREWS
MICHAEL MYERS	TONY MORAN
MICHAEL MYERS (AGE 6)	WILL SANDIN

e don't know exactly who we are, or where we are, but as seen from the camera's point of view, we're somebody prowling around a generic suburban house where a teenaged girl, Judith Myers, is in her bedroom having a tryst with her boyfriend. While the couple finishes their business, we go downstairs to the kitchen, find a drawer, and quietly withdraw a butcher knife. As the boyfriend leaves, our unseen alter ego picks up a plastic Halloween clown mask and puts it on. Our vision is now reduced to what can be observed through a pair of peepholes, but we can see well enough to find our way quickly back to the bedroom, where Judith sits partially nude at a dressing table, combing her hair.

"Michael?" she asks. Her initial annoyance turns to screaming bloody horror as the knife flashes down again and again in front of the eye holes, only partially concealing the killing. The slaughter complete, the mask leads us downstairs and out the front door, where adults are just arriving. This time, when a man's voice asks "Michael?" and the mask is removed, we move to an objective point of view and realize that we have been seeing the world through the eyes of a six-year-old boy, frozen and vacant-faced in a festive clown costume, still holding the blood-stained knife.

It turns out that the little boy is Michael Myers, a first-grader in Haddonfield, Illinois, who has murdered his older sister for no

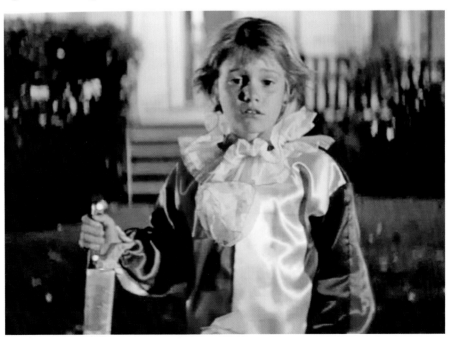

The unmasked face of Michael Myers (Will Sandin), a Halloween killer at the age of six

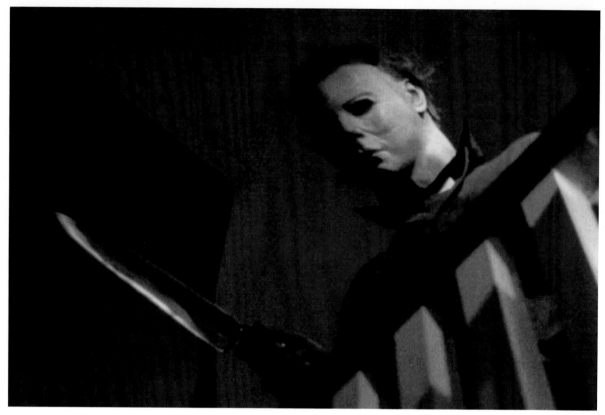

Michael Myers (Tony Moran), all grown up

discernible reason on Halloween night, 1963. He will remain in a semicatatonic state for fifteen years, becoming an enigma and an obsession for his custodial psychiatrist, Dr. Sam Loomis (Donald Pleasence). On Halloween 1978, the year he reaches adulthood, Michael escapes while being conveyed to another facility and returns to Haddonfield wearing a cadaverous mask. He begins stalking a chaste and studious babysitter named Laurie Strode (Jamie Lee Curtis) and savagely kills her more sexually adventurous friends. It's not long, however, before he zeroes in on Laurie.

Beyond its title, *Halloween* has an especially dynamic relationship with the actual holiday: its launching of the longest-running series of sequels and reboots in Hollywood history coincided with and contributed to the explosive growth of Halloween as the second-biggest retail holiday in America after Christmas. For many years, *Halloween* held the record as the highest-grossing independent feature ever made. The film made over $70 million on an investment of $300,000, instantly propelling John Carpenter to the front of the line as a bankable purveyor of cinematic fright.

Halloween also helped fuel the ever-expanding urban mythology of Halloween, especially the belief that young people were in mortal peril on October 31 from candy poisoners, kidnappers, and serial killers. In reality, there is no more crime directed at children and young adults on Halloween than on any other day of the year, but the *Halloween* series continued to draw energy from the cynicism and suspicion taking social root in the wake of Vietnam and Watergate, as well as following the Tylenol-tampering deaths and the Atlanta child murders of the early 1980s, both of which were prominently in the news during the weeks running up to Halloween.

The *Halloween* phenomenon reconnected the holiday to its primary, if forgotten, cultural purpose: a ceremonial acknowledgment of mortality and the never-ending cycles of life, death, and the mysteries that follow. Before John Carpenter reinvigorated the holiday with ritual human sacrifice, did anyone still make a conscious connection between a jack-o'-lantern and a grinning skull? Participants in the harvest celebrations of the ancient Celts understood that life was literally in the balance if the crops failed. But today, even with memento mori overwhelming the mediasphere, most people are still more likely to worry about the availability of pumpkin-spiced lattes than about having enough food for the winter. Modern Halloween is just as much about denying death its power as it is a surrender to it—a grim game of hide-and-seek with a relentlessly determined reaper.

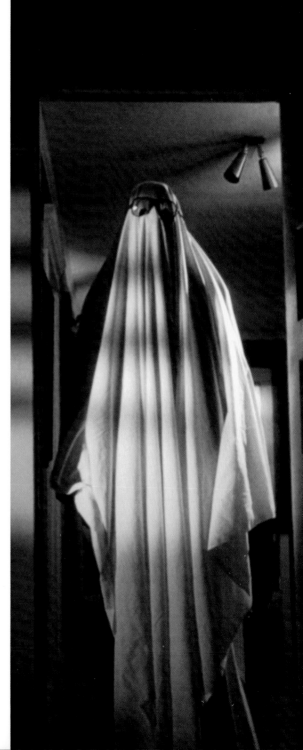

Michael's alternate Halloween disguise

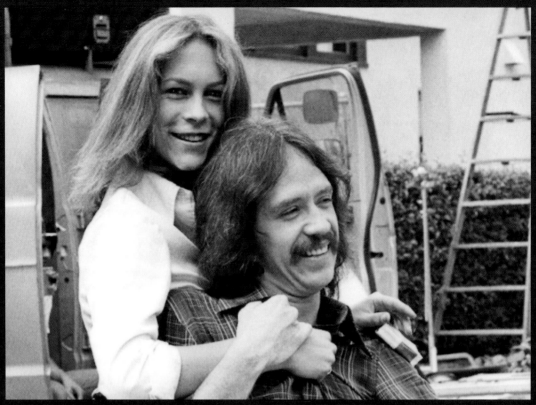

ABOVE Jamie Lee Curtis and John Carpenter on set **BELOW** Curtis and Michael in the 2018 reboot

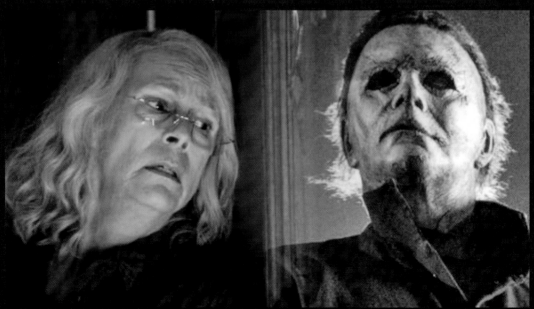

It is often claimed that Alfred Hitchcock's *Psycho* was the seminal slasher film, but most recognize *Halloween* for the distinction. Carpenter's film is, of course, inextricably linked to *Psycho* through the presence of Janet Leigh's daughter, Jamie Lee Curtis. The scene of her being attacked with a butcher knife in a closed space about the size of a shower stall had only one pop-culture antecedent but a seemingly unending stream of its own imitations. The 1978 *Halloween* has been followed by seven sequels to date: *Halloween II* (1981), *Halloween III: Season of the Witch* (1982, the only film in the franchise not involving the Michael Myers storyline), *Halloween 4: The Return of Michael Myers* (1988), *Halloween 5: The Revenge of Michael Myers* (1989), *Halloween: The Curse of Michael Myers* (1995), *Halloween H20: 20 Years Later* (1998), and *Halloween Resurrection* (2002). Two remakes using the original titles, *Halloween* (2007) and *Halloween II* (2009), were directed by Rob Zombie. A three-part reboot began in 2018 with yet another film called *Halloween* starring Jamie Lee Curtis, with plans for two additional sequels starring Curtis, *Halloween Kills* (2020) and *Halloween Ends* (2021).

Baby boomers are famous for refusing to let go of the sixties and seventies. Laurie Strode, like her original movie audiences, has reached her retirement decade still clinging to her teen years, but with a crucial difference. Hers is a nightmare nostalgia of long-ago traumatic memories that won't loosen their grip. It's too bad she can't just enjoy her films the way we did.

If you enjoyed *Halloween* (1978), you might also like:

FRIDAY THE 13TH
PARAMOUNT, 1980

Friday the 13th made the American summer camp a standard setting for slasher movies, and is still flatteringly invoked and imitated, most recently in Ryan Murphy's cleverly sardonic series *American Horror Story: 1984* (2019). At Camp Crystal Lake, a young boy named Jason Voorhees accidentally drowned when the counselors assigned to watching him were having sex instead. The counselors were then killed, and the camp closed for years, until Mrs. Voorhees, the dead boy's mother, generously reopens it for a new parade of horny teenagers, with the retributive results you'd expect. Jason isn't given his trademark hockey mask until film three of a ten-part series, a record eclipsed only by the *Halloween* franchise—twelve films to date and still counting. As Mrs. Voorhees, Betsy Palmer received a well-deserved late-career boost from the film, and she should have done more along these lines. She has a grand old time, and so should you.

Betsy Palmer as Mrs. Voorhees in *Friday the 13th*

THE SHINING

IF A HAUNTED HOTEL EVER TAKES A "SHINE" TO YOU,
IT MAY BE TIME TO CHECK OUT.

1980

nutes

RS

JAN HARLAN

AY

ND DIANE JOHNSON, FROM THE NOVEL

STARRING

JACK TORRANCE	JACK NICHOLSON
WENDY TORRANCE	SHELLEY DUVALL
DANNY	DANNY LLOYD
HALLORANN	SCATMAN CROTHERS
ULLMAN	BARRY NELSON
GRADY	PHILIP STONE
LLOYD	JOE TURKEL
DOCTOR	ANNE JACKSON

J ack Torrance (Jack Nicholson), a recovering alcoholic and aspiring writer in Boulder, Colorado, accepts the position of winter caretaker at the landmark Overlook Hotel in the Rocky Mountains, believing the solitude will aid his writing and help repair his alcohol-damaged relationship with his wife, Wendy (Shelley Duvall), and son, Danny (Danny Lloyd). The manager tells him about the Overlook's history. The hotel, built on the site of a Native American burial ground, is shuttered and completely isolated during the snowed-in months, and a previous caretaker, named Charles Grady, lost his mind to cabin fever before killing his family and committing suicide on the premises.

Danny, who has an imaginary friend named Tony, has a frightening premonition about the hotel before the family moves in. They arrive on the final day of the tourist season, and Danny is startled when the head chef, Dick Hallorann (Scatman Crothers), offers him ice cream telepathically. He then explains that he, like his grandmother, has an extrasensory gift he calls "the shining." Clearly, Danny shares it as well. Before leaving to spend the winter in Florida, Hallorann tells Danny that the building has some dark memories and warns him to stay away from room 237.

Within the first month of weather-imposed exile, Jack's ability to write doesn't improve. Danny has terrifying visions, including of a pair

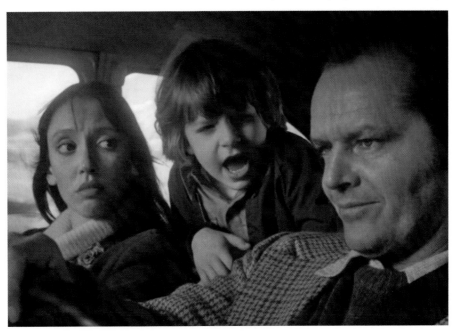

Jack and Wendy Torrance (Jack Nicholson and Shelley Duvall), along with their son, Danny (Danny Lloyd), travel to the Rockies to be winter caretakers of a snowbound hotel.

of twin girls who stare at him from the end of a corridor. Heavy snow knocks out the phone. Jack's mood becomes dark, his behavior bizarre, menacing, and violent. He tells Wendy that he has dreamed of killing her and Danny. When Danny, who has been drawn irresistibly to room 237, returns with bruises, Wendy believes that Jack has been physically abusing their son. Jack withdraws into a surreal perception of the hotel in which he meets a spectral bartender in the ballroom who serves him alcohol and encourages him to follow his resentments to their inevitable, murderous conclusion.

Based on the best-selling 1977 novel by Stephen King, Stanley Kubrick's version of *The*

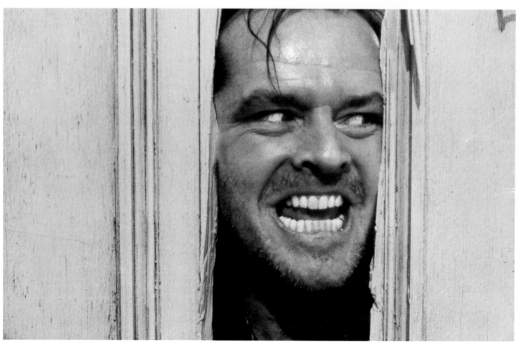

Jack grows murderously violent.

Shining has received more critical scrutiny and acclaim than any other horror film, but it has also been regarded as more of a personal statement by the filmmaker than a faithful adaptation of the novel. Many fans prefer the 1997 television miniseries, directed by Mick Garris and starring Steven Weber and Rebecca De Mornay, as a more definitive reflection of the novel. Kubrick's detractors point out that Jack Nicholson seems unhinged from the very beginning of the film, quite unlike his portrayal in the novel and miniseries, which depict a gradual descent into the horror of alcoholic relapse. King had written the book during his own struggle with alcoholic dependence.

Wendy, as Shelley Duvall played her under Kubrick's direction, emerged as a weak-willed doormat rather than a full participant in the troubled marriage, as she was written by King and played by De Mornay in the miniseries. To put it mildly, Duvall and Kubrick did not work well together, and her character almost takes the shape of the director's low opinion of the actress. As Stephen King put it, Wendy was "basically just there to scream and be stupid, and that's not the woman that I wrote about." Overall, King

Cabin fever sets in quickly, and Jack, a recovering alcoholic, shows signs of a relapse.

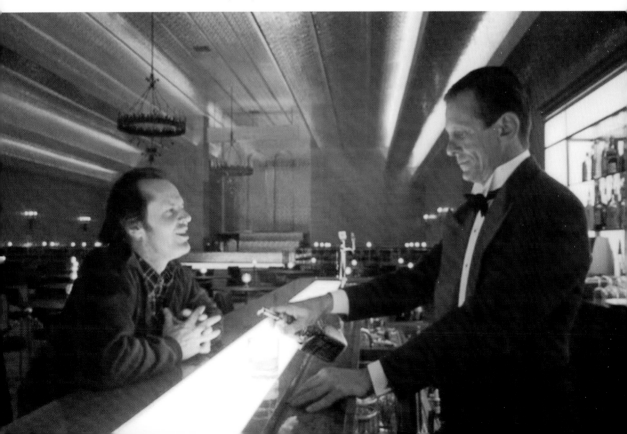

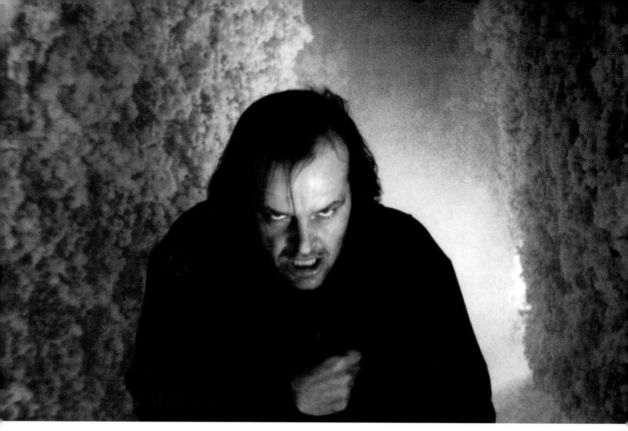

Jack and his frozen surrounding become one.

considered the film to be "a great big beautiful Cadillac with no motor inside." The most fervent adherents of Kubrick find a multiplicity of near-subliminal clues to the director's more cryptic intentions and messages. The most comprehensive guide to this line of critical thinking, among others, can be found in Rodney Ascher's fascinating, if controversial, 2012 documentary, *Room 237*.

Kubrick, a legendary perfectionist, spent a full year shooting the film at EMI Elstree Studios, outside London, the same production facility where the great Hammer horror classics were created. The actors became exhausted with almost daily script rewrites and endless retakes. The scene in which Wendy swings a baseball bat at Jack needed 127 takes before Kubrick was satisfied. Nicholson (who won the role after King objected to the potential casting of Robert De Niro, Robin Williams, or Harrison Ford) reportedly stopped memorizing his lines and did quick studies of the rewritten material just before shooting. The film cemented Nicholson's edgy star power, but King felt that even he had been miscast. Among the actors King would have preferred were Jon Voight or Michael Moriarty.

If you enjoyed *The Shining* (1980),
you might also like:

CARRIE

UNITED ARTISTS, 1976

Stephen King's first novel is an enduring best seller, and with good reason. No novel before *Carrie* had ever described the unvarnished emotional brutality of American high school: the cruel rituals of initiation, exclusion, and scapegoating were instantly recognizable to millions. Imagine a grim travesty of "Cinderella" recast as a revenge melodrama, with a high school prom standing in for the prince's ball and Cinderella showing up with a terrorist's incendiary device. Sissy Spacek made her first screen splash being soaked with pig's blood, earning a Best Actress Oscar nomination in the title role of the school's designated odd girl out. Piper Laurie, who received a Best Supporting Actress Oscar nomination, almost steals the show as Carrie's religious-fanatic mother seeking, and finally achieving, ecstatic martyrdom. The final twist scene, which has been endlessly imitated but never done so well as here, still has the power to shock. If at all possible, watch it with somebody who's never seen it before, and enjoy the show.

Sissy Spacek as the blood-soaked queen
of the prom in *Carrie*.

THE THING

THE SHAPE OF SCREAMS TO COME.

Universal, 1982
Color, 129 minutes

DIRECTOR
JOHN CARPENTER

PRODUCERS
DAVID FOSTER, LAWRENCE TURMAN, WILBUR STARK

SCREENPLAY
BILL LANCASTER, FROM THE NOVELLA *WHO GOES THERE?*
BY JOHN W. CAMPBELL JR.

STARRING

R. J. MACREADY	KURT RUSSELL
DR. BLAIR	WILFORD BRIMLEY
NAULS	T. K. CARTER
PALMER	DAVID CLENNON
CHILDS	KEITH DAVID
DR. COPPER	RICHARD DYSART
VANCE NORRIS	CHARLES HALLAHAN
GEORGE BENNINGS	PETER MALONEY
CLARK	RICHARD MASUR
GARRY	DONALD MOFFAT
FUCHS	JOEL POLIS

The fear of being "taken over" by an outside entity, be it supernatural or extraterrestrial, is a theme that frequently drives both horror and science fiction films, and is often the element that blurs the lines between the genres. For instance, is *Invasion of the Body Snatchers* (1956) horror or sci-fi? It's difficult to tell. Many critics would say it's both, and audiences are likely not to worry about the distinction so long as the story delivers an entertaining thrill. John Carpenter's *The Thing* is an excellent example of a film that serves both genres exceedingly well—even though, on its first release, its unprecedented level of grotesque special effects repelled reviewers and audiences alike. Today, however, the film is widely hailed as

a visual-effects milestone in imaginative cinema of the predigital era.

The Thing is based on John W. Campbell Jr.'s 1938 novella *Who Goes There?* which was originally very loosely adapted to the screen in 1951 as *The Thing from Another World*, directed by Christian Nyby and produced by Howard Hawks. Campbell's story is regarded as one of the most influential works of pre–World War II literary science fiction, a claustrophobic tale of an Antarctic research team stalked by an alien life form that can convincingly counterfeit the appearance and behavior of any terrestrial organism, including members of the research crew themselves. A tense guessing game of who's human and who's not grips the reader to

A shape-shifting alien entity invades the American base, spreading paranoia among the team.
Who is real and who is not? From left, T. K. Carter, Richard Masur, Donald Moffat, and Kurt Russell.

The Thing from Another World (1951) was the first screen adaptation of John W. Campbell Jr.'s novella *Who Goes There?* James Arness played the alien as a standard movie monster, not a shape-shifter.

the climax. Campbell's influence can be readily detected in paranoia-inflected 1950s films like *It Came from Outer Space* (1953) and *Invasion of the Body Snatchers*. Oddly, the central elements of shape-shifting and paranoia were completely dropped from *The Thing from Another World*, its alien unimaginatively recast as James Arness in a padded Frankenstein's-monster costume with lobster-like claws. A proper telling of Campbell's story hadn't even been attempted.

Therefore, when Universal acquired the remake rights in 1976, it essentially gained the opportunity to adapt the original story for the first time. The project was first assigned to Tobe Hooper, director of *The Texas Chainsaw Massacre* (1974), but no viable script emerged. John Carpenter wasn't seriously approached until the huge success of *Halloween* in 1978 made him a bankable contender. Another box-office hit, Ridley Scott's viscerally grisly *Alien* (1979), made it clear that mixing over-the-top physical horror and science fiction might be a winning combination. But Campbell's story was highly interiorized, with little physical action at all, and

Antarctic researcher R. J. MacReady (Kurt Russell) discovers an abandoned
Norwegian outpost, destroyed by an unknown force.

Bill Lancaster's original script kept the monster largely unseen, as in *Alien*.

Rob Bottin, who had created special makeup for Carpenter's *The Fog* (1980) as well as the werewolf transformations for Joe Dante's *The Howling* (1981), urged Carpenter to bring the horror completely out of the shadows. From the time of German expressionism, the grotesque imagery of horror films owed a certain debt to the visual distortions of modern art movements, especially expressionism and surrealism. This influence came to the fore in the 1980s, when special-effects makeup innovations like latex foam made possible infinitely plastic depictions of the human form. Bottin's morphing monstrosities in *The Thing* bring to mind Salvador Dali's melting timepieces given human shape, as well as the ferocious, twisted forms of painter Francis Bacon in works like *Three Studies for Figures at the Base of a Crucifixion*.

Kurt Russell was cast in the lead role of R. J. MacReady; among others considered were Christopher Walken, Jeff Bridges, Nick Nolte, Sam Shepard, Tom Atkins, and Jack Thompson.

Carpenter's completed film followed Campbell's story with remarkable fidelity, filled out with special effects Campbell could never have imagined. In Antarctica, MacReady and his research team discover a destroyed Norwegian outpost and the charred, frozen remains of a misshapen creature with human internal organs. One of the team's sled dogs, which had visited the Norwegian encampment, reveals itself to have been absorbed by a voracious alien organism that can take on the shape of any living thing. It may or may not have taken the shape of a team member who spent time alone with the dog, and the thawed, half-transformed humanoid poses a similar threat. It soon becomes difficult to know exactly who is alien and who is not, except when one of the spectacularly gruesome transformations is witnessed. The team is systematically decimated until only a few remain, and none are sure of the others' true nature.

The larger cultural import of visceral Grand Guignol–esque spectacle in late twentieth-century cinema has been extensively analyzed and debated, but it is likely that at least some of the appetite for blood and guts arises not from sadism but rather from the need to reaffirm the body in all its messy biological reality against the onslaught of the cold technology that engulfs us. In movies like *The Thing*, nobody is a computer inside. We see the proof.

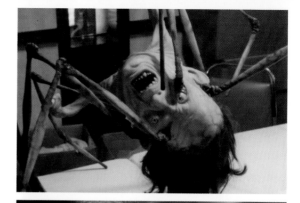

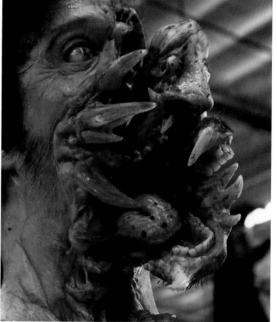

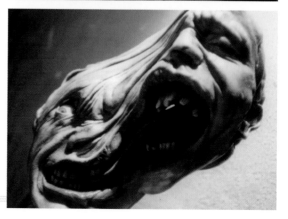

Special-makeup-effects artist Rob Bottin's shape-shifting creations for *The Thing* subjected the human body to a nearly surreal level of stress and distortion.

If you enjoyed *The Thing* (1982), you might also like:

THE FLY

20TH CENTURY FOX/BROOKSFILMS, 1986

By 1986, Canadian filmmaker David Cronenberg had already established himself as a major purveyor of "body horror" in films like *Scanners* (1981) and *Videodrome* (1983), but he saved his most intense exploration of visceral unease for *The Fly*. This was not a remake of the famous 1958 film starring David Hedison and Vincent Price; rather, it built on the central premise of George Langelaan's short story, in which a scientist experimenting with teleportation has his molecular structure mixed with that of a housefly. In the story, and in the earlier film, the teleporter accident results in an instant transformation of the researcher into a half-human, half-insect monstrosity. In Cronenberg's version, the transformation is agonizingly slow and crushingly tragic. The film was taken by many critics of the time to be an allegorical depiction of the AIDS epidemic, though Cronenberg insisted he intended a much more general metaphor for disease and mortality. *The Fly* earned Chris Walas and Stephan Dupuis an Academy Award for Best Makeup. The film's tagline ("Be afraid. Be very afraid.") went viral in popular culture.

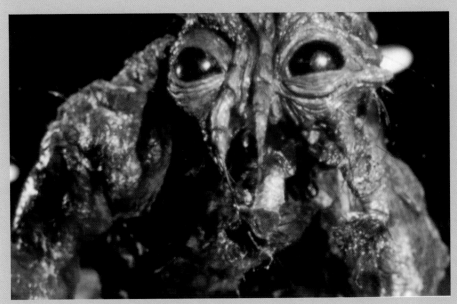

Jeff Goldblum as Seth Brundle, half man and half housefly, in *The Fly*

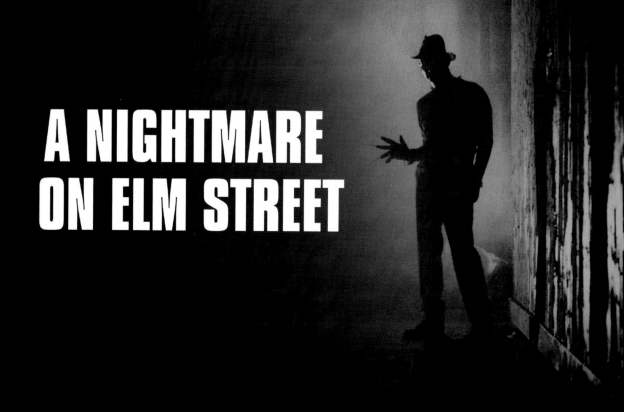

A NIGHTMARE ON ELM STREET

AND IF YOU DIE BEFORE YOU WAKE . . . YOU'VE PROBABLY MET FREDDY.

New Line Cinema, 1984
Color, 91 minutes

DIRECTOR
WES CRAVEN

PRODUCERS
STANLEY DUDELSON, ROBERT SHAYE, AND JOSEPH WOLF

SCREENPLAY
WES CRAVEN

STARRING
LT. THOMPSON JOHN SAXON
MARGE THOMPSON RONEE BLAKLEY
NANCY THOMPSON HEATHER LANGENKAMP
TINA GRAY AMANDA WYSS
ROD LANE JSU GARCIA
GLEN LANTZ JOHNNY DEPP
DR. KING CHARLES FLEISCHER
SGT. PARKER JOSEPH WHIPP
FRED KRUEGER ROBERT ENGLUND
TEACHER LIN SHAYE

Horror movies frequently depict nightmares in the course of their stories, but it is much rarer for a film to serve nightmares as the main course. In *A Nightmare on Elm Street*, the first installment of a highly successful franchise including nine feature films and two television series, we are reminded of the ancient link between nightmares and the tropes of modern horror. The medieval incubus and succubus were dream demons who sexually attacked their victims during sleep, draining their life energy in the process. Folklorists often cite the incubus/succubus legend as a major source of all things vampiric. The closely related "old hag" phenomenon, involving sleep paralysis and the vision of a horrible crone straddling and immobilizing the sufferer, is an occurrence well-known to sleep researchers. And bad dreams in general have been regarded as omens from antiquity.

Freddy Krueger (Robert Englund), the resident bogeyman of the *Elm Street* franchise, is an updated version of an incubus: a consummate demon, but one with a dreamy twist. Instead of lurking in closets or shadows, Freddy stalks his victims in their dreams, a place where he has the power to actually kill. Have a nightmare about Freddy, and it's possible you won't wake up.

In the quiet, tree-lined town of Springwood, Ohio, the parents share a secret. Freddy Krueger was a notorious local child killer who got off on

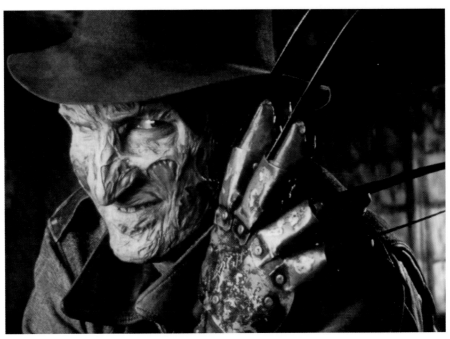

Robert Englund as Freddy Krueger

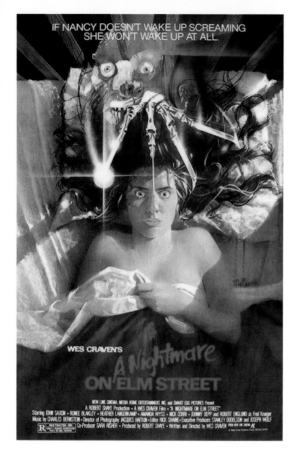

IF NANCY DOESN'T WAKE UP SCREAMING
SHE WON'T WAKE UP AT ALL

WES CRAVEN'S
A Nightmare
ON ELM STREET

NEW LINE CINEMA, MEDIA HOME ENTERTAINMENT, INC. and SMART EGG PICTURES Present
A ROBERT SHAYE Production • A WES CRAVEN Film • "A NIGHTMARE ON ELM STREET"
Starring JOHN SAXON • RONEE BLAKLEY • HEATHER LANGENKAMP • AMANDA WYSS • NICK CORRI • JOHNNY DEPP and ROBERT ENGLUND as Fred Krueger
Music by CHARLES BERNSTEIN • Director of Photography JACQUES HAITKIN • Editor RICK SHAINE • Executive Producers STANLEY DUDELSON and JOSEPH WOLF
Co-Producer SARA RISHER • Produced by ROBERT SHAYE • Written and Directed by WES CRAVEN

a technicality, infuriating the adults and inciting them to vigilante justice. They burn Freddy alive and never pay for their crime. Freddy has his own revenge, however, and begins entering their children's dreams with gruesomely fatal results. Freddy appears to his victims bearing hideous burn scars, a ratty striped sweater and battered fedora, and his trademark weapon: a leather glove, the fingers and thumb tipped with steak-knife blades. In the first film, Johnny Depp (in his screen debut) falls asleep and immediately is swallowed up and literally pureed by his bed, a geyser of blood shooting up as if from an uncovered blender. For the first television broadcasts, the bed vomited dry bones instead.

Freddy's primary targets in the first film are Nancy Thompson (Heather Langenkamp) and her circle of friends, who are apparently being picked off to scare Nancy all the more. After all, her mother, Marge (Ronee Blakley), was one of the ringleaders of Freddy's fiery lynching. While Nancy is taking a bath, Freddy's finger-blades break the surface of the water like a shark fin. When he harasses her on the phone, the bottom half of the receiver turns into a tongue that tries to French kiss her. These pranks aside, in his first incarnation Freddy is fairly grim, but as the franchise gets rolling, he finds his more ideal level as a sardonic spook, not unlike the wisecracking Crypt-Keeper of EC Comics fame. Robert Englund wasn't the first choice for the role; he replaced the originally cast David Warner (*The Omen*), who became unavailable, but Englund certainly made the part his own. Director Craven has said that a partial inspiration for the character was an actual schoolyard bully named Fred Krueger who tormented Craven as a child.

At first, Craven had no plans for a sequel, but the original film's twisty, is-it-real-or-not denouement left the door wide open for more. *A Nightmare on Elm Street 2: Freddy's Revenge* (1985) was a stand-alone follow-up, without any of the original cast and not directed by Craven. He did, however, return to helm one of the best

Freddy haunts the boiler room where he was lynched by angry parents.

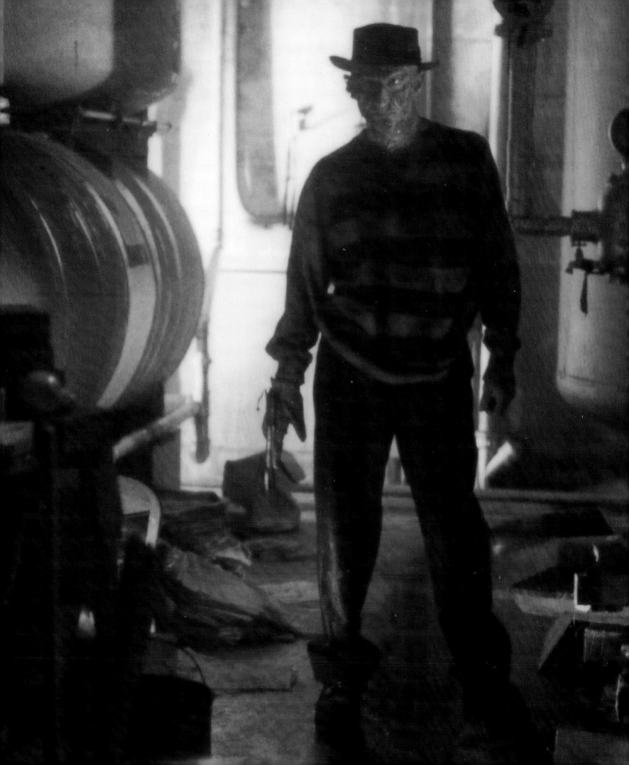

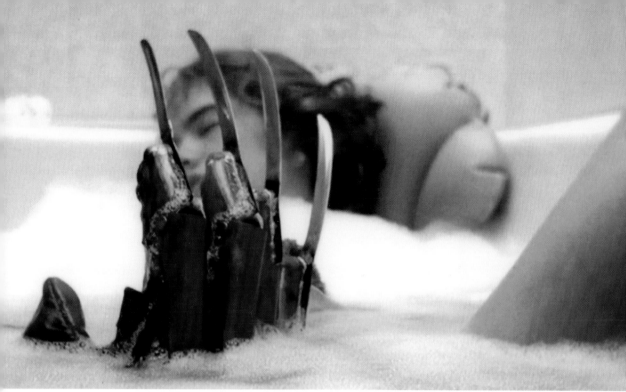

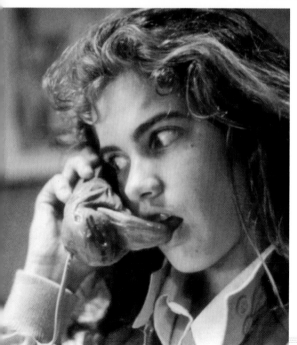

installments of all, *A Nightmare on Elm Street 3: Dream Warriors* (1987), in which Freddy came into his own as a macabre jokester. The series kept rolling with *A Nightmare on Elm Street 4: The Dream Master* (1988), *A Nightmare on Elm Street 5: The Dream Child* (1989), *Freddy's Dead: The Final Nightmare* (1991), and *Wes Craven's New Nightmare* (1994), in which Heather Langenkamp returned to play herself in a clever meta-narrative in which the film and its making blur into a single scary story. *Freddy vs. Jason* (2003) blended two franchises, and the film

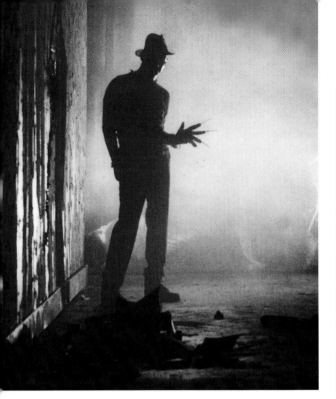

Welcome to his nightmare!

series concluded with *A Nightmare on Elm Street* (2010), a remake of the original, without Robert Englund.

Freddy's Nightmares (1988–1990) was an anthology television series with Freddy hosting (and sometimes appearing in) stories set in the franchise's town of origin, Springwood, Ohio. *A Nightmare on Elm Street: Real Nightmares* (2005) was a reality game show, also hosted by Englund as Freddy, in which contestants were challenged to confront their real worst fears.

If you enjoyed *A Nightmare on Elm Street* (1984), you might also like:

INSIDIOUS
FILMDISTRICT DISTRIBUTION, 2011

Dreams aren't the only unconscious state of mind that can allow dark forces to intrude. In *Insidious*, a family moves into a new house, and something in the shadowy attic frightens young Dalton (Ty Simpkins) so badly that he falls into a mysterious, intractable coma. When hospital treatment is ineffective, the boy comes home and sets off a barrage of paranormal phenomena. The family flees the house, but the haunting follows them to their new home. Director James Wan reportedly chose *Insidious* to counter the reputation he had earned as the creator of the eight grisly *Saw* films (2004 to present), the highest-grossing independent horror franchise of all time but also criticized as one of the most violent. The much tamer but no less chilling *Insidious* franchise thus far comprises four films that build their shocks with psychological indirection rather than grotesque set pieces.

J. LaRose and Rose Byrne

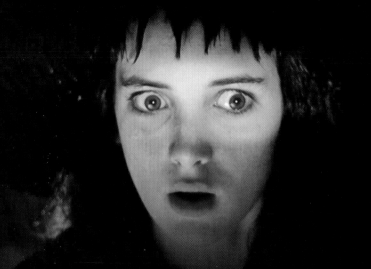

BEETLEJUICE

WANT TO HAUNT YOUR HOUSE? FIRST, CHECK THE USER'S MANUAL.

The Geffen Company, 1988
Color, 92 minutes

DIRECTOR
TIM BURTON

PRODUCERS
MICHAEL BENDER, RICHARD HASHIMOTO, LARRY WILSON

SCREENPLAY
MICHAEL MCDOWELL AND WARREN SKAAREN, FROM A STORY
BY MICHAEL MCDOWELL AND LARRY WILSON

STARRING

ADAM	ALEC BALDWIN
BARBARA	GEENA DAVIS
JANE BUTTERFIELD	ANNIE MCENROE
BETELGEUSE	MICHAEL KEATON
DELIA	CATHERINE O'HARA
CHARLES	JEFFREY JONES
LYDIA	WINONA RYDER
OTHO	GLENN SHADIX
JUNO	SYLVIA SIDNEY
MAXIE DEAN	ROBERT GOULET
BERNARD	DICK CAVETT
GRACE	SUSAN KELLERMANN

n Tim Burton's *Beetlejuice*, Adam and Barbara (Alec Baldwin and Geena Davis) are the cutest young married couple you'll ever meet. It's too bad they're dead. Actually, they're quite alive at the very beginning of the film, lovingly settling into a Norman Rockwell–esque Connecticut farmhouse and planning on spending an idyllic lifetime there. However, in swerving to miss a meandering puppy while crossing a picturesque covered bridge, they plunge their car upside down into a creek. Returning home, they can't remember escaping the car or even the walk back. Then things get really strange. Visitors can't see them. And the truth slowly dawns: they have joined the ranks of the recently deceased and have no idea how to navigate the territory, much less haunt a house.

To their horror, their real estate agent sells the home to an obnoxious nouveau riche New York couple, Charles and Delia Deetz (Jeffrey Jones and Catherine O'Hara), who promptly start steaming off the homey wallpaper and adding trendy postmodern ornamentation everywhere. Their I-was-a-teenage-goth daughter, Lydia (Winona Ryder), is far more attuned to the house's supernatural frequencies than her parents, and soon is making friends with the former residents/current hangers-on.

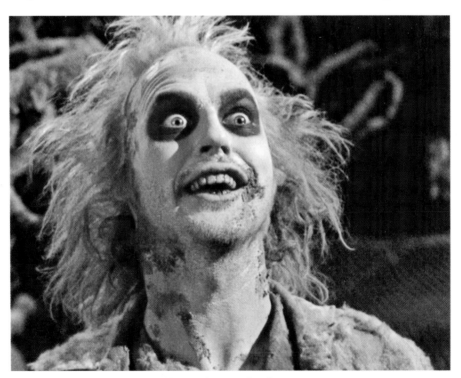

Michael Keaton as Betelgeuse

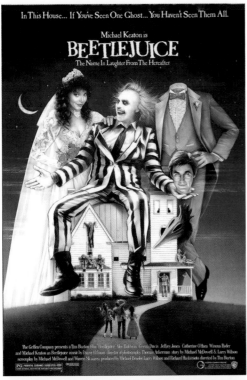

Michael Keaton is

BEETLEJUICE
The Name In Laughter From The Hereafter

The Geffen Company presents a Tim Burton film Beetlejuice Alec Baldwin Geena Davis Jeffrey Jones Catherine O'Hara Winona Ryder and Michael Keaton as Beetlejuice music by Danny Elfman director of photography Thomas Ackerman story by Michael McDowell & Larry Wilson screenplay by Michael McDowell and Warren Skaaren produced by Michael Bender Larry Wilson and Richard Hashimoto directed by Tim Burton

Being dead is a lot like going to the DMV, it turns out. You don't do anything but wait and wait and try to make sense of all the rules and regulations spelled out in a thick manual for the recently departed. Adam and Barbara can't be bothered with the hassle, and instead they summon the services of a "bio-exorcist" who advertises on ghost television, offering to expel the pesky living from the lives of the dead. His name is Betelgeuse, pronounced "Beetlejuice," and he is an even more obnoxious character than the interlopers at the house: loud, wheedling, conniving, obviously untrustworthy, apparently sociopathic, and definitely lecherous. He frankly looks like a demon clown who couldn't be bothered to finish applying his makeup. Keaton's performance doesn't seem totally coherent—composed of too many arbitrary tics and twitches—but then, he's

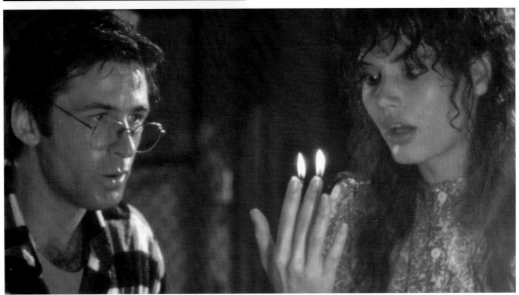

Alec Baldwin and Geena Davis as Adam and Barbara

One of Betelgeuse's more outlandish materializations

playing a character that doesn't really want to be figured out. Nonetheless, Keaton is always a pleasure to watch, if only to anticipate or be surprised by his next out-of-left-field acting trick.

In any event, Betelgeuse puts on quite a spooky show for the Deetzes, but instead of being frightened away, the relentlessly materialistic owners strike on the idea of buying up all the town's real estate and turning everything into one big haunted theme park. From there it's a wild ride to the finish, and not at all clear which side will win. Will crass property development triumph, as it always seems to do in life? Or is

there a way the living and the dead can finally make peace with each other and coexist in separate but equal dimensions?

Beetlejuice is not a film to be taken seriously on any plane, but it can be enjoyed on a multiplicity of levels. There is frequently more than one kind of humor on display at any moment, and your involuntary smile barely has a chance to stop. Burton aficionados will recognize any number of visual ideas that are wrapped into his later work, especially *The Nightmare Before Christmas*. Baldwin and Davis anchor the film wonderfully as warm and appealing characters who just

ABOVE Adam's unsuccessful attempt at a haunting **BELOW** The marriage of Betelgeuse and Lydia

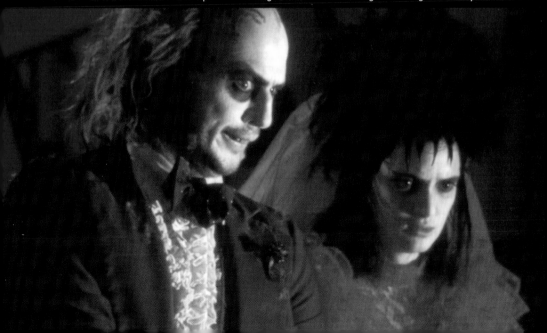

want to keep their relationship normal, whether they're alive or not, and no matter what kind of awful, cartoony goings-on are thrown at them. They're especially fun to watch as they tug and stretch their ectoplasmic faces like taffy, trying to fashion themselves into frightening apparitions but failing, because in the final analysis they're just too darn nice.

The possibility of a sequel to *Beetlejuice* has been kicked around since 1990, when Burton commissioned a script by Jonathan Gems called *Beetlejuice Goes Hawaiian*, but the project stalled with the director's involvement in *Batman Returns* (1992). Seth Grahame-Smith was hired by Warner Bros. in 2011 to pursue a different sequel, this one set twenty-seven years after the original story. Winona Ryder was especially keen to play a grown-up Lydia, but no commitments were announced by other original cast members. After a flurry of script rewriting in 2017, nothing concrete materialized, and in early 2019 Warner Bros. seemed to officially give the project its own manual for the recently deceased, but later in the year resurrection rumors began to resurface. Following a Washington, D.C., tryout, a musical adaptation of the original film opened in April 2019 at New York's Winter Garden Theater on Broadway for a limited seven-month run.

If you enjoyed *Beetlejuice* (1988), you might also like:

SLEEPY HOLLOW
PARAMOUNT, 1999

Tim Burton pulls out all the stops in this big-screen, big-budget extravaganza inspired by Washington Irving's classic tale "The Legend of Sleepy Hollow," about Ichabod Crane's fateful All Hallows' Eve encounter with the Headless Horseman. In Burton's telling, there are many more than one headless character; as the film's advertising tagline promised, "HEADS WILL ROLL," and indeed they do. As played by Johnny Depp, Crane is no longer a gawky Hudson Valley schoolmaster but a New York City constable called up the river to investigate a series of beheadings that may involve a supernatural Hessian horseman in search of his own head. This is an especially good choice for Halloween viewing, given the source material. A remarkable special-effect scene near the end, in which one of the characters convincingly self-decapitates on camera, is reason alone for a second viewing, or at the very least a rewind.

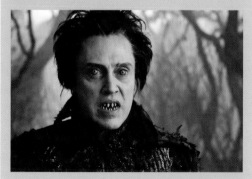

Christopher Walken as the Hessian horseman in *Sleepy Hollow*

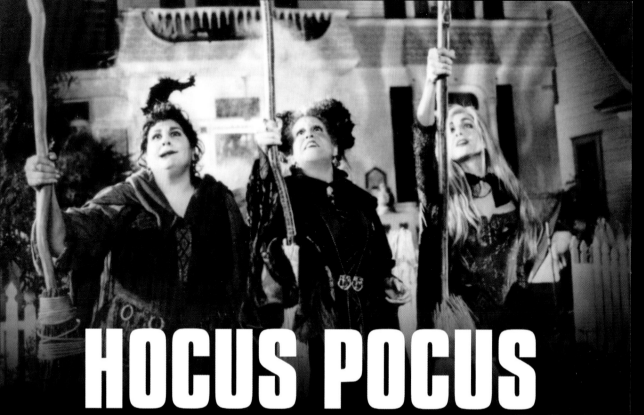

HOCUS POCUS

CONDEMNED SALEM WITCHES *ALMOST* HAVE THE LAST LAUGH.

Disney, 1993
Color, 96 minutes

DIRECTOR
KENNY ORTEGA

PRODUCERS
STEVEN HAFT, DAVID KIRSCHNER, RALPH WINTER

SCREENPLAY
MICK GARRIS AND NEIL CUTHBERT, FROM ORIGINAL STORIES
BY MICK GARRIS AND DAVID KIRSCHNER

STARRING
WINIFRED BETTE MIDLER
SARAH SARAH JESSICA PARKER
MARY KATHY NAJIMY
MAX OMRI KATZ
DANI THORA BIRCH
ALLISON VINESSA SHAW
EMILY AMANDA SHEPHERD
ERNIE ("ICE") LARRY BAGBY
JAY TOBIAS JELINEK
BILLY BUTCHERSON DOUG JONES
THACKERY BINX SEAN MURRAY

On Halloween, 1693, a trio of witches, Winifred, Sarah, and Mary Sanderson (Bette Midler, Sarah Jessica Parker, and Kathy Najimy), abduct a young girl named Emily (Amanda Shepherd) to their cottage near Salem, Massachusetts, and work black magic to absorb her vitality to regain their own youth. The girl dies, and her brother, Thackery Binx (Sean Murray), who failed to save her, confronts the weird sisters, only to be turned into a black cat cursed to live forever with his guilt. The witches are captured and hanged, but not before a curse is cast that will resurrect them on Halloween if a virgin lights Winifred's magic candle that burns with a black flame.

Three hundred years pass, and it is Halloween again. Max Dennison (Omri Katz) is a boy whose family has uprooted him from their Los Angeles home and relocated to Salem. He develops a crush on a girl named Allison (Vinessa Shaw), whose family owns the original Sanderson sisters' house, which has been preserved as a witchcraft museum. Max asks Allison if he can see the house, and she invites him and his younger sister, Dani (Thora Birch), inside. Max, very interested in girls but still sexually inexperienced, lights the black-flame candle, satisfying the curse's requirement that only a virgin can resurrect the witches.

Released from their long death-sleep, the

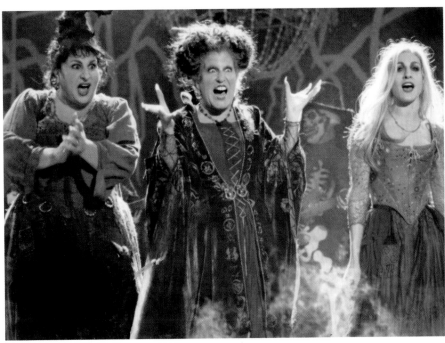

The Sanderson sisters: Mary (Kathy Najimy), Winifred (Bette Midler), and Sarah (Sarah Jessica Parker)

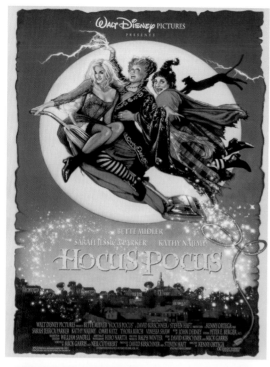

wacky witches decide to suck the souls from every child in Salem, and they go after Dani first. They need to complete their rejuvenation by daybreak or risk disintegrating in the sun. The kids flee the museum, but not before Thackery the cat advises Max to take Winifred's sentient spellbook, which can see through an eye embedded in its cover. The witches chase Max, Allison, and Dani to a cemetery, where Winifred resurrects her long-ago unfaithful lover, Billy Butcherson (Doug Jones), as a zombie to assist the chase. But as they pass through the streets of Salem, they are appalled at what Halloween has become: a common public holiday, not an esoteric rite. The chase continues all night and all around the town (and wouldn't you know: Winifred even stops to belt out what sounds an awful lot like a Bette Midler number). After a great deal of slapstick, the whole group ends up back at the cemetery for a final blowout reckoning that sorts out everyone's issues, interpersonal and supernatural, including the long quest of Thackery to escape the damnation of eternal cathood and be reunited and reconciled with his sister.

Hocus Pocus is a ridiculous, and ridiculously enjoyable, film—and not a bad choice at all to have playing as a backdrop during your next Halloween party. The nonstop, over-the-top mugging of Midler, Parker, and Najimy is a show in itself, even with the volume turned down. *Hocus Pocus* is yet another film that survived

Allison (Vinessa Shaw), Dani (Thora Birch), and Max (Omri Katz) aren't quite sure what dark powers they've managed to unleash.

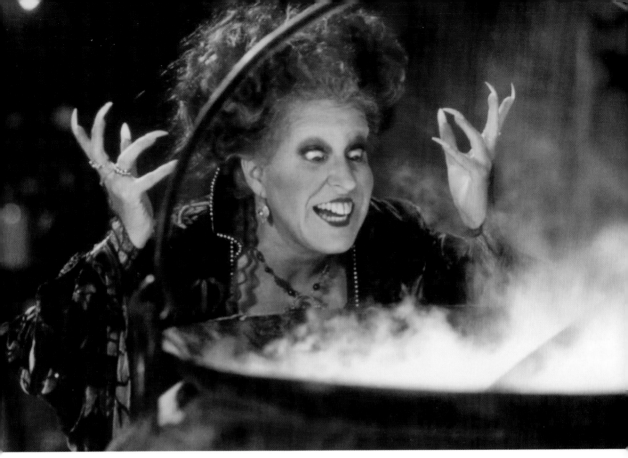

Bette Midler stirs up a spell.

box-office disaster—it lost Disney a reported $16.5 million—and extraordinarily bad reviews (*Entertainment Weekly* called it "acceptable scary-silly kid fodder that adults will find only mildly insulting. Unless they're Bette Midler fans. In which case it's depressing as hell"), only to rise from its own ashes with a cult imprimatur and an eternally loyal fan base.

Aaron Wallace's 2016 book *Hocus Pocus in Focus: The Thinking Fan's Guide to Disney's Halloween Classic* called itself "a lighthearted but scholarly look at the film in all its spooky-kooky glory." As the cover blurb describes things, "In 1993 Walt Disney Pictures released a movie that would change a generation . . . but it took a while." The book also makes the case that "far from the forgotten relic it was destined to become, *Hocus Pocus* has taken its place alongside *The Wizard of Oz*, *Harry Potter*, and *Home Alone*—a bona fide classic that's sure to stay alive for generations to come."

Unsurprisingly, the film has especially endeared itself to the city of Salem, Massachusetts, where the story is set and some exterior

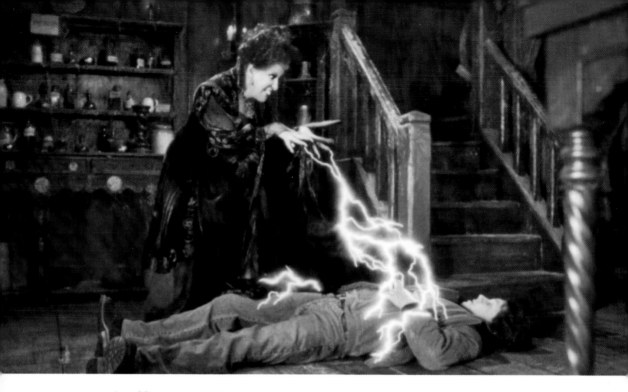

scenes were shot. The twenty-fifth anniversary of the film's release was celebrated by Salem's Haunted Happenings Grand Parade, an annual Halloween event given an official *Hocus Pocus* theme in 2018. Simultaneously, the E! network cablecast its own *Hocus Pocus 25th Anniversary Halloween Bash*, which reunited Bette Midler, Sarah Jessica Parker, and Kathy Najimy with other *Hocus Pocus* alumni in nostalgic fun at the decidedly movie-friendly Hollywood Forever Cemetery. Rumors of a sequel or remake have been percolating for years; in 2017 Mick Garris confirmed that he was working on a screenplay for a television film called *Hocus Pocus 2*.

ABOVE Winifred treats Max to her own brand of shock therapy. **BELOW** Winifred's long-ago boyfriend, Billy Butcherson (Doug Jones), helps Max, Allison, and Dani elude the witches.

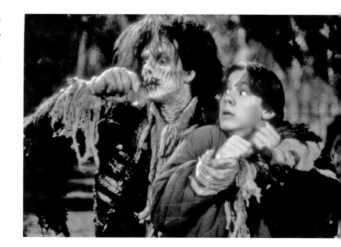

THE WITCHES

LORIMAR FILM ENTERTAINMENT, 1990

Novelist Roald Dahl wasn't happy with the happy ending Nicolas Roeg substituted for the melancholy one that concluded his widely admired young adult novel. Nonetheless, and despite initially poor box office, *The Witches* had a positive critical reception, and, like *Hocus Pocus*, eventually achieved cult status. Luke, a recently orphaned Norwegian boy, travels with his grandmother to a hotel in England, where an organization purporting to be the Royal Society for the Prevention of Cruelty to Children is holding a convention. In reality, it is a gathering of witches intent on removing all children from England by turning them into mice. The striking character designs were created by Jim Henson Productions. Anjelica Huston's hag getup as the undisguised Grand High Witch involved not only heavy prosthetics but mechanics as well, and, Huston reported, was exceedingly uncomfortable to wear. Despite Dahl's displeasure with the ending, the film served his darker intentions quite well.

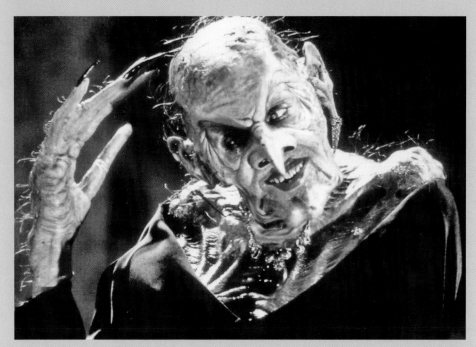

Anjelica Huston as the Grand High Witch in *The Witches*

SCREAM

DO YOU *REALLY* KNOW HOW TO SURVIVE A HORROR MOVIE?

Dimension Films, 1996
Color, 111 minutes

DIRECTOR
WES CRAVEN

PRODUCERS
BOB WEINSTEIN, HARVEY WEINSTEIN, CATHY KONRAD

SCREENPLAY
KEVIN WILLIAMSON

STARRING
DEPUTY DEWEY	DAVID ARQUETTE
SIDNEY PRESCOTT	NEVE CAMPBELL
GALE WEATHERS	COURTENEY COX
TATUM RILEY	ROSE MCGOWAN
STUART	MATTHEW LILLARD
RANDY	JAMIE KENNEDY
BILLY LOOMIS	SKEET ULRICH
CASEY BECKER	DREW BARRYMORE
PHONE VOICE	ROGER JACKSON
STEVE ORTH	KEVIN PATRICK WALLS
CASEY'S FATHER	DAVID BOOTH
CASEY'S MOTHER	CARLA HATLEY
NEIL PRESCOTT	LAWRENCE HECHT
KENNY JONES	W. EARL BROWN
COTTON WEARY	LIEV SCHREIBER

"What's your favorite scary movie?" the unidentified caller asks. Casey Becker (Drew Barrymore) is a high school student who at first enjoys the flirty, anonymous attention. But then the caller becomes menacing and says that her boyfriend is a hostage and will be killed unless she can correctly answer certain questions about horror movies. She tries as best as she can but gives a wrong answer, after which her boyfriend is disemboweled. The questions keep coming, and when she refuses to answer, she is murdered by a killer in a ghostly mask and found by her parents swinging from a tree, gutted like her boyfriend, entrails hanging.

It was the opening scene of Wes Craven's *Scream* that let 1996 audiences know the film wasn't going to be another formula slice-and-dice. There was nothing routine about killing off a star like Drew Barrymore just a few minutes into a movie. Even in *Psycho*, Hitchcock let Janet Leigh survive half the film before sending her off to the shower, and that was still a pretty unsettling good-bye.

Originally titled *Scary Movie*—a title saved by screenwriter Kevin Williamson for yet another, lighter-hearted franchise—*Scream* earned $173 million worldwide and effectively reinvigorated the horror genre, which in the 1990s was swamped by tired sequels to films that

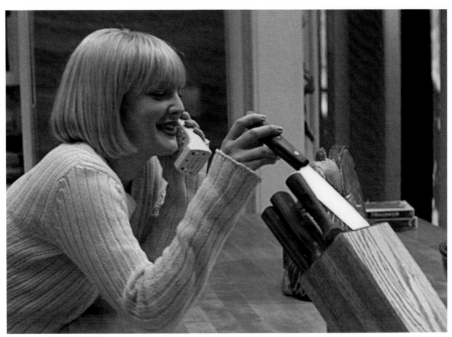

Casey Becker (Drew Barrymore) plays a teasing phone game of horror movie trivia.

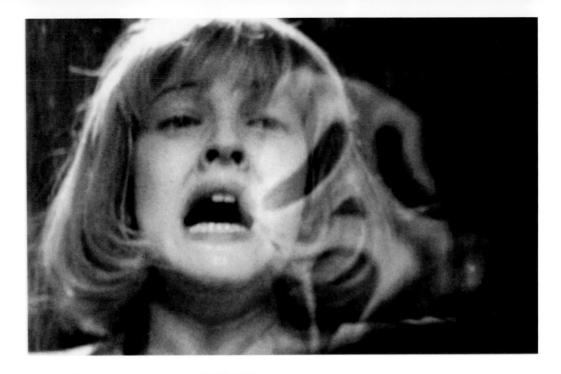

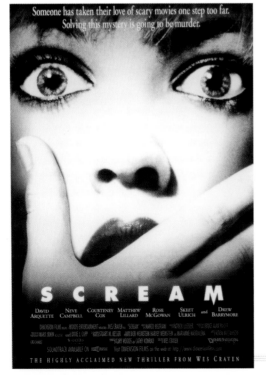

Someone has taken their love of scary movies one step too far.
Solving this mystery is going to be murder.

S C R E A M

DAVID NEVE COURTENEY MATTHEW ROSE SKEET and DREW
ARQUETTE CAMPBELL COX LILLARD McGOWAN ULRICH BARRYMORE

THE HIGHLY ACCLAIMED NEW THRILLER FROM WES CRAVEN

If you play with Ghostface, it's a game of life and death.

were already sequels or worn-out remakes. The freshest thing about *Scream* was that it expected its audiences, as well as its characters, to be fully aware of modern horror movie conventions, and to use the knowledge strategically to anticipate the next scare. It's not so much a slasher movie as a movie about the whole *idea* of slasher movies. The characters drop actors' names and even wonder who will play one another on-screen if the melodrama unfolding around them ever gets made into a horror film. The irony is, we're already watching that film.

The film's video-store maven, Randy (Jamie Kennedy), spells out the basics to a group of teens at a slasher festival: "To successfully survive

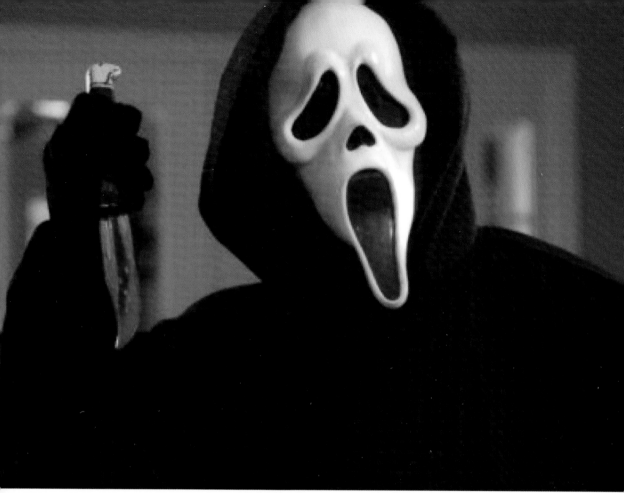

Every movie slasher needs an iconic mask. It's a rule.

a horror movie, you have to abide by the rules." First, "You can never have sex: the minute you do, you're as good as gone. Sex equals death." Second, "Never drink or do drugs: it's an extension of the first." And third, "Never, ever say, 'I'll be right back. . . .'" Because you won't.

Following the bloodbath prologue, *Scream* settles down into its story proper, the ordeal of a small town traumatized by the killings and worried that there will be more. The town is right to fret. High school student Sidney Prescott (Neve Campbell) is still dealing with the death of her mother, killed by a never-apprehended slasher one year ago. Is it possible the killer has returned? Sidney begins receiving threatening calls and suspects her boyfriend, Billy (Skeet Ulrich). Gale Weathers (Courteney Cox), a tabloid television reporter, is eager to dig

up dirt and cast suspicion anywhere if it makes a good story. Deputy Sheriff Dewey Riley (David Arquette) is earnest but goofy, in his own mind always about to crack the case. Suspicion flies in every direction, and at one point or another everyone seems like a plausible killer. And the characters in *Scream* who think they know everything about horror dynamics are often the most at risk because of their overbearing confidence.

The extra-gruesome effects were created by the KNB EFX Group, comprising Robert Kurtzman, Greg Nicotero (later a major force behind *The Walking Dead*), and Howard Berger, all experts in the horror genre. They manufactured over fifty gallons of artificial blood for the production, as well as realistic throat cuttings, guttings, and dripping blood. A good deal of their work went unseen as director Craven tussled with the MPAA rating board, submitting eight separate cuts of the film to address their objections, trimming and shortening the most elaborate and accomplished gore effects to avoid a revenue-killing NC-17 rating. In order to retain the shock value of Drew Barrymore's murder scene, he falsely claimed that the actress was simply unavailable for reshoots. And the film finally got its R rating.

The *Scream* franchise expanded to four films over fifteen years, all directed by Craven: *Scream 2* appeared in 1997, *Scream 3* in 2000, and *Scream 4* in 2011. *Scream: The TV Series* had a three-season run from 2015 to 2019, employing a completely new set of characters.

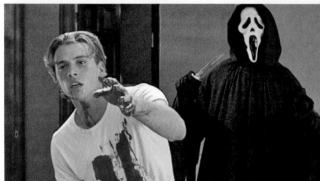

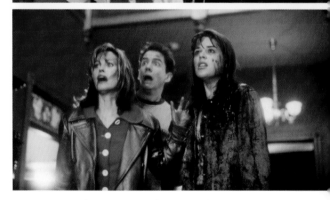

TOP Reporter Gale Weathers (Courteney Cox) confers with Deputy Sheriff Dewey (David Arquette). **MIDDLE** Ghostface catches up with Billy Loomis (Skeet Ulrich). **BOTTOM** Gale Weathers, Randy Meeks (Jamie Kennedy), and Sidney Prescott (Neve Campbell) all register completely appropriate reactions to a slasher epidemic.

CREEPSHOW

LAUREL PRODUCTIONS, 1982

Creepshow, Stephen King's first produced screenplay, is an anthology of five short films, four of which are based on his own published short stories, and one written directly for the screen. *Creepshow* is also an imaginary horror comic featured in the film's prologue and epilogue, confiscated from a boy named Billy (King's son Joe, later the horror writer Joe Hill). Billy turns instead to The Creep, the comic book's master of ceremonies, who materializes outside his window and tells a series of funny/horrible tales in the legendary tradition of EC Comics. The first is "Father's Day," in which a rotting corpse crawls out of its grave to avenge itself on a murderous daughter. "The Lonesome Death of Jordy Verrill" stars King himself as a simpleminded man who discovers a toxic meteorite that causes his body and anything he touches to uncontrollably sprout weeds. "Something to Tide You Over" is another revenge-of-the-dead tale, this one with a watery twist. "The Crate" involves a container found by a college janitor containing a ravenous, ape-like monster. The final story, "They're Creeping Up on You," stars E. G. Marshall as a germophobe whose hermetically sealed apartment loses all protection in a blackout and is overrun by a filthy sea of cockroaches.

Your master of ceremonies, The Creep, in *Creepshow*

GET OUT

GUESS WHO'S COMING TO DINNER? POD PEOPLE, MAYBE.

Blumhouse, 2017
Color, 104 minutes

DIRECTOR
JORDAN PEELE

PRODUCERS
JASON BLUM, JORDAN PEELE, EDWARD H. HAMM JR., SEAN MCKITTRICK

SCREENPLAY
JORDAN PEELE

STARRING

CHRIS WASHINGTON	DANIEL KALUUYA
ROSE ARMITAGE	ALLISON WILLIAMS
MISSY ARMITAGE	CATHERINE KEENER
DEAN ARMITAGE	BRADLEY WHITFORD
JEREMY ARMITAGE	CALEB LANDRY JONES
WALTER	MARCUS HENDERSON
GEORGINA	BETTY GABRIEL
ANDRE LOGAN KING	KEITH STANFIELD
JIM HUDSON	STEPHEN ROOT
ROD WILLIAMS	LIL REL HOWERY
LISA DEETS	ASHLEY LECONTE CAMPBELL

Jordan Peele, the comedian previously best known for his work on the Comedy Central sketch show *Key and Peele*, didn't feel like he had to make a major adjustment when he turned his mind to making an independent horror film. Horror and comedy, he knew, were both highly structured genres, each involving careful pacing and closely calibrated "reveals." Not to mention that laughing and screaming are both time-honored tension-relieving strategies, in art and in life.

In *Get Out*, Chris Washington (Daniel Kaluuya), a black photographer, agrees to spend a weekend with the family of his white girlfriend, Rose Armitage (Allison Williams), who are unaware that Rose's relationship is interracial. Rose's father, Dean (Bradley Whitford), is a neurosurgeon, and her mother, Missy (Catherine Keener), a hypnotherapist. They seem welcoming, but still they make very odd comments about race. Equally disconcerting to Chris is the strangely dazed behavior of the family's black employees, Walter, who tends the grounds, and Georgina, who keeps the house.

Chris experiences insomnia, and Missy convinces him to participate in a hypnotherapy session, ostensibly to help him stop smoking. After revealing personal details unrelated to smoking during the trance, he is led by Missy to a psychological void she calls "the sunken place." Although he remembers the session as a dream, in the morning he indeed has developed an aversion to cigarettes.

At the Armitages' yearly estate party, held the same day, rich white people repeatedly compliment Chris on his physical condition

Chris has an open talk with Rose, her dad, and her mom. Or does he?

and speak glowingly of black athletes like Tiger Woods. They tell him they would have backed a third term for Barack Obama. They stare at him with frozen smiles. He meets another strange black man, Logan King (Keith Stanfield), and sends a photo of Logan from his phone to his friend Rod Williams, a TSA agent, who is sure that the man's real name is Andre Hayworth, a missing person and possible kidnapping victim.

Chris believes that there is much more to learn, and he begins to question Rose's part in what seems to be a race-based conspiracy. Only when he is rendered helpless is he told the complete story of what, exactly, the Armitages expect of him.

It's difficult to talk about *Get Out* without revealing its imaginative central premise or too much of its plot resolution, but let's just say that Peele has constructed a devilish metaphorical device that makes the whole idea of "cultural appropriation" stunningly literal, as well as satirizing the uneasy mixture of condescension and cultural envy that has often informed the attitude of liberal white elites toward people of color. In particular, Peele zeros in on the widespread mythology of superior physical prowess among blacks, and how this might be exploitatively tapped for the benefit of aging whites.

Personality hijacking, replacement bodies, hypnotic mind control, and brainwashing are durable themes in science fiction and horror, and Peele's film reflects the legacy influence of a number of works, including *Invasion of the Body Snatchers* (1956, 1978, 1993, and 2007 adaptations), *The Thing*, and *The Stepford Wives*. Peele

Jordan Peele directs Betty Gabriel.

ABOVE Bradley Whitford and Catherine Keener as Dean and Missy Armitage **BELOW** Daniel Kaluuya as Chris Washington and Allison Williams as Rose Armitage

has stated that *The Stepford Wives* was indeed a conscious template for *Get Out*'s gated, manicured suburbia. There's also palpable influence from another Ira Levin book-turned-film. The fixed expressions of the guests at the Armitages' garden party uncannily conjure the faces of the true-believing devil worshippers who gathered around Mia Farrow when she finally got a glimpse of her demon child in *Rosemary's Baby*.

The initial reviews of *Get Out* were extraordinarily good, and so was word of mouth. As the British critic Frank Kermode, writing in the *Observer*, noted, "Beneath the beatific

smile of twenty-first-century liberalism, *Get Out* finds the still grinning ghoulish skull of age-old servitude and exploitation unveiled during a rollercoaster ride into a very American nightmare." *Time* called it "the horror movie we need today." *Get Out* was an event film to talk about, not just go to see. The film's $4.5 million investment yielded a worldwide gross of $255.5 million, an extraordinary ratio by any standard. It received four Academy Award nominations, winning for Best Original Screenplay, and it was named one of the ten best films of 2017 by *Time*, the American Film Institute, and the National Board of Review.

ABOVE Chris attends a very awkward garden party.
BELOW Jordan Peele directs Daniel Kaluuya.

HEREDITARY

A24/PALMSTAR MEDIA, 2018

Like *Get Out*, *Hereditary* is a film that pushes a genre premise uncomfortably close to the real world, with impressive results. Almost all horror films revolve around death, but almost none realistically examine the dynamics of grief among the survivors. In *Hereditary*, Toni Collette gives a bravura performance as a woman having difficulty processing the loss of her difficult and controlling mother, and who eventually steps into the realm of the supernatural.

The emotions are very raw, and the harrowing story has such a shocking, completely unexpected development that you should really try to read nothing beyond this description if you haven't yet seen it. Definitely not for younger kids. The tightly knit cast gives an astonishing ensemble performance, the acting of Alex Wolff and Milly Shapiro as Colette's children being especially accomplished and haunting. You just can't take your eyes off them.

Toni Collette in *Hereditary*

BIBLIOGRAPHY

In addition to the sources listed, much passing information was gleaned from clippings, studio press releases, promotional material, and ephemera held by the Billy Rose Theatre Division, New York Public Library for the Performing Arts at Lincoln Center; the Margaret Herrick Library of the Academy of Motion Picture Arts and Sciences; the British Film Institute; and the author's personal collection.

Books

Clarens, Carlos. *An Illustrated History of the Horror Film*. New York: G. P. Putnam's Sons, 1967.

Guiley, Rosemary Ellen. *The Encyclopedia of Vampires, Werewolves, and Other Monsters*. New York: Checkmark Books, 2005.

Inguanzo, Ozzy. *Zombies on Film: The Definitive Story of Undead Cinema*. New York: Universe/Rizzolli, 2014.

Kane, Joe. *Night of the Living Dead: Behind the Scenes of the Most Terrifying Horror Movie Ever*. New York: Citadel Press, 2010.

Koszarski, Richard. *Mystery of the Wax Museum*. Madison: University of Wisconsin Press, 1979.

LaValley, Al, ed. *Invasion of the Body Snatchers: Don Siegel, Director*. New Brunswick, NJ: Rutgers University Press, 1989.

Mank, Gregory William. *Hollywood Cauldron: Thirteen Horror Films from the Genre's Golden Age*. Jefferson, NC: MacFarland and Company, 1994.

McCarthy, Kevin, and Ed Gorman, eds. *"They're Here . . .": Invasion of the Body Snatchers: A Tribute*. New York: Berkley Books, 1999.

Price, Victoria. *Vincent Price: A Daughter's Biography*. New York: Open Media Distributors, 2014.

Rigby, Jonathan. *English Gothic: Classic Horror Cinema 1897–2015*. Cambridge, England: Signum Books, 2015.

Riley, Philip J., ed. *Dracula: The Original 1931 Shooting Script*. Abescon, NJ: MagicImage Filmbooks, 1990.

Skal, David J. *Halloween: The History of America's Darkest Holiday*. Mineola, NY: Dover Publications, 2016.

———. *The Monster Show: A Cultural History of Horror*, rev. ed. New York: Farrar Straus and Giroux, 2004.

Wallace, Aaron. *Hocus Pocus in Focus: The Thinking Fan's Guide to Disney's Halloween Classic*. Orlando, FL: Pensive Pen Publishing, 2016.

Walters, Jerad, ed. *Nosferatu: History, Criticism and Interpretation*. Lakewood, CO: Centipede Press, 2005.

Weaver, Tom, and Michael Brunas. *Universal Horrors: The Studio's Classic Films, 1931–1946*, 2d ed. Jefferson, NC: McFarland and Company, 2007.

Zinoman, Jason. *Shock Value: How a Few Eccentric Outsiders Gave Us Nightmares, Conquered Hollywood, and Invented Modern Horror*. New York: Penguin Press, 2011.

Periodicals

Groves, Bob. " 'Them!' Giant Ants that Spawned a Film Legacy." *Los Angeles Times*, April 17, 1988.

Taylor, Al. "Them!" *Fangoria #5*, April 1979.

Digital Media

Back to the Black Lagoon: A Creature Chronicle. DVD documentary supplement to *Creature from the Black Lagoon*. Universal City, CA: Universal Studios Home Video, 2000.

Black Sunday. DVD audio commentary by Tim Lucas. New York: Kino Lorber Classics, 2012.

Invasion of the Body Snatchers. DVD audio commentary by Richard Harland Smith. Chicago: Olive Films, 2018.

Monster by Moonlight: The Immortal Saga of the Wolf Man. DVD documentary supplement to *The Wolf Man*. Universal City, CA: Universal Studios Home Video, 2000.

Online Resources

afi.com
classichorrorfilmboard.com
imdb.com
TCMDb.com

ACKNOWLEDGMENTS

The author gratefully acknowledges the following people and resources for making this book possible: Cindy Sipala, acquisitions editor at Running Press, for approaching me about the project and for her ongoing enthusiasm, support, and many helpful suggestions; at Turner Classic Movies, John Malahy, Jennifer Dorian, Genevieve McGillicuddy, Heather Margolis, Pola Changon, and TCM's licensing agent, Aaron Spiegeland at Parham Santana; at Running Press, publisher Kristin Kiser, assistant editor Britny Brooks-Perilli, designer Josh McDonnell, publicist Seta Zink, production manager Katie Manning, production editor Michael Clark, and copyeditor Kelley Blewster for her meticulous attention. Eileen Flanagan at Turner Brand Central offered much helpful assistance in navigating the vast Turner visual library. Ron and Margaret Borst once more opened the incomparable Borst collection for my illustration use, and proved invaluable in locating some particularly hard-to-find images. Happy Halloween to all!

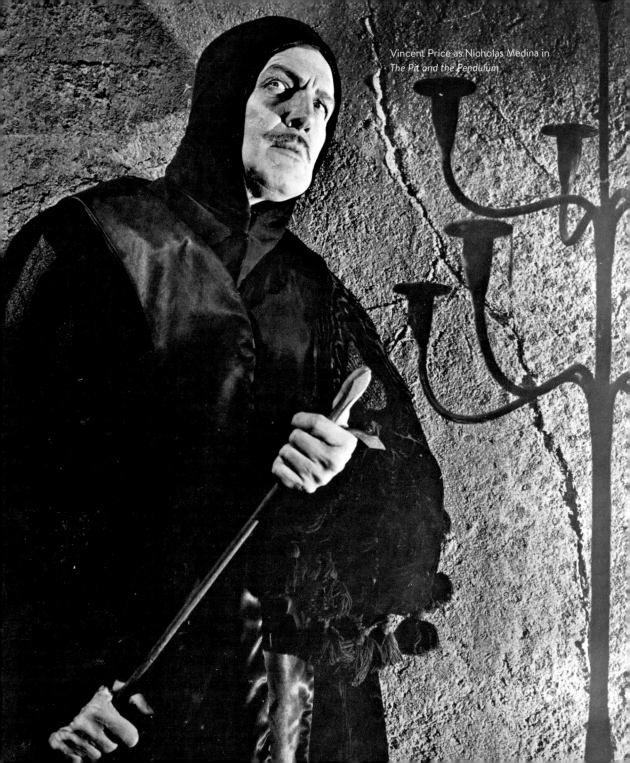

Vincent Price as Nicholas Medina in
The Pit and the Pendulum

INDEX

Page numbers in italics refer to images

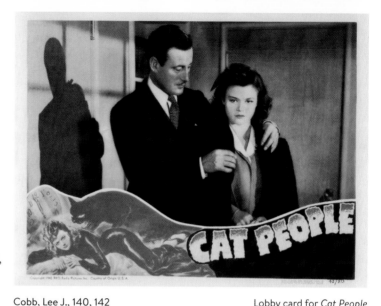

Lobby card for *Cat People*

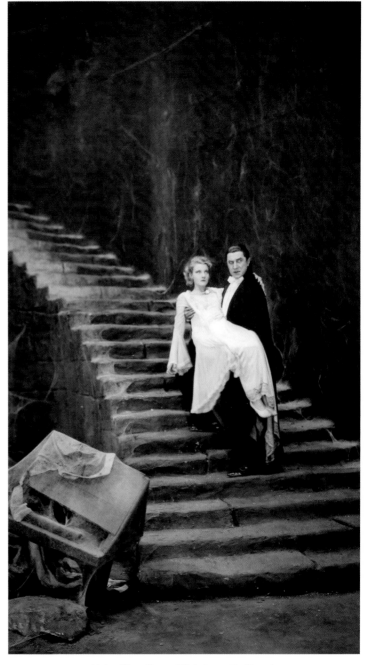

Helen Chandler and Bela Lugosi in *Dracula*

Jessica Tandy, Tippi Hedren, and Rod Taylor in *The Birds*

Robert Englund in *A Nightmare on Elm Street*

Danny Lloyd in *The Shining*

Lon Chaney and Bela Lugosi in *The Wolf Man*

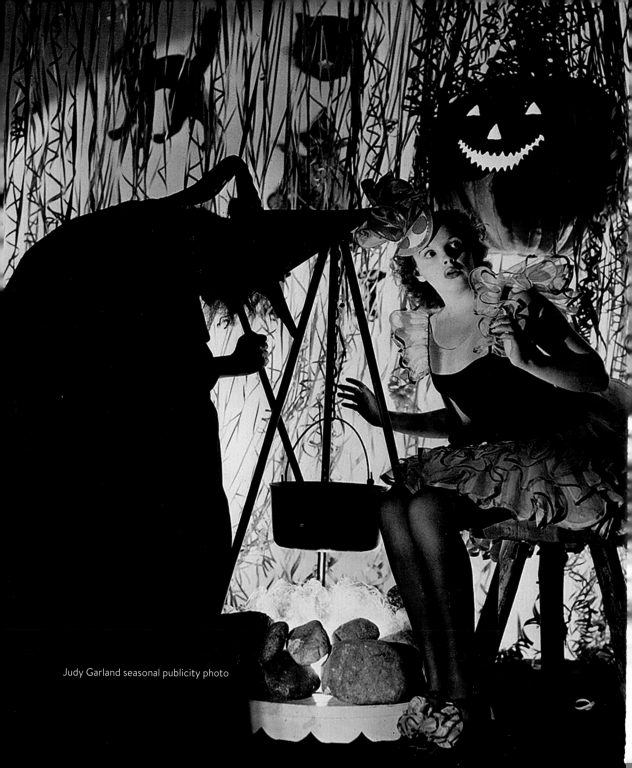

Judy Garland seasonal publicity photo

DR. JEKYLL AND Mr. HYDE

A ROUBEN MAMOULIAN PRODUCTION

YOU MAY NOT BELIEVE IN 9 GHOSTS BUT YOU CANNOT DENY TERROR

METRO-GOLDWYN-MAYER presents A ROBERT WISE PRODUCTION

THE HAUNTING

THE EXORCIST

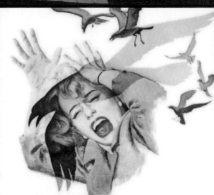

ALFRED HITCHCOCK'S "The Birds"

TECHNICOLOR

STARRING

ROD TAYLOR · JESSICA TANDY
SUZANNE PLESHETTE